Digital Cameras

Mark Edward Soper

Contents

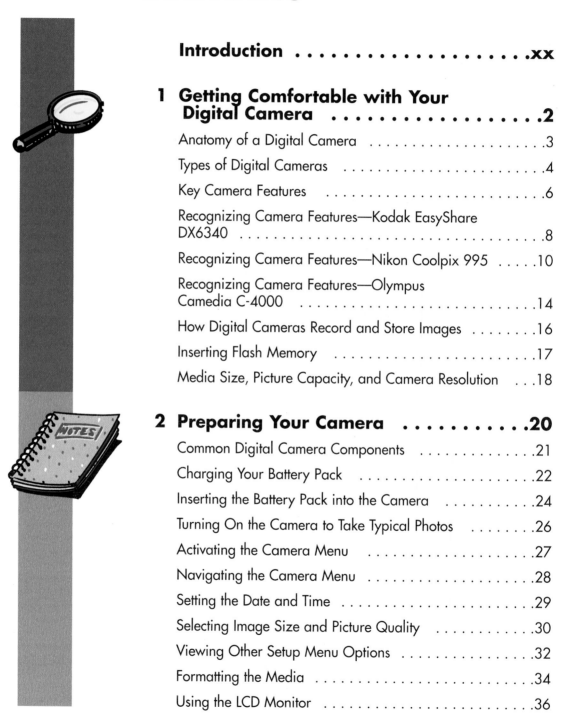

Easy Digital Cameras

International Standard Book Number: 0-7897-3077-4

Library of Congress Catalog Card Number: 2003116079

Printed in the United States of America

First Printing: May 2004

07 06 05 04 4 3 2 1

Trademarks

Warning and Disclaimer

Bulk Sales

Que Publishing offers excellent discounts on this book when ordered in quantity for bulk purchases or special sales. For more information, please contact

U.S. Corporate and Government Sales

1-800-382-3419

corpsales@pearsontechgroup.com

For sales outside the U.S., please contact

International Sales

1-317-428-3341

international@pearsontechgroup.com

Associate Publisher
Greg Wiegand

Acquisitions Editor
Michelle Newcomb

Development Editors
Todd Brakke
Kevin Howard

Managing Editor
Charlotte Clapp

Project Editor
Tonya Simpson

Production Editor
Benjamin Berg

Indexer
Erika Millen

Proofreaders
Charlotte Clapp
Megan Wade

Technical Editor
Greg Perry

Publishing Coordinator
Sharry Gregory

Multimedia Developer
Dan Scherf

Interior Designer
Anne Jones

Cover Designer
Anne Jones

Page Layout
Susan Geiselman

Graphics
Tammy Graham

Dedication

In memory of my mother, Anna Mae Soper (1933–1985).

She would have enjoyed how easy it is to capture life with digital photography.

—Mark E. Soper

Acknowledgements

The author of any book, including this one, is just one of the many people who make it possible.

I want to thank

Almighty God—He created the world and gave us the insight to view it, appreciate it, and record it through photography and other visual arts.

Cheryl—who has encouraged me to see the everyday world and our family as exciting subjects for photography.

Ian—who has become the finest photographer in our family.

Jeremy—who loves to explore the fusion of photography and graphics.

Kate and Hugh—who are responsible for the birth of Jarvis, the young "star" of many of the photographs in this book.

Ed and Erin; Bruce, Dawn, Michael, and Matthew; Steve and Stephanie; Mom Christmas—who helped me capture holidays and special events for this book.

Photography fans John Kizlin and Donnie Owen—who lent some of the digital cameras and accessories featured in this book.

The folks at Schmitt Photo (www.schmittphoto.com) and Robert's Distributors (www.robertsimaging.com)—who showed me some of the newest digital cameras and helped me contact vendor representatives.

Russell Shaw—who suggested some of the tasks in this book and provided photographs of the beautiful Pacific Northwest and its animal life.

Greg Wiegand—who green-lighted this project and built the terrific team that helped put it together.

Michelle Newcomb—who brought me into the project and helped me understand the unique features of the *Easy* series.

Todd Brakke and Kevin Howard—who helped bring out the best through their suggestions and critiques.

Greg Perry—who kept the technical discussions on track.

Ben Berg—who helped exterminate spelling and other textual glitches.

Tonya Simpson—who kept chapters flowing in the right direction.

Sharry Gregory—who kept everything organized and kept those checks coming!

Susan Geiselman—who prepared the book for printing.

Dan Scherf—who developed the companion CD.

Erika Millen—who made sure the index helps you find what you need—quickly.

And the rest of the Que team, working together to make sure you get the best technology books on the market.

—Mark Edward Soper

About the Author

Mark Edward Soper is president of Select Systems and Associates, Inc., a technical writing and training organization located in Evansville, Indiana. Get more information at the Select Systems Web site at www.selectsystems.com. Mark is a 20-year veteran of the computer industry whose first technical articles appeared in the late 1980s. Mark has written more than 140 articles on topics ranging from computer upgrades and memory technologies to laser printer tips and tricks, Internet access, and new features in Windows and Linux for publications such as *Maximum PC*, *PCNovice/SmartComputing Guides*, *PCNovice*, *SmartComputing*, the *PCNovice/SmartComputing Learning Series*, *WordPerfect Magazine*, *The WordPerfectionist*, and *PCToday*.

Mark has been a serious amateur photographer since 1971, so he brings more than 30 years' experience to this book. In addition to working as a high school and college newspaper and yearbook photographer, he has also worked as a church directory photographer. His work has been published in the *Durand (Michigan) Express* newspaper and *Passenger Train Journal* magazine. In recent years he has used his photographic and computer skills to create image archives for several libraries in southwestern Indiana.

Mark has taught computer troubleshooting and other technical subjects to thousands of students from Maine to Hawaii since the early 1990s. He is an A+ Certified hardware technician and a Microsoft Certified Professional.

Mark is the author of *Absolute Beginner's Guide to A+ Certification*, *Absolute Beginner's Guide to Cable Internet Connections*, and *PC Help Desk in a Book*. Mark has also written for other publishers in the Pearson Education family, including the recent *TechTV's Upgrading Your PC, Second Edition* for Peachpit/TechTV Press (http://www.peachpit.com) and *The Complete Idiot's Guide to High-Speed Internet Connections* for Alpha Books.

Mark is the coauthor of Que's *Upgrading and Repairing PCs: Field Guide* and its predecessors (the *Technician's Portable Reference* series), and he has also contributed to many other Que books in this series, including *Upgrading and Repairing PCs* from the 11th Edition to the current 15th Anniversary Edition; *Upgrading and Repairing Laptops*; *Upgrading and Repairing Networks, Second Edition*; and *Upgrading and Repairing PCs, 12th Edition, Academic Edition*.

Mark has also contributed to several volumes in Que's *Special Edition* series, including *Special Edition Using Windows Millennium*; *Special Edition Using Windows XP Home Edition*; *Special Edition Using Windows XP Home Edition, Bestseller Edition*; *Special Edition Using Windows XP Professional*; and *Special Edition Using Windows XP Professional, Bestseller Edition*. Mark is also a contributor to *Platinum Edition Using Microsoft Windows XP*.

Watch for details about these and other book projects at the Que Web site at http://www.quepublishing.com.

Mark welcomes comments at mesoper@selectsystems.com.

We Want to Hear from You!

As the reader of this book, *you* are our most important critic and commentator. We value your opinion and want to know what we're doing right, what we could do better, what areas you'd like to see us publish in, and any other words of wisdom you're willing to pass our way.

As an associate publisher for Que Publishing, I welcome your comments. You can email or write me directly to let me know what you did or didn't like about this book—as well as what we can do to make our books better.

Please note that I cannot help you with technical problems related to the topic of this book. We do have a User Services group, however, where I will forward specific technical questions related to the book.

When you write, please be sure to include this book's title and author as well as your name, email address, and phone number. I will carefully review your comments and share them with the author and editors who worked on the book.

Email: feedback@quepublishing.com

Mail: Greg Wiegand
 Associate Publisher
 Que Publishing
 800 East 96th Street
 Indianapolis, IN 46240 USA

For more information about this book or another Que title, visit our Web site at www.quepublishing.com. Type the ISBN (excluding hyphens) or the title of a book in the Search field to find the page you're looking for.

1 Each step is fully illustrated to show you how it looks onscreen.

It's as Easy as 1-2-3

Each part of this book is made up of a series of short, instructional lessons, designed to help you understand basic information that you need to get the most out of your computer hardware and software.

2 Each task includes a series of quick, easy steps designed to guide you through the procedure.

3 Items that you select or click in menus, dialog boxes, tabs, and windows are shown in **bold**.

How to Drag:
Point to the starting place or object. Hold down the mouse button (right or left per instructions), move the mouse to the new location, then release the button.

drag

drop

Click:
Click the left mouse button once.

Double-click:
Click the left mouse button twice in rapid succession.

Looking Up Synonyms

Start

1 Click

2 Click **3** Click **Click 4**

1 After you select the word for which you want to see synonyms, open the **Tools** menu and choose **Thesaurus**.

2 The Thesaurus dialog box opens. If two or more choices are in the **Meanings** list, click the one that most closely matches the meaning you want.

3 In the **Replace with Synonym** list, click the word you want to use.

4 Click the **Replace** button to close the thesaurus and replace your original word with the synonym. **End**

INTRODUCTION
Another feature of FrontPage is the built-in thesaurus that can suggest some synonyms, alternative words with the same meaning, for text that you've typed.

HINT — Canceling the Thesaurus
If you don't like any of the suggested synonyms better than your original word, click **Cancel** in the Thesaurus dialog box to close it.

HINT — Finding More Choices
To display a new list of synonyms based on one of the suggestions in the Replace with Synonym list, click the suggestion and then click the **Look Up** button.

Introductions explain what you will learn in each task, and **Tips and Hints** give you a heads-up for any extra information you may need while working through the task.

See next page

See next page:
If you see this symbol, it means the task you're working on continues on the next page.

End

End Task:
Task is complete.

Right-click:
Click the right mouse button once.

Pointer Arrow:
Highlights an item on the screen you need to point to or focus on in the step or task.

Selection:
Highlights the area onscreen discussed in the step or task.

Click & Type:
Click once where indicated and begin typing to enter your text or data.

Introduction

In 2003, digital camera sales surpassed film camera sales for the first time ever, and sales in 2004 and beyond are expected to be even bigger. Chances are, you're part of the reason. You might have been using a 35mm, APS, or other point-and-shoot camera before purchasing a digital camera, or your digital camera might be your first camera purchase ever. In either case, welcome to the world of digital photography!

This book is designed to give you a friendly, task-oriented introduction to digital photography. It won't make you an expert overnight, but it will help you get comfortable with your camera and its features, take better pictures, and share them with others.

Like other books in the *Easy* series, this book is task-oriented: You learn by doing. The tasks I've chosen are designed to be the most common tasks typical photographers perform with their cameras and with printers, data transfer devices, and other accessories and programs.

Because of the wide variety of digital camera brands, models, and features on the market, I've used three typical point-and-shoot cameras throughout the course of the book. Because taking pictures is only the beginning of your digital photography journey, I've also used a variety of printers, data transfer devices, software utilities, and programs in the parts of the book dealing with data transfer, printing, editing, and other post-photography tasks. Your camera and software are likely to be different than those I've chosen to use. Don't worry about it. As a task is described, I use tips and hints to discuss variations you may encounter in the products you use. The tasks are written in such a way that you can follow along with your own camera, printer, and software, even if they're different than the ones I use. Keep your instruction manuals handy to learn how to perform tasks I describe with the products you use.

The book contains 13 parts.

Part 1, "Getting Comfortable with Your Digital Camera," introduces you to the different types of digital cameras, their major features, how they work, and the media types they use to store photos. The major features of each of the three cameras used in the book are also identified.

Part 2, "Preparing Your Camera," helps you get your camera ready for your first photo. From inserting batteries and configuring the camera menu to formatting the media, this part guides you through the process.

Part 3, "Digital Photography Basics," shows you how to use your camera's zoom lens to compose pictures, how to adjust exposure, how to use exposure lock, how to measure the light for accurate exposure in different lighting conditions, how to review your photos, and how to use a flash.

Part 4, "Taking Digital Photos—Outdoors," shows you how to shoot good pictures in a variety of lighting conditions, from noon to night and from bright sun to fog and clouds.

Part 5, "Taking Digital Photos—Indoors," shows you how to use flash, available light, and supplementary lighting to get good interior photos.

Part 6, "Using Advanced Camera Features," shows you how to shoot panoramic views, how to control aperture and shutter speed settings for more creative control, how to shoot short movies, how to shoot photo sequences, how to use a tripod, and how to use the self-timer.

Part 7, "Transferring Digital Photos to Your Computer," shows you how to use USB cables, flash memory card readers, and camera docks to copy your photos to your PC for printing, editing, and sharing.

Part 8, "Scanning Old Photos," shows you how to use image scanners to bring your existing photos, slides, and negatives into the digital age and color-correct them in the process.

Part 9, "Viewing and Managing Your Digital Photos," shows you how to configure your PC to make photo viewing easier, how to display your photos as a slideshow, and how to delete unwanted photos.

Part 10, "Enhancing Your Digital Photos," shows you how to use photo editors such as Adobe Photoshop Elements (a free 30-day trial is included on the CD packaged with this book) to fix red-eye, rotate photos, adjust colors and brightness, crop photos, and fix other problems.

Part 11, "Printing Your Digital Photos," shows you how to use dedicated photo printers, snapshot printers, printer docks, and general-purpose inkjet printers to create snapshots, enlargements, and multiple print sizes on a single sheet of photo paper.

Part 12, "Presenting and Sharing Your Photos," shows you how to email your photos, use them to enhance an eBay sales listing, send your photos to an online photo album/printing site, create a slideshow you can email or burn to CD, and insert your photos into a Microsoft Word or PowerPoint file.

Part 13, "Storing Your Digital Photos," shows you how to transfer your photos to recordable CD, DVD, USB, or other types of removable-media drives; how to rename and organize your photos to make it easier to find the pictures you want; and how to repair damaged CDs.

By the time you finish this book, you'll be ready to create digital masterpieces you can share, and have fun doing it! See you in Part 1!

Getting Comfortable with Your Digital Camera

Digital cameras look like film-based cameras, but instead of using film to record images, they use an electronic sensor called a charge-coupled device (CCD). The CCD is divided into three million or more pixels on typical mid-range cameras. Most cameras use one of various types of flash memory cards to store the digital images that the CCD creates. A few cameras use mini-CDs or floppy disks instead. Together, the CCD and flash memory or other recording media replace film in a digital camera.

Anatomy of a Digital Camera

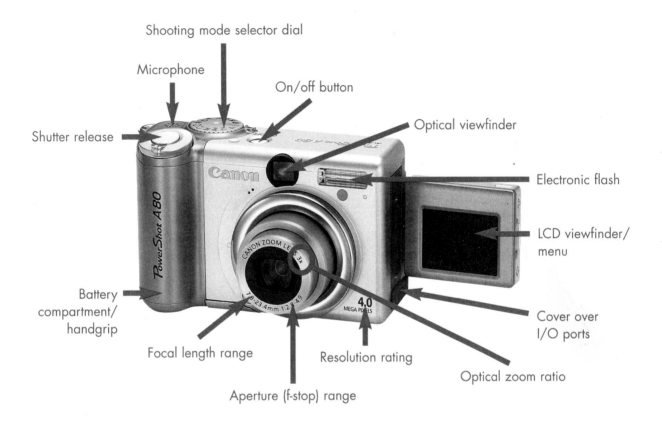

Shooting mode selector dial

Microphone

On/off button

Shutter release

Optical viewfinder

Electronic flash

Battery compartment/ handgrip

LCD viewfinder/ menu

Focal length range

Resolution rating

Cover over I/O ports

Aperture (f-stop) range

Optical zoom ratio

Photo courtesy of Canon USA, Inc.

PART 1

Types of Digital Cameras

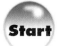

Start

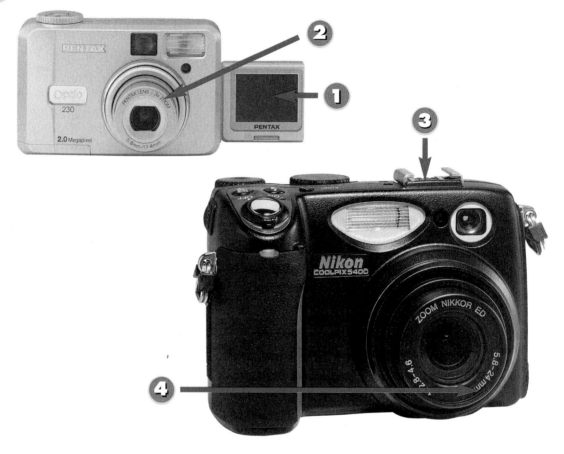

1 Even simple point-and-shoot cameras have an LCD display for composing pictures and configuring the camera.

2 A 3x optical zoom lens is typical of point-and-shoot cameras.

3 A few mid-range cameras have a hot shoe or other provision for removable electronic flash.

4 Most mid-range cameras offer longer zoom ratios (this one has a 4x instead of a 3x zoom).

INTRODUCTION

Digital cameras can be divided into several categories, based on their lenses, their resolution (number of horizontal and vertical pixels), the type of storage they use, and the level of manual control they provide for exposure and focus.

TIP

Point-and-Shoot Cameras
The Pentax Optio 230 is a typical point-and-shoot digital camera. It has limited manual control, a short (3x) zoom range, and relatively low resolution (2 megapixels). *Photo courtesy Pentax, Inc.*

TIP

Mid-Range Cameras
The Nikon Coolpix 5400 is a typical mid-range digital camera. It offers a wide range of manual picture controls and a 5.1 megapixel resolution for enlargements up to 16×20 inches. *Photo courtesy Nikon USA.*

5 Many high-end cameras offer a wide lens opening (f2.8–3.1) for better shooting in dim light.

6 Many high-end cameras offer selectable auto/manual focus for more creative control of focus.

7 Interchangeable lenses enable digital SLR cameras to use lenses made for film cameras.

8 Digital SLR cameras can also use the same electronic flash units made for film cameras.

End

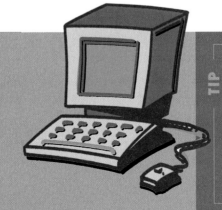

TIP

Advanced Cameras
The Fuji FinePix S7000 is a typical advanced digital camera. It features single-lens-reflex (through-the-lens) optical viewing, 6 megapixel resolution, and high-quality movie mode. *Photo courtesy Fuji Photo Film USA, Inc.*

TIP

Interchangeable Lenses
The Canon EOS Digital Rebel is a typical interchangeable-lens digital single-lens-reflex (SLR) camera. It can use the same lenses and accessories as the Canon EOS series of single-lens-reflex 35mm film cameras. *Photo courtesy Canon USA, Inc.*

Key Camera Features

Start

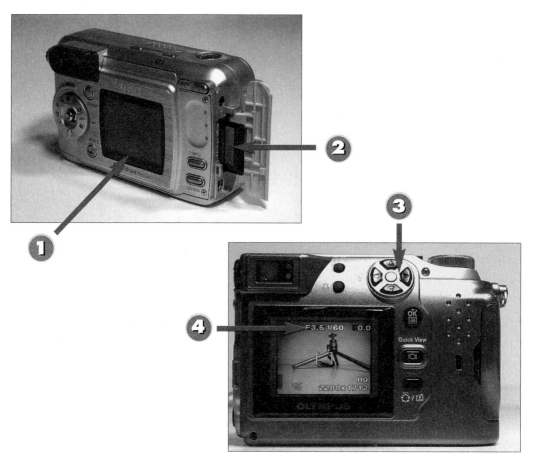

1 An LCD viewfinder helps you compose your photos.

2 Removable flash memory enables you to shoot more photos.

3 The mode control helps you select the right shooting mode for the conditions.

4 Exposure detail in the LCD display shows you the shooting mode and whether you need to use a flash.

INTRODUCTION

With so many brands and models of digital cameras on the market, choosing the best model for your needs can be confusing. In this task, you learn about the most important camera features to look for in each category of camera.

TIP

Removable Storage
Make sure your camera has removable storage. It's very helpful during a long shooting day to be able to switch flash memory cards and keep taking pictures. Part 2 discusses the different types of removable storage in more detail.

HINT

Overriding Normal Exposure
For tricky lighting situations, like when the sun is behind the subject, it's helpful to be able to override the normal exposure settings. It's even better if you can manually select the aperture or shutter speed.

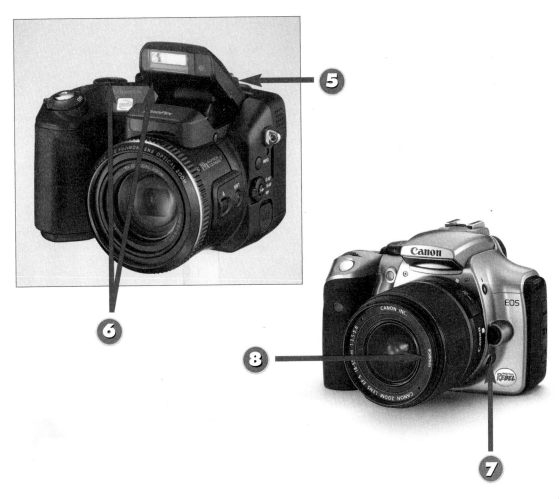

(5) A TTL viewfinder helps you compose your photos with less battery drain than using the LCD display at all times.

(6) Manual and automatic exposure controls enable better photos under tricky lighting conditions.

(7) A depth-of-field preview button helps you determine the area of sharp focus.

(8) Lenses that accept standard filter sizes allow you to protect your lens and enable special optical effects.

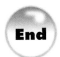

End

TTL Viewfinder

TIP

If you're a serious photographer, you need through-the-lens (TTL) viewing. A small electronic or optical TTL viewfinder helps you compose your pictures accurately without using the LCD display and draining battery power.

Interchangeable Lenses

TIP

The most versatile digital single-lens-reflex (SLR) cameras use interchangeable lenses. If you already have a Canon or Nikon autofocus 35mm SLR, you can use the same lenses on the new breed of Canon and Nikon digital SLR cameras.

Recognizing Camera Features—
Kodak EasyShare DX6340

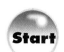
Start

① **Electronic flash**

Optical viewfinder

Autofocus sensors

②

Wide/Tele zoom control

LCD display

③

Control dial

④

① The 3.1 megapixel resolution is sufficient for creating high-quality enlargements up to 8×10 inches.

② The camera features a Schneider Variogon 4x zoom lens.

③ The joystick provides four-directional control for setup menus and also acts as a push-button.

④ The share button emails and prints photos through optional camera and printer docks.

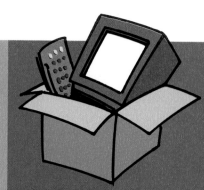

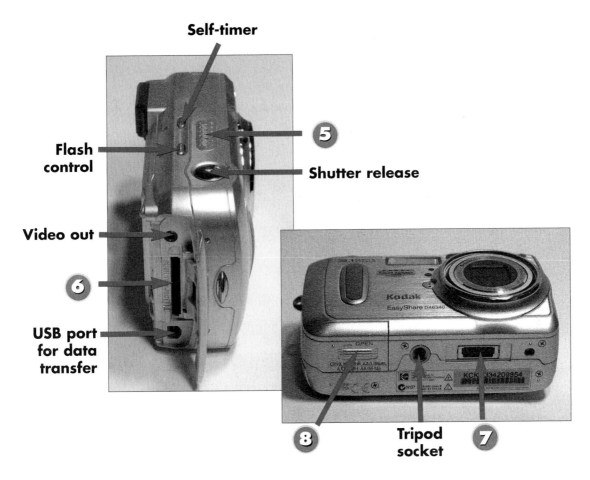

Self-timer

Flash control

Shutter release

Video out

USB port for data transfer

Tripod socket

⑤ The camera has a built-in microphone for recording sound in movie mode.

⑥ Along with internal memory, the camera has a MultiMediaCard (MMC) or Secure Digital (SD) flash memory slot.

⑦ The docking port enables the camera to connect to Kodak camera and printer docks.

⑧ The camera can use alkaline, Ni-MH, or lithium AA or battery packs for power.

End

HINT

Power Jacks Aren't for Battery Recharging
The Kodak EasyShare DX6340 has an AC adapter port (not shown), but as with most digital cameras, it cannot be used to recharge the camera's own batteries. However, if you want to recharge batteries without removing them from the camera, Kodak's camera and printer docks include a rechargeable battery.

Recognizing Camera Features—
Nikon Coolpix 995

Start

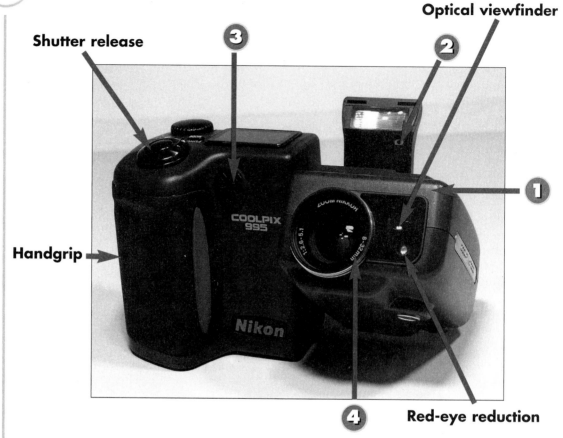

Shutter release

Optical viewfinder

③

②

①

Handgrip →

④

Red-eye reduction

① The Coolpix 995 is one of several Nikon models that feature a swiveling lens.

② Open the pop-up flash if you want to use it; close it to turn it off.

③ The (covered) AC adapter connector can be used to power the camera for indoor shooting.

④ A 4x zoom lens helps bring distant subjects closer than a 3x model would.

Here's a view all around the Nikon Coolpix 995, a mid-range digital camera that is used for tasks in other parts of this book.

TIP

Using the Swiveling Feature
You can use the swivel feature to shoot above your head or at waist level while still composing your photos in the LCD display.

HINT

Saving Battery Power
If you plan to shoot a lot of photos indoors or use the camera to transfer pictures, pick up an AC adapter made for your camera if one wasn't included. It beats buying batteries!

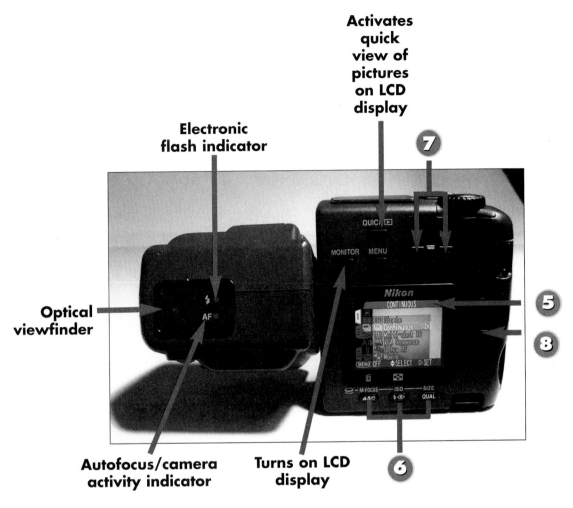

Activates quick view of pictures on LCD display ⑦

Electronic flash indicator

Optical viewfinder

Autofocus/camera activity indicator

Turns on LCD display ⑥

⑤

⑧

⑤ The Nikon Coolpix 995 has extensive creative controls in its setup menu.

⑥ It also features button-based controls for focusing mode (l), flash/ISO (c), and picture size/quality (r).

⑦ W (wide) and T (tele) buttons control the zoom lens.

⑧ The four-way control selects setup menu options.

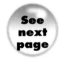

See next page

TIP

Practice Makes Perfect!
Although many digital cameras have simpler controls than the Coolpix 995, even point-and-shoot cameras have several setup menu and shooting control settings. Practice making the settings you want before you go "live."

HINT

Keeping Your Camera Clean
Because the LCD display provides shooting information as well as a preview of your photo, you should keep it clean with a microfiber cloth.

On/off/mode control

Shutter button

**Electronic flash
on-off switch**

⑩ You can control the shooting mode and other settings with the control cluster behind the shutter button.

⑩ The status window indicates current settings and the number of exposures left on the memory card.

⑪ The battery life indicator should be checked before you take pictures.

⑫ The number of exposures left varies with the size of flash memory and the picture quality settings used.

HINT

**Keep Extra "Film"
on Hand**

Flash memory cards are cheap enough these days that you should keep a spare one handy so you can change cards in the middle of shooting.

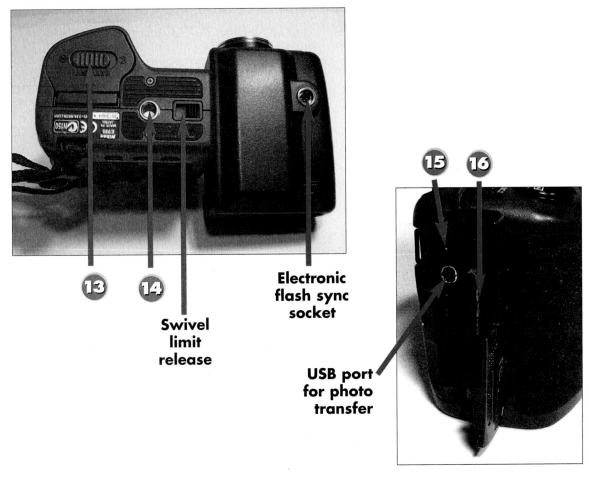

Swivel limit release

Electronic flash sync socket

USB port for photo transfer

15 · 16

13 The Coolpix 995 uses a rapid-charge proprietary battery pack.

14 It can be attached to a tripod for low-light shooting.

15 It can be connected to a TV for playback.

16 It uses Compact Flash memory cards for storage.

Carry Your Video Cable with You

You can put on a show anywhere you can find a TV with a video-in jack if you carry your camera's video-out cable with you. You can also plug your camera into a VCR's video-in jack.

Recognizing Camera Features—
Olympus Camedia C-4000

Start

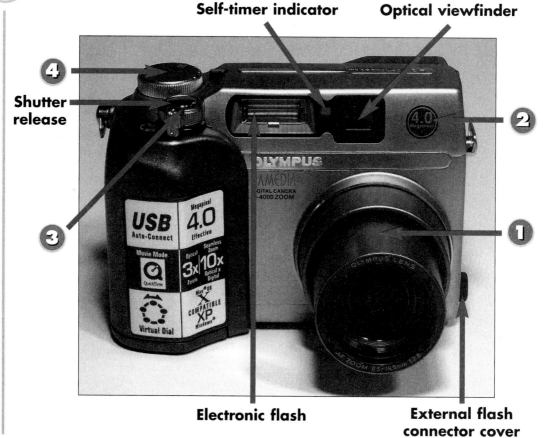

Self-timer indicator

Optical viewfinder

4

Shutter release

3

2

Electronic flash

1

External flash connector cover

1 The Olympus Camedia C-4000 has a high-speed (f2.8–f3.1) zoom lens for shooting in dim light.

2 The 4-megapixel maximum resolution enables it to create high-quality 11×14-inch enlargements.

3 The front-mounted zoom lens control makes it easy to zoom and shoot quickly.

4 The top-mounted control dial controls shooting and reviewing options.

INTRODUCTION

Here's a tour of the Olympus Camedia C-4000, an advanced mid-range digital camera that will be used for tasks in other parts of this book.

HINT

F-Stops Exposed

The smaller the f-stop number, the wider the lens opening and the more light can enter the lens. Many digital cameras have zoom lenses with an f2.8 rating at wide angle, but drop to f4.5 or less at telephoto. The C-4000's f-stop is about the same at wide angle (f2.8) as at longest telephoto (f3.1), so you can use the full zoom range indoors or in less than sunny conditions outdoors.

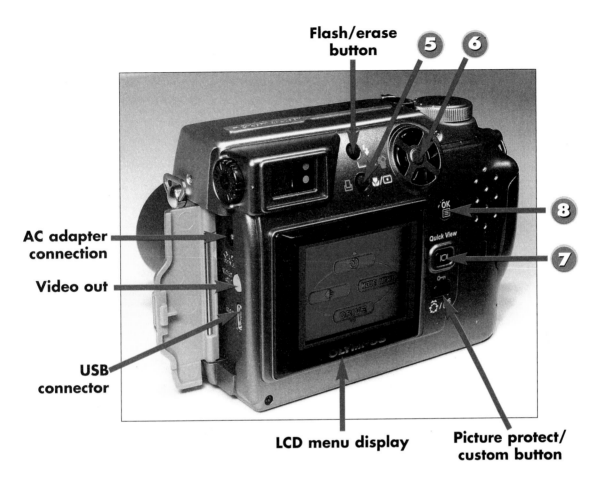

Flash/erase button — 5 6

AC adapter connection

Video out

USB connector

8

Quick View
7

LCD menu display

Picture protect/ custom button

5 You can print directly from the camera to various models of Olympus dye-sublimation printers.

6 The four-way virtual dial lets you control menu options and shooting mode settings.

7 The Quick View button turns on the LCD display for picture composing.

8 The OK button confirms menu options.

End

One-Button Access
Create a custom function with the setup menu, and you can select it with one push of the custom button.

Using the Virtual Dial
Many cameras use a multipurpose control; its exact function depends upon the current mode. Practice makes perfect.

How Digital Cameras Record and Store Images

Compact Flash

Smart Media

Mini-CD

Memory Stick

xD-Picture Card

MultiMediaCard (MMC)

Penny (for size comparison)

Secure Digital (SD)

Floppy disk

INTRODUCTION

Conventional cameras use film to record images; the film must be developed before it can be used for prints. Instead of film, digital cameras use an image sensor to receive the image from the lens and convert it into digital form. After the image is converted into digital form, the camera stores the image digitally, usually on some type of flash memory storage. Flash memory is a type of memory that uses electricity to record data in digital format, but unlike the memory found in computers, flash memory "remembers" the information after the camera is turned off or the card is removed from the camera.

TIP

How They Store Images
Cameras that use floppy disks store the picture magnetically. Cameras that use mini-CDs use a powerful laser to record photos. Floppy and mini-CD media is compatible with standard computer drives.

Inserting Flash Memory

Start

Open

① ②

③ Insert

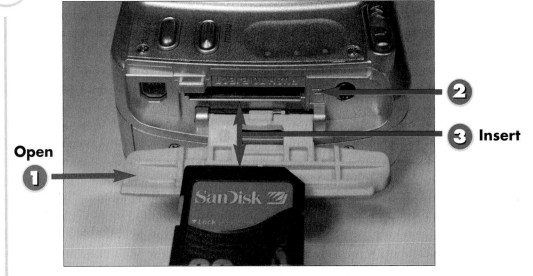

④

① Open the cover over the flash memory card slot.

② Locate the markings indicating the orientation for the card.

③ Line up the flash memory card with the slot.

④ Push the card into place.

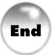

End

INTRODUCTION

Compact Flash uses two rows of connectors on one end of the module, while other types use a row of connectors on the back side of the module. Regardless of the module type, the module must be oriented correctly before it can be installed. In this task, I show you how to correctly insert SD/MMC media into a typical digital camera.

TIP

Removing Flash z Memory Cards
Compact Flash cards are usually ejected with a push button or slider. To remove other types, gently push the memory in until it is released from the locking mechanism, and then slide it out.

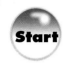

Start

Media Size, Picture Capacity, and Camera Resolution

Flash Memory Types and Capacities

	32MB	64MB	128MB	256MB	512MB	1GB
Memory Stick	✓	✓	✓	✓		
Memory Stick PRO			✓	✓	✓	✓
Compact Flash	✓	✓	✓	✓	✓	✓
SmartMedia	✓	✓	✓			
MultiMediaCard	✓	✓	✓			
SecureDigital	✓	✓	✓	✓	✓	✓
XD-Picture	✓	✓	✓	✓	✓	✓

INTRODUCTION

When you buy a roll of film, the number of pictures you can shoot with that roll is specified on the film package: 24 exposures is a typical size. However, the number of shots you can store on digital camera media before you need to change it depends upon factors such as the size of the media in megabytes and the camera's resolution (measured in megapixels). See Part 2 for more about setting camera resolution.

HINT

Hitting the Flash Memory "Sweet Spot"
Generally, the best price per megabyte (MB) can be found when you buy flash memory cards in the middle or upper levels of the size range.

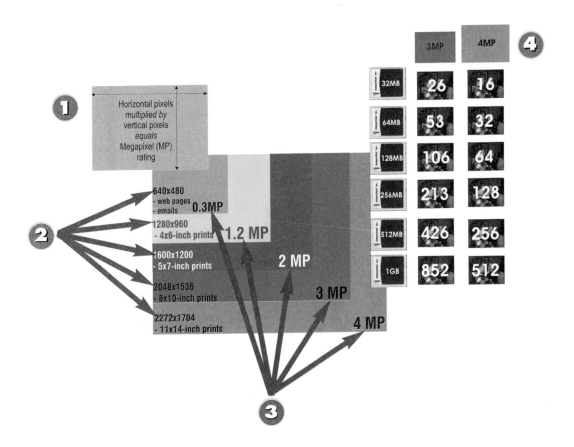

1 Calculating the megapixel rating for a digital camera.

2 Camera/photo resolution.

3 Approximate megapixel rating.

4 Number of high-quality photos varies by camera resolution and flash memory card size.

End

HINT
Your "Mileage" May Vary
The numbers shown on this page for flash memory capacity might vary because of variations in how different cameras compress data when storing photos and because of differences in subject matter.

HINT
Quality Settings Affect Capacity
You can store more photos by reducing the resolution of your photos or by reducing the quality setting. However, this will cause your photos to be less sharp and less suitable for printing. Buy another flash memory card instead.

Preparing Your Camera

In Part 1, "Getting Comfortable with Your Digital Camera," you learned about the major controls and features of your digital camera. However, until the camera is prepared for use, you won't be able to take pictures.

The following tasks show you how to charge your camera's battery pack, how to turn on the camera, how to set the camera's basic options (date/time, picture size and quality), and how to prepare the flash memory or other medium your camera uses to store digital photos.

Common Digital Camera Components

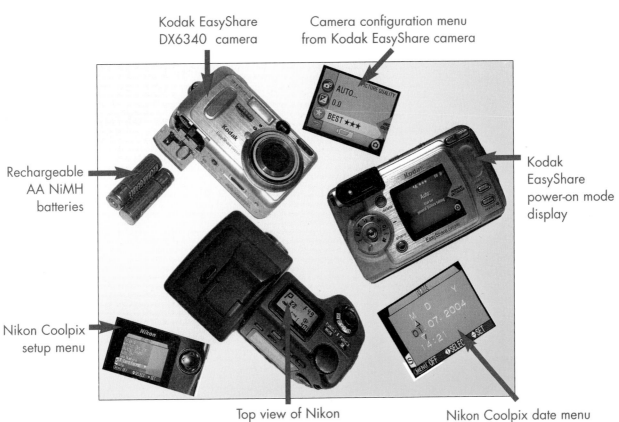

Kodak EasyShare
DX6340 camera

Camera configuration menu
from Kodak EasyShare camera

Rechargeable
AA NiMH
batteries

Kodak
EasyShare
power-on mode
display

Nikon Coolpix
setup menu

Top view of Nikon
Coolpix 995 after being
turned on

Nikon Coolpix date menu

Charging Your Battery Pack

Start

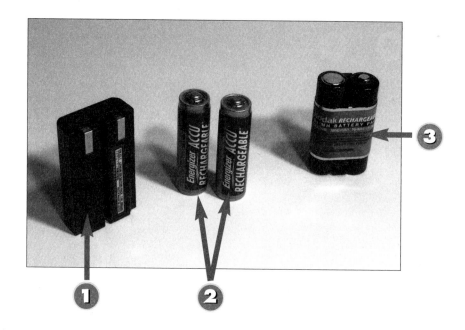

1 Some Nikon cameras use this Li-Ion battery pack.

2 Many digital cameras use two or more NiMH rechargeable AA batteries.

3 Some Kodak digital cameras can use this NiMH battery pack in place of two AA batteries.

Although some digital cameras can be operated with off-the-shelf alkaline AA-size batteries, many are designed to use proprietary rechargeable battery packs. Rechargeable batteries must be charged before they can be used.

TIP

Battery Technologies
The Kodak NiMH battery pack is equivalent to two AA-size NiMH batteries, and either can be used in Kodak EasyShare cameras in place of AA alkalines. However, the Nikon battery pack uses Li-Ion technology and has a proprietary form factor and voltage.

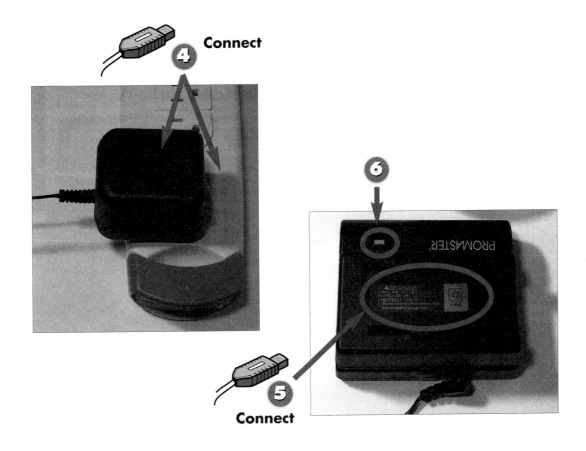

Connect

Connect

4. To charge a proprietary battery pack or batteries outside of the camera, plug the charger into an AC outlet.

5. Slide or snap the battery pack into the charger to start the charging process.

6. Remove the battery when fully charged. This might be indicated by a signal light or might require you to wait a specified amount of time.

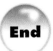

End

TIP

Correct Polarity
If the camera uses rechargeable AA batteries, make sure the batteries are placed in the charger correctly. Reversing the polarity on the batteries will damage the batteries or the charger.

HINT

AC Adapters
Although AC adapters are available for most digital cameras, they are usually not designed to recharge batteries. You might also need to remove the batteries before using an AC adapter. Check the camera's instructions for details.

TIP

Camera Docks
Some camera docks can also recharge batteries inside the camera. This feature usually requires you to use the rechargeable battery provided with the camera dock.

Inserting the Battery Pack into the Camera

Start

1 **Remove**

3

2

Open

1 Remove the batteries from the charger.

2 Open the battery compartment.

3 Note the battery polarity (usually indicated inside the compartment or on the cover).

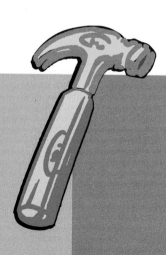

After the battery pack is charged, you need to insert it into the camera. This task shows you how to insert a pair of rechargeable AA batteries into a typical digital camera.

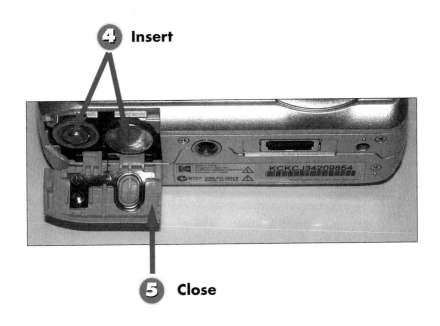

4 Insert

5 Close

4 Insert the batteries into the camera.

5 Close the battery cover.

End

Start

Turning On the Camera to Take Typical Photos

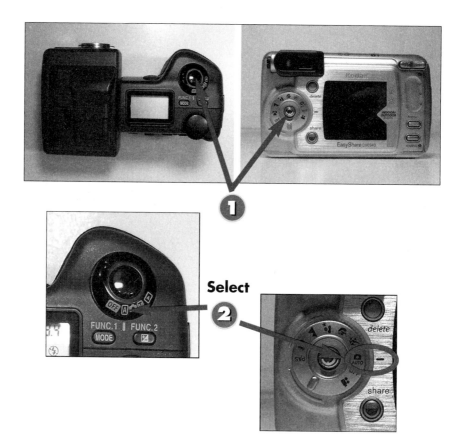

Select

1 Locate the camera's on-off switch on the rear or top of the camera.

2 Turn the dial to the desired mode (use the "A" or "Auto" mode if you're unsure which to choose).

End

HINT

Auto Mode
Select the "A" or "Auto" mode for normal shooting. Other modes are discussed in later parts of this book.

TIP

Turning On the LCD Display
Some cameras turn on the LCD display immediately, while others require you to turn on the LCD display manually. See Part 1 for details.

Activating the Camera Menu

Start

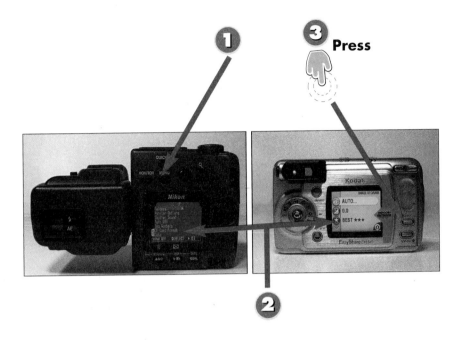

①

③ Press

②

① With the camera turned on, locate and press the menu button on the rear of the camera.

② The camera's LCD display should bring up a menu that allows you to configure the camera.

③ Press the menu button to close the menu.

End

INTRODUCTION

You can start taking pictures as soon as you install batteries in the camera. However, if you don't use your camera's setup menu to set the date, time, and picture quality when you first use the camera, your photos will be stored with the wrong date and time, and you might not be using the camera's best quality settings. In this task, you learn how to access typical camera setup menus.

Feature Controls

TIP
If the feature you want to use doesn't have a separate control button on the top, front, or rear of the camera, chances are you need to use the camera or setup menu to enable, disable, or configure it.

Navigating the Camera Menu

Start

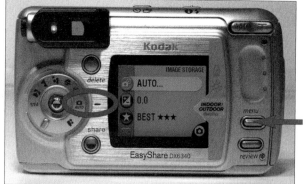

Press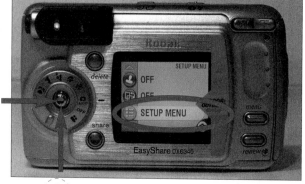

Push down

Press

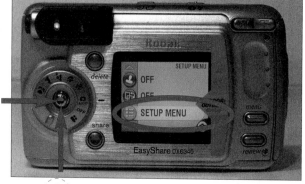

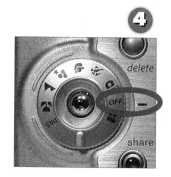

1 Turn on the camera and activate the menu.

2 Push down on the joystick to scroll the menu downward (try scrolling down to the setup menu).

3 To select a menu, push the joystick in.

4 Turn off the camera when finished.

End

HINT

Menu Controls
The Kodak EasyShare camera's four-way joystick also acts as a pushbutton. To open a menu item, press the joystick in. Other cameras use a four-way rocker control or an array of pushbuttons for menu navigation.

HINT

Following Along
As you read this and the following tasks, you will find it useful to activate the menu on your digital camera and follow along. You should also have your camera manual handy as this process varies from camera to camera.

Setting the Date and Time

Start

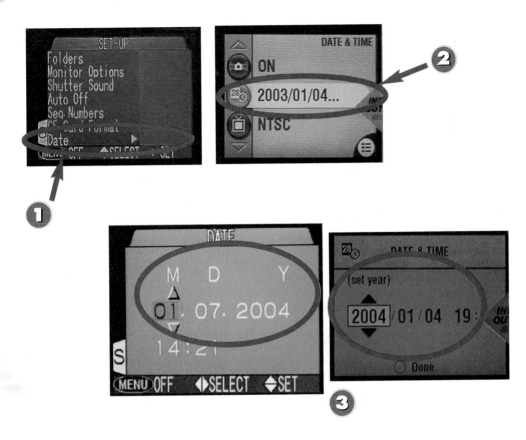

Activate the camera's menu and move to the date menu option with the camera's
pointing device.

Select the correct year, month, day, and time.

Press the **Menu** button when done to save the changes.

End

INTRODUCTION

When you take a picture with a digital camera, the picture is recorded as a file that can be transferred to your computer. The camera's built-in date is used to indicate when you recorded your photos unless you set the correct date yourself. In this task, you learn how to set the correct date.

HINT

Menu Navigation
Typically, you move the pointing device up and down to select a value in a typical menu, and side to side to move from one field to another. Push the pointing device button in or to the right to open the selected item for editing.

Selecting Image Size and Picture Quality

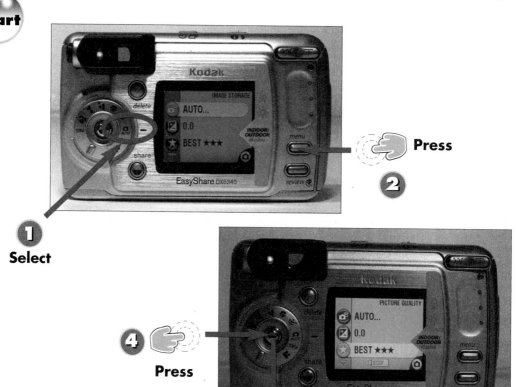

Start

1 Select

2 Press

3 Push down

4 Press

1 Turn on your camera in Auto mode.

2 Open the menu.

3 Scroll down to the image size menu with the joystick.

4 Push the joystick to open the image size menu.

Most digital cameras allow you to choose from two or more image sizes (in pixels) for storage of your digital photographs. As you learned in Part 1, the larger the dimensions of the picture, the more storage space it requires. A larger size in pixels also enables you to make larger high-quality prints. In this task, you learn how to select an image size suitable for use with a printer dock.

TIP

Selecting Image Size
Some digital cameras, such as the Nikon CoolPix 995 used for some exercises in this book, use a pushbutton on the rear of the camera to select image size instead of the camera menu.

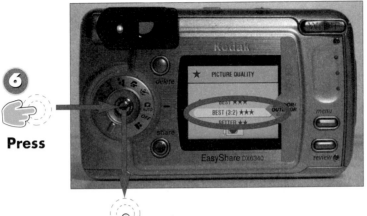

6 **Press**

5 **Push down**

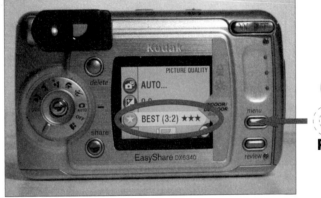

7 **Press**

5 Scroll down to **Best (3:2)** (recommended for printing from printer docks).

6 Press the joystick to select this setting.

7 Press the **Menu** button to retain your settings.

End

Reducing Picture Size
You can always reduce the size of a large photo for use on a Web site or in email after you take it. See Part 12, "Presenting and Sharing Your Photos," for methods you can use to reduce the size of a large photo for use in email or on the Web.

Picture Quality Terms
Different vendors use different terms to refer to image sizes. For example, Nikon uses the terms Basic, Normal, and Fine for small, medium, and large picture sizes. See your camera manual for the details of a particular camera's image size settings.

Selecting Image Quality
Some cameras also enable you to select different levels of image quality as well as image size. This option might be incorporated into the image size menu or use a separate menu.

Viewing Other Setup Menu Options

Start

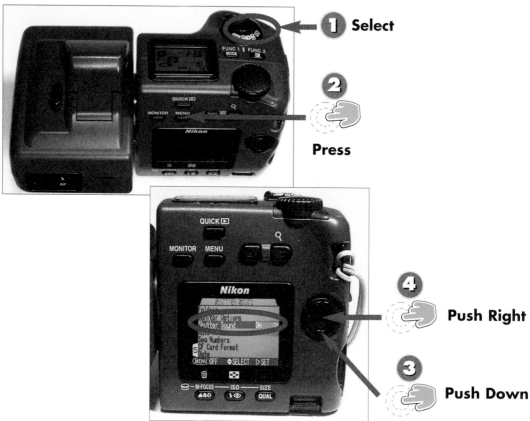

1 Select

2 Press

4 Push Right

3 Push Down

1 Turn on the camera, selecting **Auto** mode.

2 Press the **Menu** button on the rear of the camera.

3 Use the four-way control to scroll down to **Shutter Sound**.

4 Press the right arrow on the four-way control to see the current setting and use the up/down arrows to change it.

INTRODUCTION

In addition to setting date/time and image size/quality values, you might also need to view or change other camera settings. This task shows you how to view the shutter sound and auto off options, using the Nikon Coolpix 995 as an example.

HINT

Changing Settings
With the Nikon Coolpix 995 and similar models, select the menu item with the right arrow. Move between menu options with the up and down arrows. Select the desired option with the right arrow. Press **Menu** to save changes and exit.

HINT

Shutter Sound
The Shutter Sound option is present on many digital camera models. When enabled, it provides audible confirmation that you've taken a picture. Turn it off if you're shooting in a location where silence is preferred (such as a concert or recital).

Press

Push Right

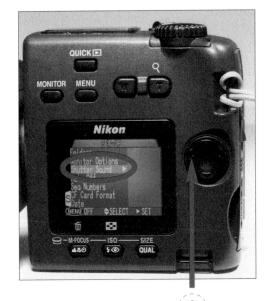

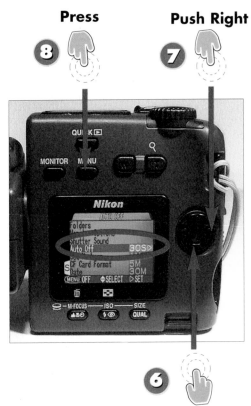

**Push
Left**

Push Down

⑤ Press the left arrow until **Shutter Sound** is highlighted.

⑥ Scroll down to **Auto Off**.

⑦ Press the right arrow to view the current setting; use the up/down arrows to change the setting.

⑧ Press the **Menu** button to return to shooting mode.

End

Auto Off

To save power, the camera and LCD monitor shut off automatically after the interval specified by Auto Off. Longer intervals than the default 30 seconds tend to use up battery life more quickly.

Changing Auto Off Settings

If you need to track your subject for a long time before you shoot, increase the Auto Off interval. This prevents the delay required for the camera to power up, refocus, and recalculate exposure after you push the power button.

Formatting the Media

Start

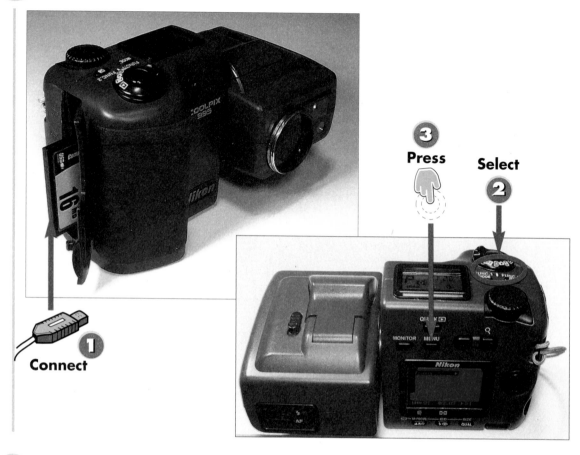

Press

Select

2

Connect
1

1 Insert the memory card into the camera.

2 Turn on the camera.

3 Open the camera menu (press the **Menu** button).

INTRODUCTION

Some types of media can be used as soon as you insert them in the camera. Other types of media, depending upon the media and the camera, must be formatted before they can be used. In this task, you learn how to format a Compact Flash card in a Nikon digital camera.

HINT

Beware of Lost Photos
If you format media that contains photos or other information, the information is lost.

Push Right

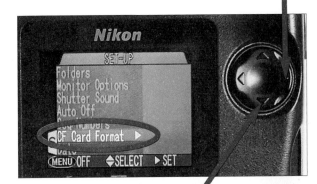

Push Down

Push Right

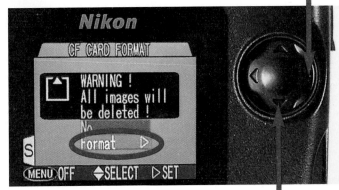

Push Down

4 Scroll down to the **CF Card Format** option.

5 Select the **CF Card Format** option.

6 Scroll down to **Format** to continue.

7 Select **Format** to complete the process.

End

Selecting Options
Press the right arrow to select an option with this camera. With other cameras, you might press a different button after using the arrow keys or joystick to select an option.

No Card, No Photos
Most digital cameras can't be turned on unless a flash memory card is properly inserted. If you can use your camera without a flash memory card, your camera has built-in flash memory.

Using the LCD Monitor

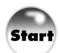

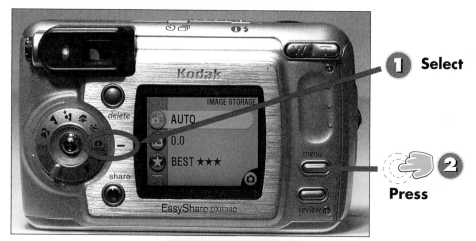

1 Select

2 Press

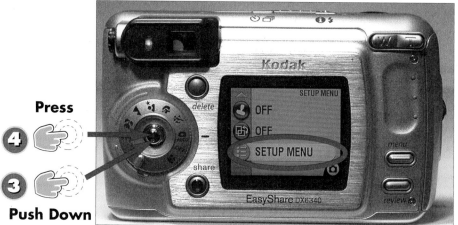

Press

4

3

Push Down

1 Turn on the camera in **Auto** mode.

2 Press the **Menu** button.

3 Scroll down to the **Setup** menu option with the joystick.

4 Press the joystick to open the **Setup** menu.

INTRODUCTION

Most point-and-shoot digital cameras feature optical and LCD viewing. The optical viewfinder does not provide accurate framing for photos, especially at close distances. The LCD monitor uses battery power more quickly, but shows you accurate framing and exposure information. This task shows you how to turn on the Liveview LCD display on a Kodak EasyShare DX6340 digital camera.

TIP

LCD Differences
Some digital cameras enable the LCD monitor by default. If your digital camera is a single-lens-reflex design with TTL viewing (see Part 1 for examples), you can use the TTL viewfinder instead of the LCD display.

 Press

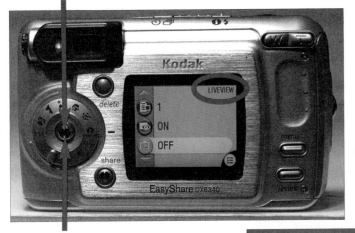

 Push Down

 Push Up

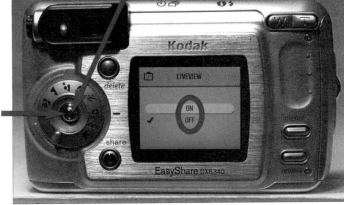

 Press

5 Scroll down to the **Liveview** option.

6 Press the joystick to open the **Liveview** menu.

7 Scroll up to **On**.

8 Push the joystick to enable Liveview.

End

Closing the Menu
Press the **Menu** button to close the menu and return to shooting mode using the LCD display.

Turning Off the LCD
After Liveview is enabled, you can temporarily toggle the LCD display on and off by pushing the joystick button. On other camera models, a similar on/off button turns on or turns off the LCD display.

Creative LCD Uses
Because the LCD display can be viewed from an angle, and swivels on some models, you can take pictures from more angles than with the optical viewfinder. You can hold your camera over your head or around a crowd and still see your subject.

Digital Photography Basics

In Part 1, "Getting Comfortable with Your Digital Camera," you learned about the different types of digital cameras and how digital cameras store images. In Part 2, "Preparing Your Camera," you learned how to prepare your digital camera for use. Now, it's time to take your first photos!

When you set your digital camera for full automatic mode (see Part 2), you're ready for point-and-shoot convenience as you record family memories and special events. Although the camera takes care of setting exposure and focus for you, you still need to understand other basic camera features, such as the zoom lens, light metering, and focus lock, to ensure that you get the pictures you want.

When you pick up your camera, use your right hand to operate the zoom and shutter button and your left hand to steady the camera. Be sure to keep your fingers away from the lens, the flash, and the optical viewfinder (if you decide to use it).

Common Camera Controls

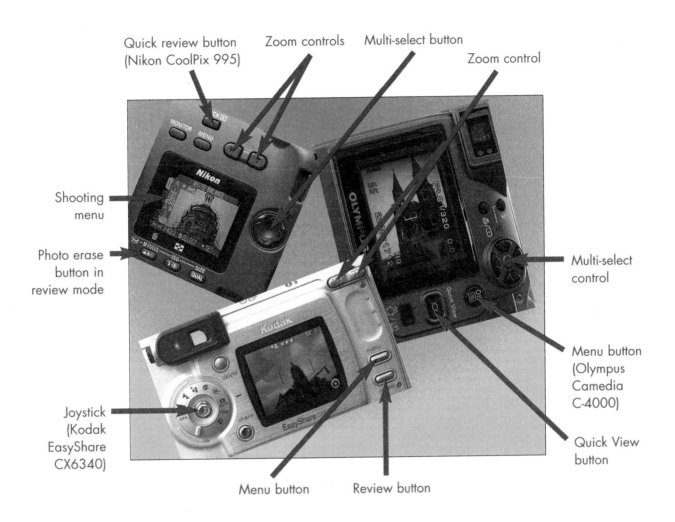

Quick review button (Nikon CoolPix 995)

Zoom controls

Multi-select button

Zoom control

Shooting menu

Photo erase button in review mode

Multi-select control

Joystick (Kodak EasyShare CX6340)

Menu button (Olympus Camedia C-4000)

Quick View button

Menu button

Review button

Using the Zoom Lens

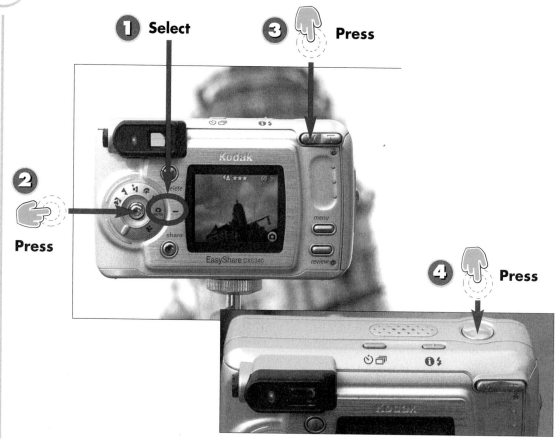

Start

1 Select

3 Press

2 Press

4 Press

1 Turn on the camera and select **Auto**.

2 If the LCD display doesn't come on, press the joystick to turn it on.

3 Press and hold the **W** (zoom out) button on the rear of the camera until the display shows the widest view of the subject.

4 Press the shutter button on top of the camera to take a picture.

Almost all digital cameras feature a zoom lens, which is a lens that can be adjusted to bring distant subjects closer or provide an overall view of a scene. Zoom lenses are usually referred to by the level of magnification from the lowest to the highest magnification. For example, a 4× optical zoom brings objects 4× closer at maximum zoom than at minimum zoom. In this task you learn how to adjust the zoom controls to frame your photo as you'd prefer using a Kodak EasyShare digital camera.

Getting the Wide View
Using the lens at its widest setting is useful for shooting groups indoors and for capturing the overall look of a building or scene.

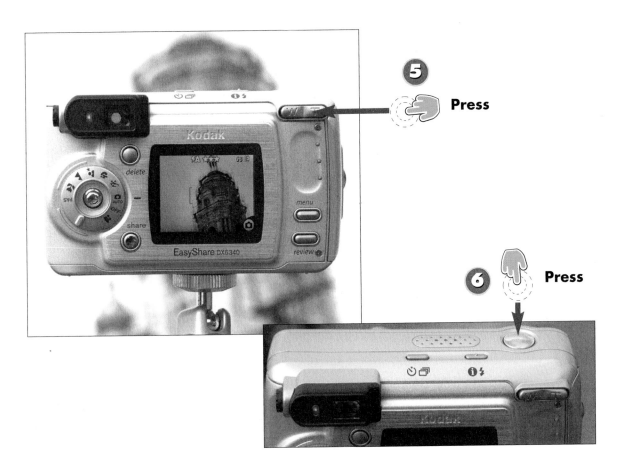

⑤ **Press**

⑥ **Press**

⑤ Press and hold the **T** (zoom in) button until the display shows the largest view of the subject's details.

⑥ Press the shutter button on top of the camera to take a picture.

See next page

Optical to Digital Zoom

Most digital cameras feature an optical zoom as well as a digital zoom. When you zoom in on a subject, most cameras pause at maximum optical zoom before switching to digital zoom.

Use a Tripod

If your digital camera supports optical zoom ratios of 6× or larger, you might want to use a tripod to support your camera when you use maximum zoom. A tripod helps prevent camera shake, which can ruin your pictures.

Variations in Zoom Controls

Some digital cameras use a zoom control wheel around the shutter button, such as the Olympus C-4000 used in some tasks in this book.

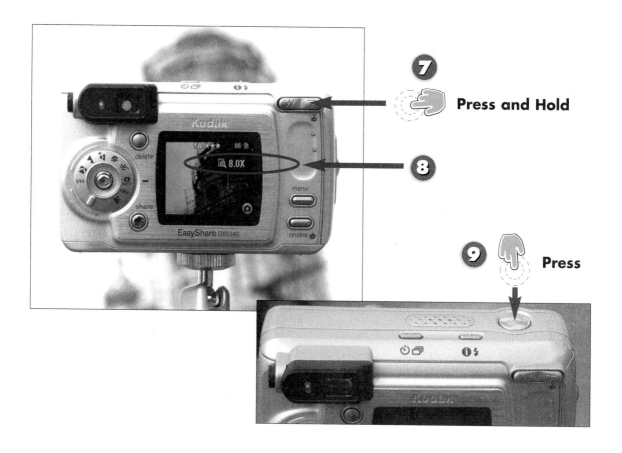

Press and Hold

Press

7 Press and hold the **T** button to activate the digital zoom.

8 Release the **T** button after the display indicates you've activated digital zoom.

9 Press the shutter button on top of the camera to take a picture.

Keeping an Eye on Digital Zoom

Most digital cameras display a special icon on the LCD display to indicate when you use digital zoom. Digital zoom enlarges the pixels in the image, so pictures taken with it aren't as clear or sharp as those taken with optical zoom.

Using a Zoom Ring

Some zoom lenses, particularly those used on high-end fixed and interchangeable-lens SLR digital cameras, use a zoom ring on the lens itself. Turn it to zoom in or out.

10 Picture taken from wide-angle view.

11 Picture taken with full optical zoom (telephoto view).

12 Picture taken with full digital zoom.

Digital Zooms and Jaggies

Notice that the digital zoom picture shows jagged edges along the curved edges above the clock. This is because a digital zoom enlarges the pixels in the original image.

LCD Rules for Accurate Zooming

Although the optical viewfinder in most cameras adjusts as you zoom, it doesn't show the results as accurately as the LCD display.

Using Exposure Compensation (EV Adjustment)

Start

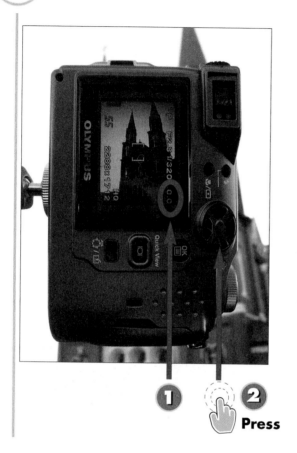
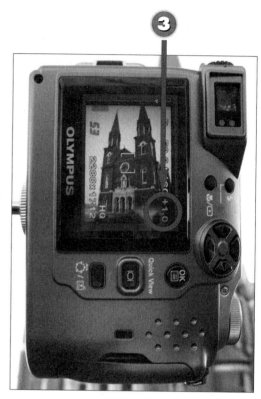

Press

1. Take a picture without using EV adjustment (for comparison).

2. Press the right arrow on the control three times to select +1.0 EV adjustment.

3. Shoot the same picture again for comparison.

INTRODUCTION

Even if your camera doesn't offer special metering modes, it probably offers an exposure compensation option known as EV adjustment, which compensates for a light subject (such as snow) against a dark background or a dark subject against a light background. EV adjustment enables you to set the camera to provide up to two values more or less exposure than the camera would normally provide. This task shows you how to use this method to adjust for a dark subject against a light background using an Olympus C-4000.

HINT

How EV Adjustment Works
Each positive EV value is the same as opening up the lens an additional f-stop or using the next slower shutter speed. Each negative EV value is the same as using a smaller f-stop or faster shutter speed. See Part 6 for more information.

4 The scene without EV adjustment.

5 The scene with EV adjustment

End

EV Adjustment for Creative Purposes
You can also use EV adjustment to manipulate the lighting in a scene for creative purposes. For example, if you set the EV Adjustment to -2.0, you create a "day for night" (very dark) look for your early morning or late afternoon photos.

Turn Off EV Adjustment
Don't forget to turn off EV adjustment after you use it. Some cameras retain this setting even if you turn off the camera and turn it back on.

Using Exposure and Focus Lock

Start

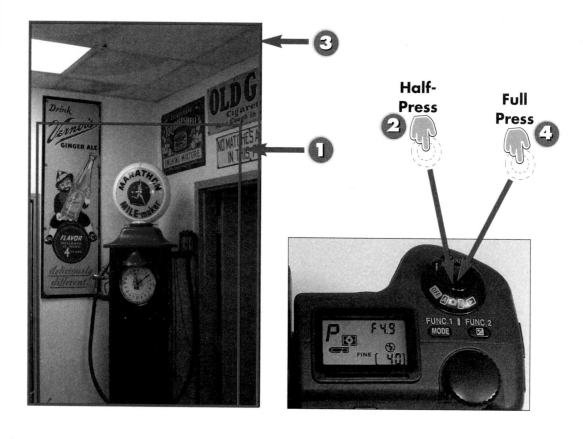

Half-Press ② ✋

Full Press ✋ ④

① Point the camera at the subject you want to be focused and exposed (avoiding an unwanted light source).

② Press the shutter button down halfway to lock the exposure and focus.

③ Recompose the picture as desired.

④ Press the shutter button down all the way to take the photo.

End

INTRODUCTION

Both the autofocus and autoexposure features of typical digital cameras assume that the principal subject is located in the center of the picture. However, photos are often much more interesting if the subject is off-center. To provide proper focusing and exposure, many digital cameras feature exposure and focus lock, which enable the user to focus on the subject, use the subject to determine the correct exposure, and then recompose the photo while retaining the desired focusing target and exposure.

Selecting a Lock Area
You might want to turn the camera 90 degrees from your final composition or use the zoom lens to help select an area of the subject for focus/exposure lock. This is also helpful if the camera can't autofocus properly.

Viewing Metering Modes

Start

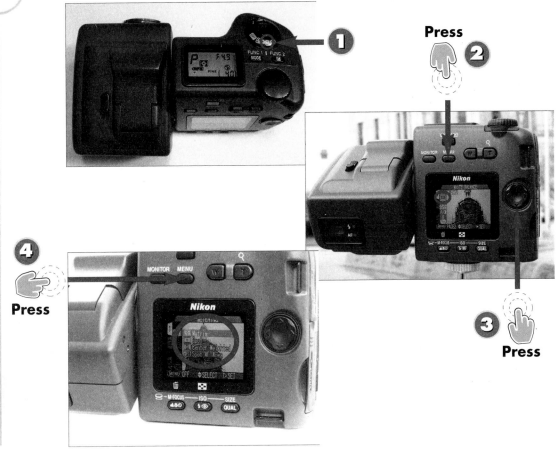

Press ①

Press ②

Press ③

Press ④

① Turn the camera on and select **M** (manual control) mode.

② Press the **Menu** button to open shooting menu #1.

③ Press the multi-selector down to move to the metering menu.

④ There are four modes: matrix, spot, center-weighted, and spot AF area. Select one and press **Menu** to close the menu.

End

To enable you to get accurate exposures, even when light sources come from different angles and lighting is sometimes uneven, many digital cameras enable you to adjust the normal light meter setting. In this task, you learn how to access the metering modes available on a typical mid-range digital camera, a Nikon CoolPix 995.

Choosing the Right Mode

Most cameras use matrix, multipattern, or center-weighted metering as their default metering methods. They're best for evenly lit scenes or when the principal subject occupies most of the photo. Use spot metering when the subject is much brighter or darker than the rest of the scene.

Using Spot-Metering Mode

Start

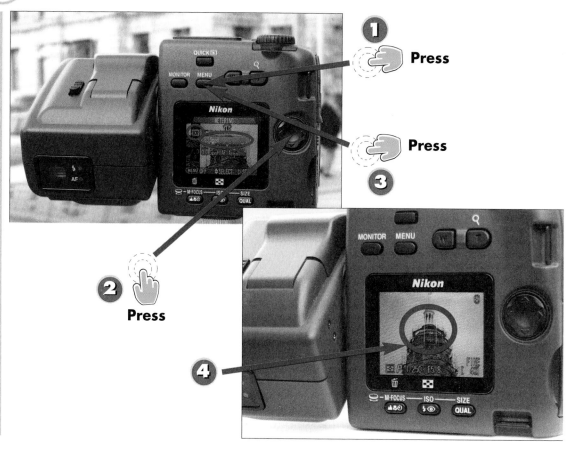

① Press

② Press

③

② Press

④

① Press the **Menu** button.

② Select **Spot** metering.

③ Press **Menu** to close the menu.

④ Line up the rectangle with the area you want to use to set the exposure.

If you want to take a picture of an object that is much brighter or darker than its surroundings, such as a building with bright sky behind it, you should use spot-metering mode to ensure correct exposure. This task shows you how to select this mode and use it to take your photo using the Nikon CoolPix 995.

TIP

Picking the Area to Measure
View the subject carefully before you select the area to measure. Choose a part of the subject where you want maximum detail to show up in the final photo.

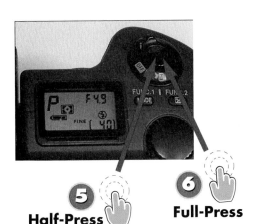

Half-Press **Full-Press**

(5) Press the shutter button halfway down to lock the exposure; recompose the photo.

(6) Push the shutter button all the way down to take the picture.

(7) Normal metering (subject too dark due to bright sky).

(8) Spot metering (subject properly exposed).

End

Choose Your Spot Carefully
When you press the shutter button down halfway, this locks the exposure as well as the focus with many digital cameras. Make sure you select the most important part of the subject to assure correct focus as well as exposure

Resetting the Meter Mode
Be sure to reset the metering mode to the default setting used for most pictures after you use spot-metering or other special modes.

Using the "Rule of Thirds"
When you compose your photo, keep the "rule of thirds" in mind for better composition. See Part 5 for more information.

Start

Reviewing and Deleting Pictures with the LCD Display

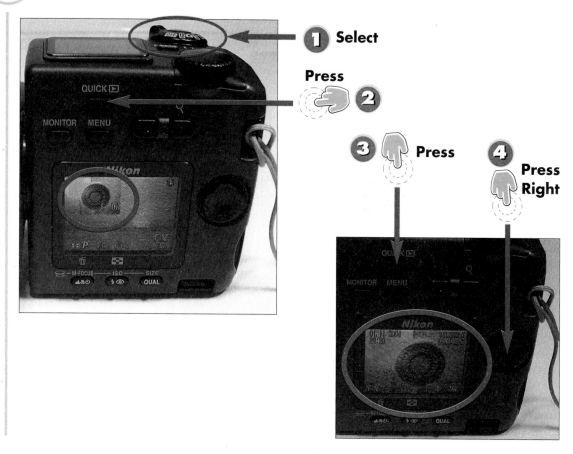

1 Select

Press

2

3 Press

4 Press Right

1 Turn on the camera.

2 Press the **Quick [>]** button to display the last photo taken.

3 Press the **Quick** button again to display the photo in full-screen view.

4 Press the right arrow on the multi-control to scroll through the photos.

After you take a few pictures, you might want to review the photos in the camera. This gives you the opportunity to delete unwanted photos and retake them. The process used by the Nikon CoolPix 995 is typical.

Seeing All the Details
The date, time, filename, resolution, and other details are displayed for each shot by some cameras when viewing photos.

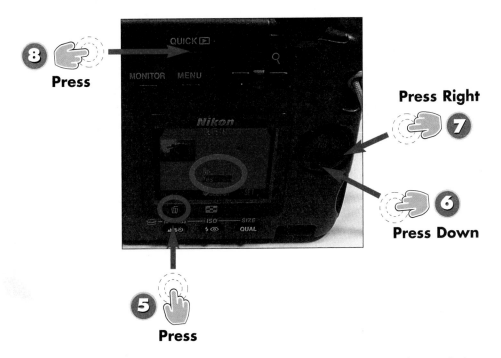

5 When you see a photo you want to discard, press the button beneath the trash can icon below the LCD display.

6 Press the down arrow on the multi-control button to highlight Yes.

7 Press the right arrow to delete the selected photo.

8 Press **Quick** to exit the review process.

End

To Delete, or Not to Delete...
Don't delete photos you might be able to fix with photo-editing software such as Adobe Photoshop Elements (see Part 10, "Enhancing Your Digital Photos"). However, even Photoshop Elements can't fix shots of your fingers or pictures you took with the lens cap on the camera. Delete these without concern.

Using Your Flash

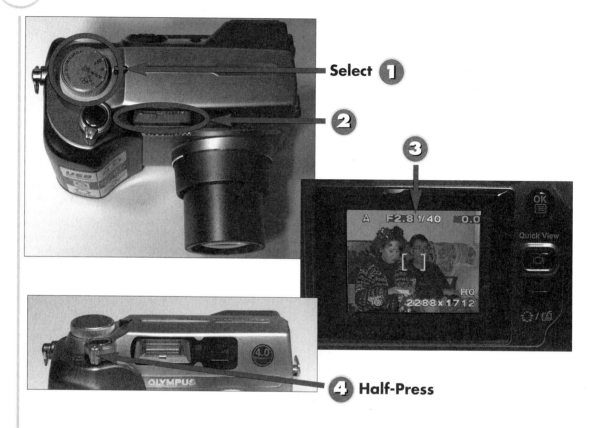

Select ①

②

③

A F2.8 1/40 0.0

HQ
2288x1712

OLYMPUS

④ Half-Press

① Turn on the camera and select **Auto (A)** mode or **P (Program)** mode.

② Make sure your fingers aren't blocking the flash.

③ Select a subject about 4–10 feet from the camera that is roughly parallel with the camera.

④ Press the shutter down halfway to lock the exposure.

INTRODUCTION

Almost all digital cameras have a built-in electronic flash. On most cameras, the flash fires automatically when the camera senses there's not enough light to create a clear picture without flash. In this task you learn how to shoot simple flash photos.

TIP

Opening the Flash Head
Some cameras require you to press a button to pop the flash head into place. Make sure the flash head is up if you want to shoot with flash.

HINT

Getting Creative with Indoor Photography
See Part 5, "Taking Digital Photos—Indoors," for more advanced indoor photo tasks and tips.

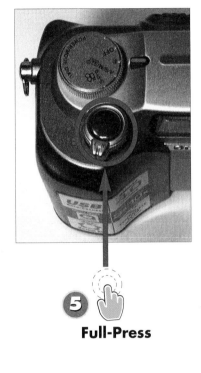

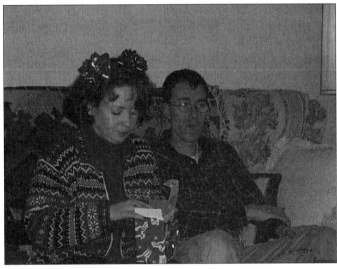

Full-Press

5 Press the shutter down all the way to take the photo.

6 The photo is a bit dark but can be enhanced or reshot.

End

Brightening Your Flash Pictures
If the flash picture is a bit dark, you can shoot it again using EV Adjustment, or use a photo editor such as Adobe Photoshop Elements (see Part 10) to fix it by adjusting the levels. The most common reasons for a slightly dark picture include high ceilings, being more than 10 feet away from your subject, or using weak batteries in your camera.

Taking Digital Photos— Outdoors

Digital cameras can be used around the clock to capture the world around you. Because most models are small and you can review your photos instantly, they're perfect to carry with you everywhere. You don't need a picture-perfect sunny day to get great photos, either. With the white balance and exposure controls built in to even low-cost digital cameras, you can take memorable pictures in almost any weather condition.

In this part, you'll learn how to set your camera for shooting at every part of the day; how to shoot at night; when and how to use fill flash; how to handle fog, snow, and dim lighting; how to shoot animals; and how to protect your camera during your field trips.

There's a world waiting to be recorded, so take your camera with you.

Outdoor Shooting Situations

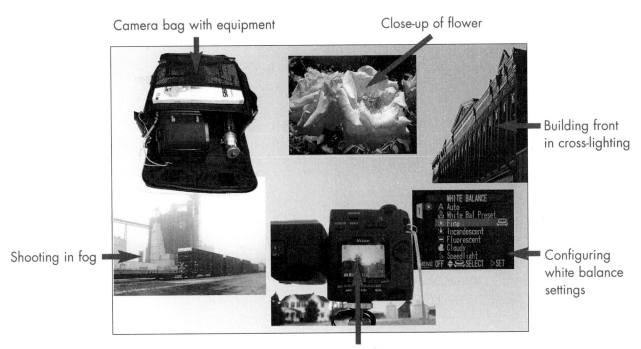

Camera bag with equipment

Close-up of flower

Building front in cross-lighting

Shooting in fog

Configuring white balance settings

WHITE BALANCE
A Auto
White Bal Preset
Fine
Incandescent
Fluorescent
Cloudy
Speedlight
MENU OFF ⬍ SELECT ▷SET

Setting up for dim-light shooting

Shooting in the Early Morning

Start

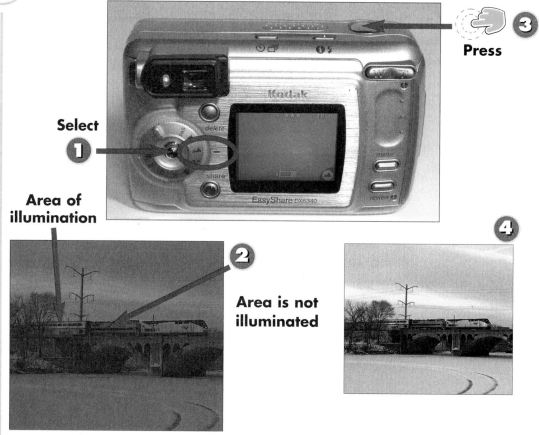

Press ③

Select ①

Area of illumination

② **Area is not illuminated**

④

① Turn on the camera and select **Scenery mode** (for distant subjects).

② If the sky is partly cloudy, wait until breaks in the clouds illuminate the main subject.

③ Shoot the photo.

④ If the photo is dark, use a photo editor to lighten it.

End

To capture the essence of early morning light, your camera's default Auto white balance setting works well. However, most digital cameras use flash in Auto exposure mode. For better photos, position yourself with your back to the early morning sun, avoid blocking your subject with your shadow, and turn off your flash. This example uses Scenery mode, which shuts off the flash automatically.

HINT

Fixing Dark Photos
You can use Adobe Photoshop Elements' Auto Levels command in the Enhance menu to fix a dark photo. To learn more, see "Adjusting Photos Which Are Too Dark or Too Light," in Part 10, "Enhancing Your Digital Photos."

Shooting in the Late Afternoon

Start

Sunlight directed toward subject

Camera subject

Camera lens pointed away from sun

Press

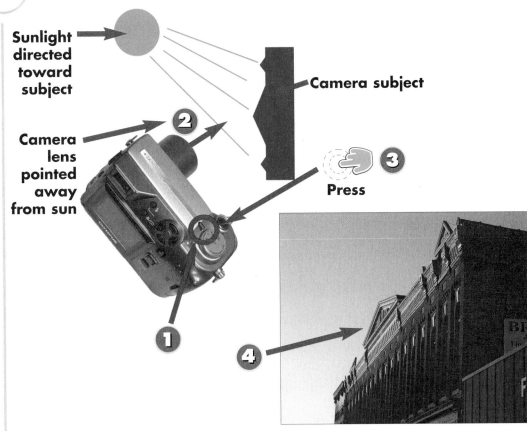

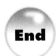

(1) Turn on the camera and select **P** (program) mode.

(2) Aim the camera so the sun is not shining directly into the lens.

(3) Take the picture.

(4) In this picture, the late afternoon sun brings out the detail in the building front.

End

INTRODUCTION

The low-angle dramatic light of a sunny late afternoon can bring excitement to photos which would be boring at other times of the day. To capture cross-lighting such as shown in this task, position yourself so the sun is off to your left and your subject is off to your right. This task uses the Olympus Camedia C-4000.

HINT

Darkening the Sky
If you have time to shoot more than one photo, try taking another photo with the camera's EV value set to -1 to darken the sky and add an extra element of drama. See Part 3, "Digital Photography Basics," for details.

TIP

Don't Flash a Good Photo Away
If the camera flash fires because of dark areas in your photo, the exposure will be set for flash, not for the existing light. Turn off the flash and try your photo again.

Adjusting White Balance Settings

Start

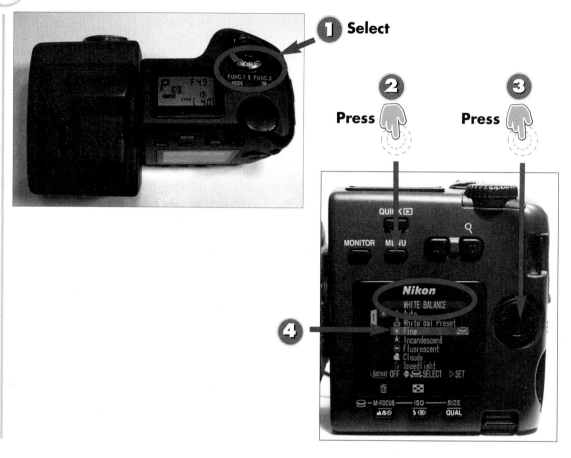

1 Select

2 Press

3 Press

4

1 Turn the camera on and select **M** (manual) mode.

2 Press **Menu** to activate the menu screen.

3 To choose an option, move the four-way control up or down until the desired option is highlighted.

4 Choose **Fine** (known as Daylight on some cameras) to set the camera for bright daylight.

INTRODUCTION

Digital cameras, unlike film cameras, can adjust to different types of light such as daylight, electronic flash, cloudy days, and others. This option is called the White Balance setting. Although virtually all digital cameras have an Auto white balance setting, you might prefer to set the white balance manually for different types of outdoor lighting, as this task demonstrates, using the Nikon Coolpix 995.

TIP

Accessing the White Balance Menu
To access the White Balance menu on many digital cameras, you might need to select a special shooting mode. Check your instruction manual for details.

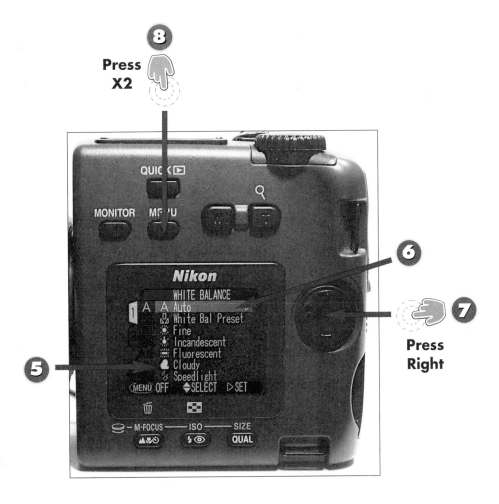

Press
X2

Press
Right

5 Choose **Cloudy** to remove excess blue on a cloudy day.

6 Choose **Auto** to reset the camera to the default white balance mode.

7 After choosing the desired white balance option, press the right arrow.

8 Press **Menu** twice to return to shooting mode.

Resetting White Balance
Some cameras reset to Auto white balance when they are turned off. However, on others, you need to reset white balance to the desired setting. Shooting with an incorrect white balance setting causes incorrect colors.

Experimenting with Settings
You can use the "wrong" white balance settings for special effects, and you might prefer to use a different setting than the recommended one for a particular type of lighting.

When to Select Daylight or Cloudy
The Auto setting can compensate for minor changes in the color of light, but for better color rendition at sunrise, sunset, or under cloudy skies, use the recommended white balance options instead if your camera provides them.

Shooting in Bright Sunlight

Start

1 A frontlit subject.

2 A backlit subject.

End

Your position in relation to the sun has a big effect on the results you get in bright sunlight. As this task shows, shooting with your back to the sun provides even light on your subject, while shooting with your subject between you and the sun can reduce color quality and the clarity of your shot.

Time for Fill Flash?

Some digital cameras automatically use flash in Auto mode. Using a fill flash can improve backlit photos. However, you might also want to try increasing the EV setting as described in Part 3.

Shooting in Fog

Start

Select ① ②

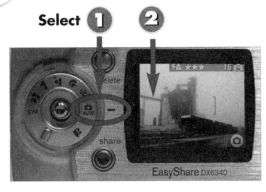

③
Press

Dark photo

④

Photo shot with +1EV exposure

① Turn on the camera and select **Auto**.

② Frame your subject so the effect of the fog on distant objects is apparent.

③ Press the shutter release to take the picture.

④ If your original photo is too dark, reshoot with +1 EV exposure compensation.

End

INTRODUCTION

Don't put your camera away on foggy days. Fog has an eerie beauty all its own, especially when you can take a picture that shows how fog gets thicker with distance, as in this example, which uses a Kodak EasyShare DX6340. If you need to reshoot the picture with exposure compensation, see Part 3 for details.

HINT

Checking Your Shot
Use your camera's preview mode to determine if you need to reshoot the picture (see the next page). If you don't have time to reshoot with more exposure, use a photo editor to lighten your picture.

Shooting in the Snow

Start

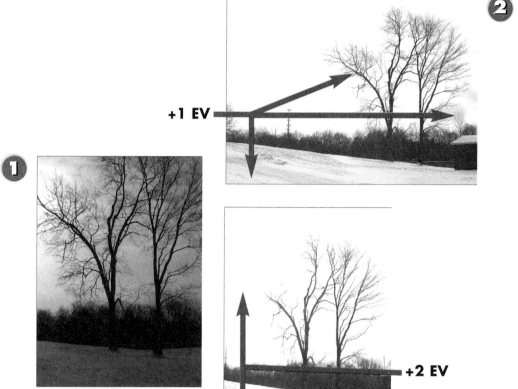

+1 EV

2

1

No exposure compensation

+2 EV

1 No exposure compensation—snow is too dark.

2 +1EV exposure compensation—snow, sky, and tree branch details are visible.

3 +2EV exposure compensation—snow and sky are too bright, causing loss of fine detail.

End

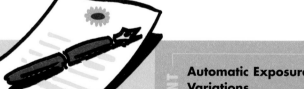

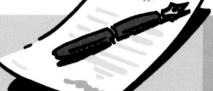

INTRODUCTION

Snow, like fog, can bring interest to subjects that might seem ordinary in good weather. Because cameras tend to assume that scenes have average reflectivity, snow tends to photograph dark if exposure compensation (see Part 3) is not used. However, as these examples show, you can use too much exposure compensation.

HINT

Automatic Exposure Variations
Some digital cameras let you shoot a series of photos using different exposure settings. This technique, often called bracketing, is very useful when you are working with difficult lighting.

Shooting a Close-up

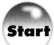
Start

Select
①

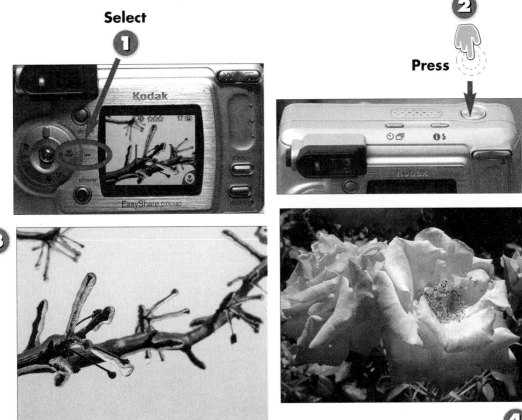

②
Press

③

④

① Turn on the camera and select Macro mode.

② Frame your subject and take the picture.

③ If the subject has a light background, use +1EV exposure compensation.

④ In bright sunlight, make sure you don't cast a shadow over your subject.

End

INTRODUCTION

In any season of the year, there are beautiful plants and objects all around you ready to be photographed. Most digital cameras feature an easy-to-use macro feature to make close-up photography simple.

Take Your Time

At normal shooting distances, digital cameras focus quickly. However, in close-up mode, many cameras take longer to focus. Use the LCD display to be sure the subject is in focus.

Shooting Scenery

Start

1 Select

2 Press

3

1 Turn on the camera and select Landscape mode.

2 On some cameras, you press a separate button for distant shooting.

3 Scenery mode provides sharp focus on very distant subjects.

End

INTRODUCTION

Most digital cameras' default Auto mode is designed for typical distances from about three feet to a few hundred feet. To shoot distant subjects, use the Landscape mode built in to many digital cameras.

HINT

Max Zoom for Max Grandeur
Use your zoom lens to bring distant subjects closer. Use a tripod or other support to avoid camera shake if you have a very long (6× or greater) optical zoom, especially if you are shooting under less than bright sunlight conditions.

Shooting on Cloudy Days

Start

② Press

① Select

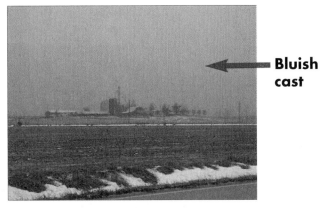
Bluish cast

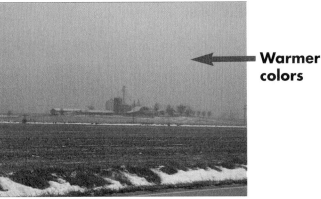
Warmer colors

① Select **Cloudy** from the White balance menu on the camera.

② Take the picture.

③ Auto white balance produces a bluish cast.

④ Cloudy white balance produces warmer colors.

End

INTRODUCTION

Cloudy days have bluer, colder light than sunny days. If you need to take pictures on a cloudy day, use the cloudy white balance setting available in some digital cameras to "warm up" the colors. See "Adjusting White Balance Settings" earlier in this part for details.

HINT

Adjusting Cloudy White Balance

If cloudy white balance produces photos with too much red, check to see if you can adjust the color balance in the camera, or use a photo editor to adjust colors.

HINT

White Balance Settings

See "Adjusting White Balance Settings," earlier in this part, for details.

Shooting in Dim Light

Start

①
Select

④ 👆 **Turn**

②

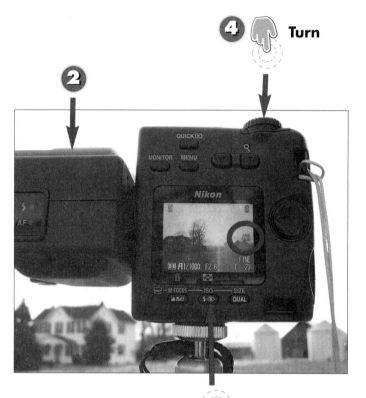

③ 👆 **Press and Hold**

① Turn on the camera and select **M** mode.

② Make sure the flash is closed or turned off.

③ Hold down the **ISO** button...

④ ...and turn the control wheel until ISO **400** appears.

INTRODUCTION

If you aren't seeing enough detail in the photos you take in dim light, you can adjust the sensitivity of your camera to light by increasing the ISO rating. Digital cameras normally use an Auto ISO rating, producing sensitivity to light roughly equivalent to ISO 100 film. This task shows you how to increase the ISO rating and what the effects can be of doing so.

HINT

More About ISO
ISO stands for International Organization for Standardization, a group which sets standards for business and industry. Learn more at **www.iso.org**.

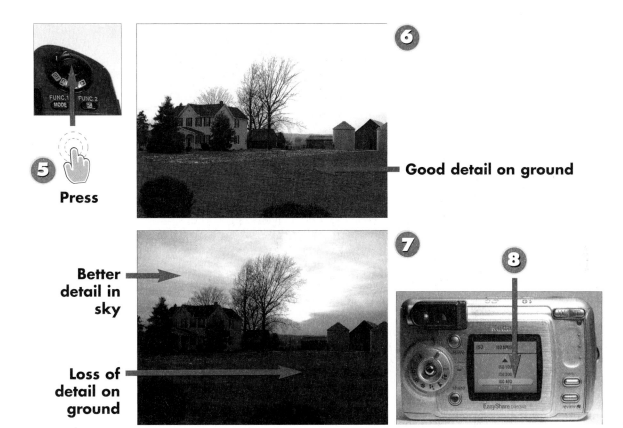

Press

Good detail on ground

Better detail in sky

Loss of detail on ground

5️⃣ Take the picture.

6️⃣ The ISO 400 rating shows good detail in dark areas.

7️⃣ The Auto ISO rating has a loss of detail in dark areas, but better detail in the sky.

8️⃣ Some cameras use a setup menu option to change the ISO rating.

ISO Demystified
Most digital cameras can be configured to use an ISO rating up to 400, which quadruples the sensitivity of the camera to light compared to the default ISO 100 rating. Keep in mind that increasing the ISO rating can cause your photos to look a bit grainy.

Reset the ISO
Don't forget to reset the ISO to the default Auto setting for normal shooting when you're done.

ISO Adjustment Indoors
You can also use ISO adjustment to help improve your indoor shooting. It can extend the effective range of your flash and help you shoot handheld shots in relatively dim light.

Shooting a Backlit Subject with Fill Flash

Start

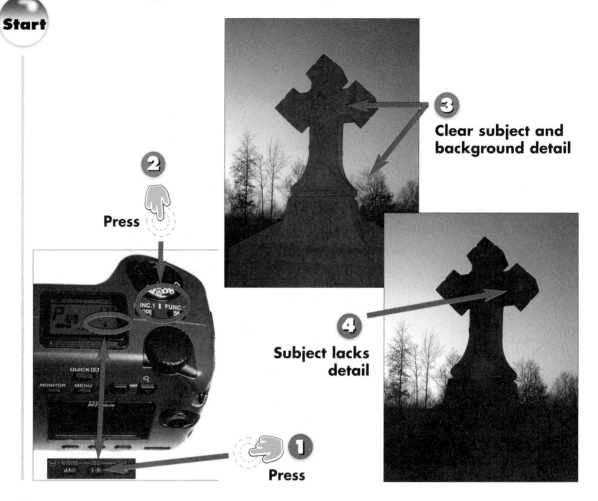

2

Press

3

Clear subject and background detail

4

Subject lacks detail

1

Press

1 After turning on the camera, select **Flash**.

2 Compose your scene and take the picture

3 Fill flash brings out the details in the subject and maintains background detail.

4 Without fill flash, the subject lacks detail.

End

INTRODUCTION

As the previous task demonstrates, adjusting the ISO setting can improve shadow detail, but can cause loss of detail in bright areas. If your subject is less than 10 feet from your camera, you might be able to use fill flash to brighten up a backlit subject without losing detail in bright areas.

HINT

Auto Flash Doesn't Always Work
Auto flash works well for fill when the scene is evenly lit. However, a bright background makes the camera's light meter think flash is not needed. By forcing the flash to fire, you get fill flash when you want it.

Shooting at Night

Start

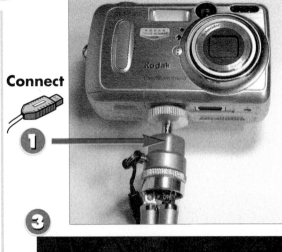

Connect

Select

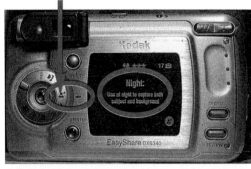

**Extra detail in
night photo mode**

**Detail lost in
auto mode**

① Attach the camera to a tripod (see Part 6, "Using Advanced Camera Features," for details).

② Turn on the camera, select **Night** mode, and take a photo.

③ Night mode uses a long exposure plus flash to capture the scene.

④ The same scene shot in Auto mode with flash doesn't bring out the same level of detail.

End

INTRODUCTION By default, most digital cameras assume that you want to use the built-in flash when the light levels are too low to use natural light. However, the flash can illuminate only a small part of the scene. Use the Night mode setting available on some digital cameras to take a long exposure which better captures an outdoor scene after dark.

Night Mode Alternatives
HINT If your camera doesn't have a Night mode setting, check for a slow flash sync setting (fires the flash after leaving the shutter open to capture available light) or shoot without a flash.

PART 4

Photographing Wild Animals

Start

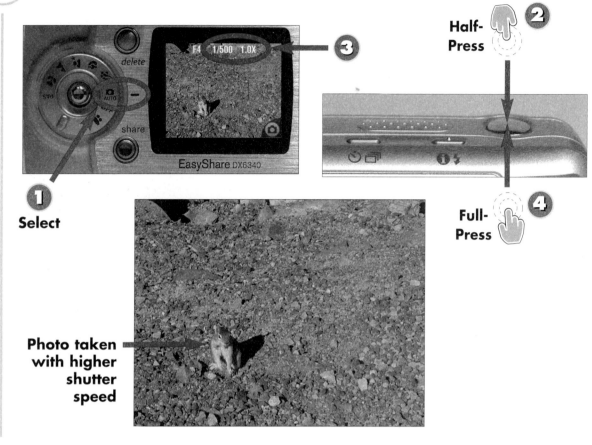

3

Half-Press **2**

1
Select

Full-Press **4**

Photo taken
with higher
shutter
speed

1 Turn on the camera.

2 Press the shutter button partway to check the exposure.

3 If the shutter speed is 1/500-second or higher, take the picture.

4 Press the shutter button all the way down.

End

INTRODUCTION

Because small animals in the wild
are unpredictable, you should
complete your camera setup
before you approach them. To
help capture the animal's environ-
ment and help compensate for an
animal's tendency to move quickly,
compose your photos to leave
room around the subject, and use
a fast shutter speed.

HINT

**Setting Faster Shutter
Speeds**
If your shutter speed is slower
than 1/500-second, the animal
could move too quickly and
blur your photo. Set the camera
for shutter priority and select
the shutter speed yourself. See
Part 6 for details.

HINT

At the Zoo
If the animals are in a shaded
enclosure or indoors, adjust the
camera's ISO to 400 to com-
pensate for the reduced
lighting.

Protecting Your Equipment

Start

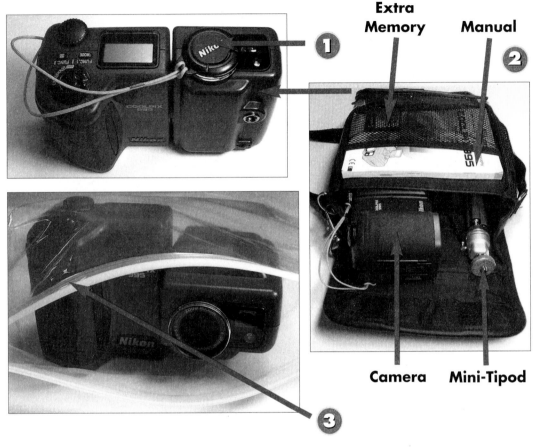

Extra Memory **Manual**

1 **2**

3

Camera **Mini-Tipod**

1 If your camera doesn't use a self-stowing lens, attach a lens cap when you're not using it.

2 Store your camera in a padded bag with room for a mini-tripod, extra flash memory, and the camera's manual.

3 Use a zippered plastic bag to protect your camera from water and sand.

End

INTRODUCTION
Digital cameras are electronic in nature, which means that impact, water, and dust can wreak havoc with their operation. This task shows you how to protect your equipment from all three types of hazards.

HINT
Shooting in the Rain
Use a plastic bag large enough to let you handle the controls through the bag while leaving the bag open at one end for shooting. If your camera has autofocus sensors on the camera body, they'll still work correctly.

HINT
Cleaning Your Lens
Use a brush to wipe away dust and grit before you clean your lens. Use camera lens cleaner and a microfiber cleaning cloth to gently wipe away fingerprints and smudges.

Taking Digital Photos— Indoors

Many digital cameras are used for the first time for indoor shooting. They're given as gifts or brought along to record a special event. Although you can get acceptable results by just aiming the camera and pushing the shutter release, your indoor photos can have just as much creativity in lighting and subject matter as outdoor photos. In this part, you learn how to control your camera when using the built-in flash as well as existing room light. You also learn the benefits of bringing along additional lighting for both portraits and for shots of jewelry and collectables. By selecting the right light source and the right white balance, your interior photos can be both a record of a special event or object and capture the mood of the moment.

Indoor Light Sources and Techniques

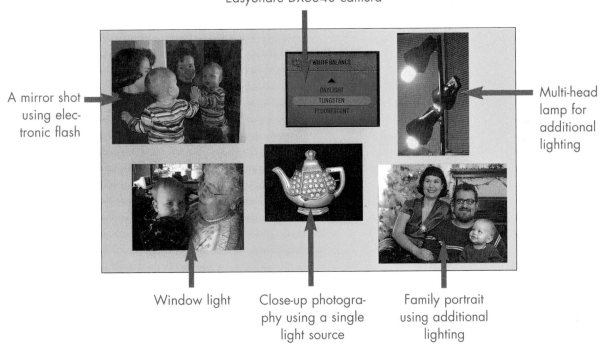

White balance menu from Kodak EasyShare DX6340 camera

A mirror shot using electronic flash

Multi-head lamp for additional lighting

Window light

Close-up photography using a single light source

Family portrait using additional lighting

WHITE BALANCE

DAYLIGHT
TUNGSTEN
FLUORESCENT

Using Electronic Flash

Start

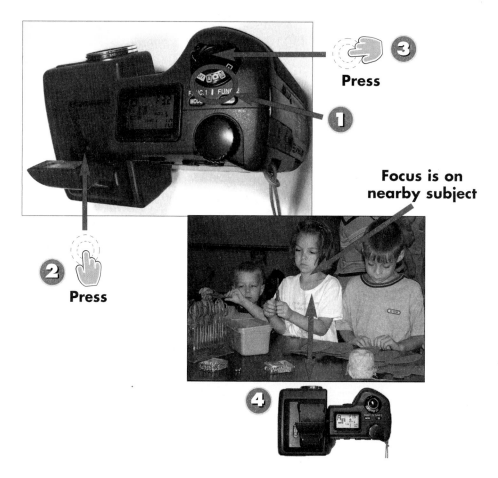

Press ③

① ②

Press

Focus is on nearby subject

④

① Turn on your camera and select **Auto**.

② Press the flash release to turn on the electronic flash.

③ After framing your shot, press the shutter release to take the picture.

④ The camera uses the distance to the center of the subject to determine focus and exposure.

Most digital cameras use their built-in electronic flashes automatically indoors. However, this alone does not ensure that you will get good photographs. Because electronic flash is a single light source that drops in intensity the farther your subject is from your camera, you need to plan your indoor shots carefully if you want good results.

HINT

Watch Those Fingers!
If your fingers block the electronic flash, your pictures will be very underexposed and probably not repairable.

5 This photo is properly exposed and focused.

6 The camera focuses and sets exposure for the background, leaving the subjects over-exposed and fuzzy.

End

HINT

Use Focus Lock

If you want to shoot a subject along the edges of your composition, use focus and exposure lock as discussed in Part 3, "Digital Photography Basics."

HINT

Shooting Through a Crowd

If you try to shoot with flash through a crowd of people, even if you use focus and exposure lock, your picture might be dark because the people close to you will block part of the light from the flash.

Journalists sometimes hold their cameras at arm's length to get a picture in a crowd. You can do it too. Just be sure to adjust the zoom lens to a wide angle and point your camera toward the subject.

Adjusting White Balance for Indoor Shooting

Start

 Push Down

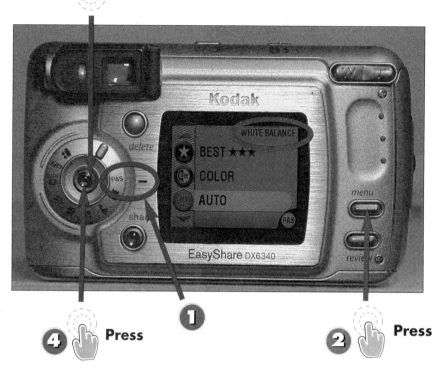

Press **Press**

1. Turn on the camera and select **PAS mode**.

2. Press **Menu**.

3. Scroll down to **White Balance**.

4. Push the joystick button to view the options.

If you want to shoot indoors without a flash, you need to switch from the default auto white balance to incandescent or fluorescent to get pleasing colors, depending upon the room light. This task shows you how to select from these white balance settings using a Kodak EasyShare DX6340 digital camera.

HINT

Different Cameras, Different Settings
To get an idea of how different cameras handle the same procedure, compare these menu options to the Nikon Coolpix 995's white balance options seen in Part 4, "Taking Digital Photos—Outdoors."

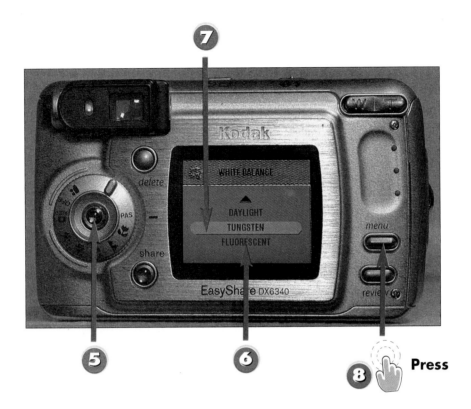

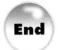 **Press**

5 Move the joystick up and down to scroll through the options and push it in to select one.

6 **Fluorescent** lights are often used in kitchens and garages.

7 **Tungsten** (incandescent) lights are used in most other rooms.

8 Once you've selected an option, press **Menu** to close the menu.

End

Don't Forget to Reset!
HINT
Make sure you reset your camera to its default Auto white balance setting after you finish shooting without a flash. Using an incorrect setting causes your photos to be too blue or too green.

Fluorescent Experiments
HINT
Although businesses often use cool white fluorescent tubes, many homes with fluorescent lights use a warm white tube. Try both settings and use the photo review option to see what works best for you.

Accessing White Balance
HINT
You normally need to set the camera for a special manual control mode to access the white balance menu. If you can't access the white balance menu, check your shooting mode.

Available Light Versus Flash Photography

Start

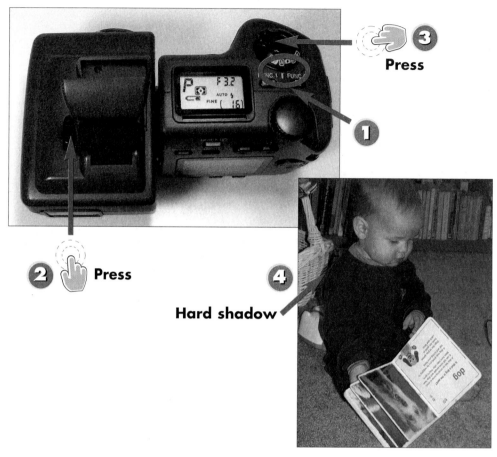

3 **Press**

1

2 **Press**

Hard shadow

4

1 Turn on the camera and select **Auto**.

2 Press the flash release to turn on the electronic flash.

3 Frame the subject and take the picture.

4 The flash photograph places a hard shadow along one edge of the subject.

INTRODUCTION

Available-light shooting can be hard to master. You need to hold the camera very steady (or use a tripod), and you need to shoot subjects that don't move around much because the camera uses wide apertures and slow shutter speeds. In this task, you compare the difference between a flash shot and an available-light shot taken with a Nikon Coolpix 995 digital camera.

HINT

Turning the Camera
When you turn the camera to shoot a vertical photo, turn the camera so the flash throws a shadow along the back side of your subject. With a subject facing right and a camera with a flash on the left side, put the left side of the camera up.

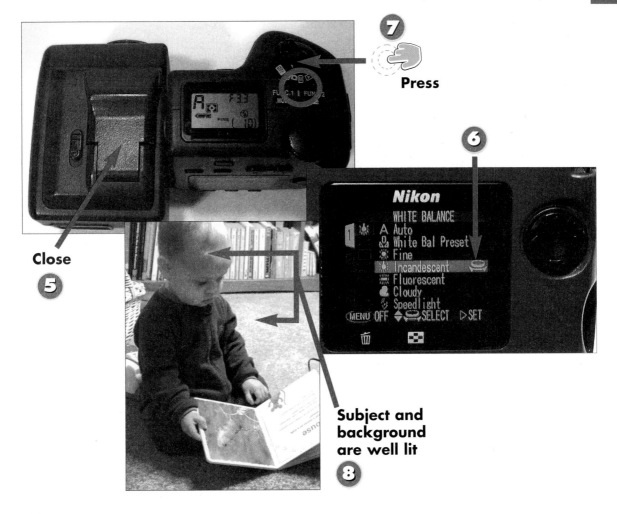

Press

Close
5

**Subject and
background
are well lit**
8

5 Switch the camera to **M mode** and close the flash.

6 Select **Incandescent (Tungsten)** white balance.

7 Wait for the subject to pause, and then take the picture.

8 The available-light photo bathes the subject and background in golden light.

End

HINT
White Balance Refresher
See "Adjusting White Balance
for Indoor Shooting," earlier in
this part, and "Adjusting White
Balance Settings," in Part 4, for
details on setting different white
balance settings.

TIP
Color Purity or Mood?
If you want accurate colors,
shoot with flash. However, if
mood and atmosphere are
more important, shoot with
available light. Use both meth-
ods to see which you prefer.

HINT
**Using All the Light
Available**
Most digital cameras' zoom
lenses allow less light to pass in
telephoto than in wide-angle
modes. To maximize the light
available, set your zoom as
wide as possible and set your
ISO to 400 (see Part 4 for
details).

Using the Wrong White Balance Setting

Start

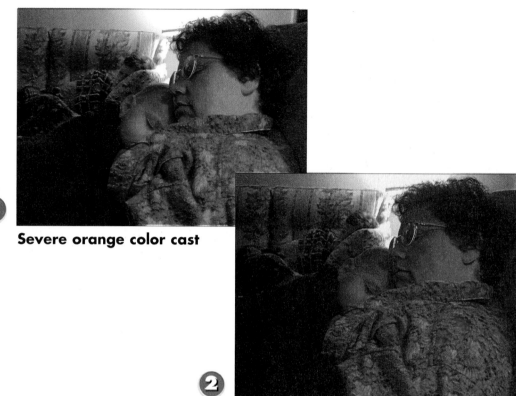

① **Severe orange color cast**

② **Natural color balance**

① Incandescent lighting using Auto white balance. Note the orange color cast.

② Incandescent lighting using tungsten/incandescent white balance. Has more natural color balance.

INTRODUCTION

For best results in indoor shooting, make sure you use the correct white balance setting for the lighting you use. In this task, you see how incorrect white balance settings distort colors.

HINT

Don't Trust Your Eyes!
The human eye automatically compensates for differences in white balance, but cameras need help. If you're not sure what the right white balance setting should be, try a couple of shots with different settings and preview them.

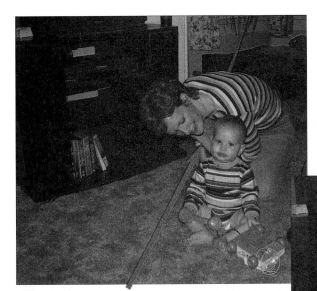

3 Severe blue color cast

Natural color balance

4

3 Electronic flash using tungsten/incandescent white balance. Note the bluish color cast.

4 Electronic flash using Auto white balance. Has more natural color.

End

Fixing Your Mistakes
If you use the wrong white balance setting for a photo, don't throw it out if it's otherwise acceptable. You can fix it with a photo editor such as Adobe Photoshop Elements. See Part 10, "Enhancing Your Digital Photos," for details.

Resetting the White Balance
Get in the habit of resetting the white balance to Auto after you use another setting. This helps avoid incorrect colors in your photos.

Shooting a Close-up with Additional Lighting

Start

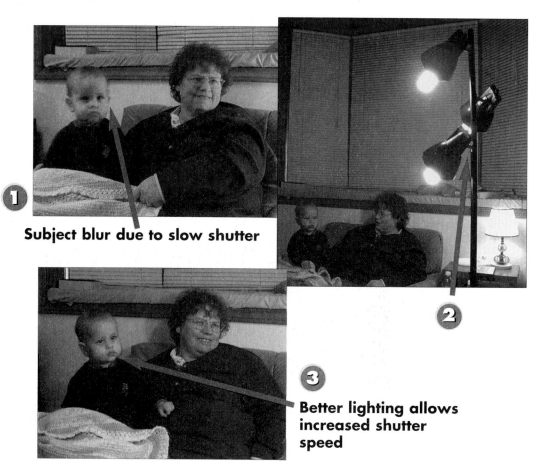

Subject blur due to slow shutter

1

2

3

Better lighting allows increased shutter speed

1 Shooting with only room light requires slow shutter speeds, which can cause subject blur.

2 By adding a floor lamp to one side of the scene, there's more light on the subject.

3 Result: Faster shutter speeds lead to successful photos, even with young children as subjects.

End

INTRODUCTION

The great photographer Arnold Newman once defined available light as "any light that's available." You don't need to be a pro to use the same philosophy. I've done a lot of photography for books using a simple three-bulb floor lamp with swivel fixtures. This task shows you how to improve your shots with a floor or table lamp.

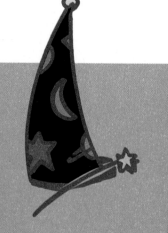

More Light, Less Wattage
HINT You can now buy warm white fluorescent bulbs with output equivalent to 200-watt incandescent bulbs. These are safe to use in ordinary household lamps because they use 45 watts of power. I use these in the lamp shown in step 2.

Avoiding Glare and Unwanted Reflection

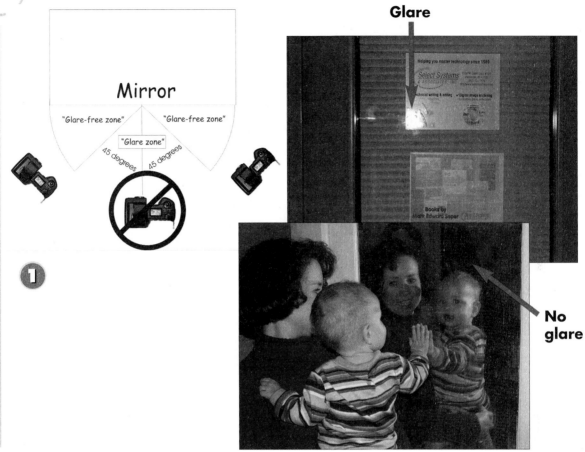

1 The "glare zone" is up to 45 degrees off-axis from a mirror or window.

2 A straight-on shot in the "glare zone" reflects the flash straight back into the lens.

3 A shot taken in the "glare-free" zone. Note how the mirror helps show both sides of the subjects.

End

INTRODUCTION

Home and business interiors alike are full of mirrors and windows. If you're not careful, they can bounce your flash straight back at you. However, by shooting at an angle, you can get great shots without glare. This task shows you how to avoid glare when shooting with a mirror or window in the background, and how to use a mirror for a more creative portrait.

HINT

Using Mirrors Creatively
A mirror shot can show hidden room details as well as another side of a human subject.

Reducing Red-Eye

Start

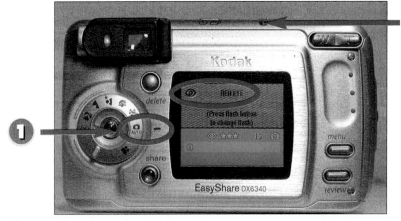

Press

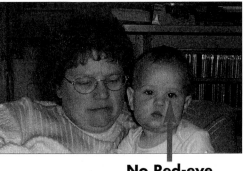

No Red-eye

Red-eye

① Turn on the camera and select **Auto**.

② Activate red-eye reduction by pressing the flash control button until **Red Eye** appears in the LCD display.

③ A photo taken using Red-Eye reduction.

④ A photo taken in normal Auto mode shows red-eye.

End

INTRODUCTION

Because almost all digital cameras feature on-camera flash units, which are very close to the lens, red-eye (bright light bouncing off the retina) is a common occurrence. However, most digital cameras can reduce red-eye by firing a series of low-power flashes to narrow the iris before taking the picture. This task shows you how to turn on this feature with a Kodak EasyShare DX6340.

HINT

Red-Eye and Fast Action
Because red-eye causes a delay of several seconds between when you push the shutter and when the picture is taken, don't use it with a moving subject. A moving subject might move out of camera range during the preflash process.

Using Window Light

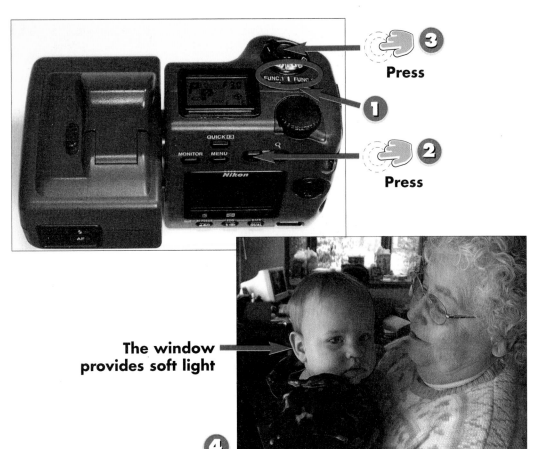

Press ③

① ②

Press

The window provides soft light

④

① Turn on the camera and select **Auto mode**.

② Zoom to wide angle to assure the largest lens opening.

③ Take the picture.

④ Note the soft, flattering light on the faces and clothing.

End

INTRODUCTION

When you use window light, you can leave your camera in Auto mode and use the normal Auto white balance setting because you're using the sun's light inside. Window light, especially when the window is several feet away from the subject, provides a soft, flattering light.

HINT

Don't Block Your Light
Stand to one side of the window to avoid blocking the light coming in. Keep in mind that early morning or late afternoon produces more intense lighting than other times of the day.

Shooting an Activity with Flash

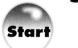

10 ft

Press

Suitable focal point

Press

1. Turn on the camera and press the flash release button to open the flash.

2. Stay within 10 feet of your subject to avoid dark photos.

3. Use the zoom lens to crop the photo.

4. Look for a focal point of action, and then take your picture.

End

If you're called upon to take pictures at a party, school event, or other activity, it's way too easy to take pictures of random activities that have no focal point or are marred by lighting problems. This task shows you how to shoot good activity photos.

HINT

Minimizing "Mugging" for the Camera

Children in particular love to show off for the camera. However, if you shoot a few pictures of them mugging then wait until they're involved in an activity to take more, you can get the pictures you want.

Better Photos with the Rule of Thirds

Start

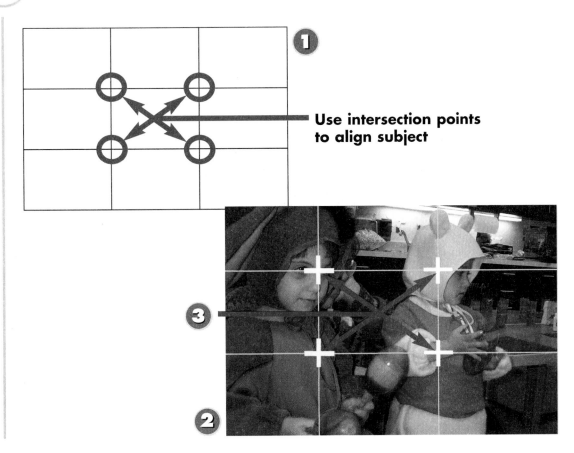

Use intersection points to align subject

1 Draw an imaginary rule of thirds box.

2 Place your subject inside the box.

3 Frame subject along the box's intersection points.

End

INTRODUCTION

Whether you're shooting indoors or outdoors, the rule of thirds is a wise strategy. As you compose your photo, draw imaginary lines to divide the image into thirds both horizontally and vertically. Then place the important elements of your composition, such as a person or an object, where the lines intersect.

TIP

Improving Photo Interest in Thirds
The basic theory behind the rule of thirds is that photos with the subject directly in the center tend to be less interesting than pictures with the subject slightly off-center.

HINT

Visualizing Rules of Thirds
To help you visualize the rule of thirds, try putting magic tape with rules of third markings along the edges of your LCD display.

Shooting a Group with Available Light

Start

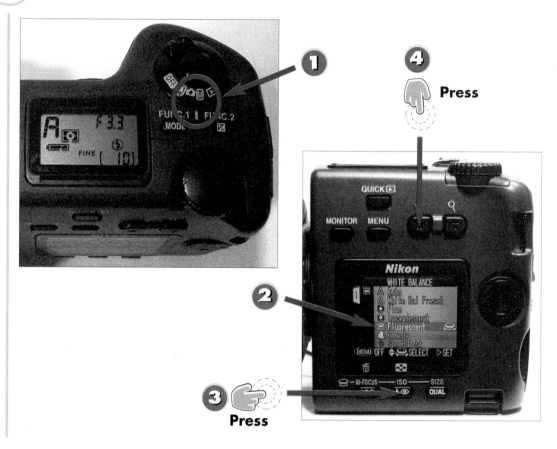

4 **Press**

2

3 **Press**

1 Turn on the camera and select **M (manual) mode**.

2 Select the correct white balance for the room light.

3 Turn off the flash.

4 Zoom to wide angle for an overall view.

INTRODUCTION

The small electronic flash units built in to typical digital cameras don't have enough power to light up a large room to capture a large group. Using available light might be the only way to capture the mood of an event, such as the audience watching a dance performance as in this example.

Flash Controls

HINT

If the flash pops up, you can turn it off by pushing it down. However, if the flash is popped up, some camera models also allow you to turn it off with the flash mode button. If the flash is built-in, you must use the flash selector button to turn it off.

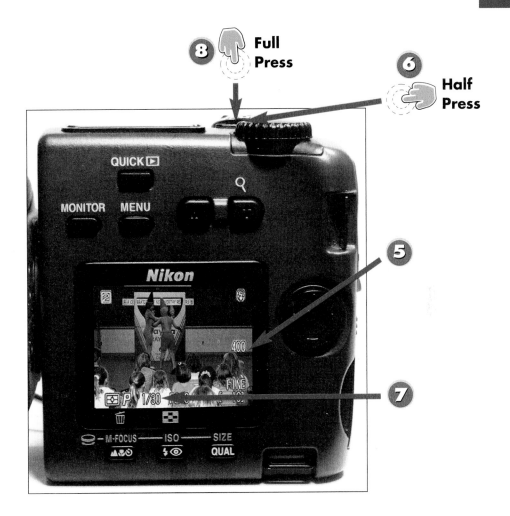

Full Press — 8

Half Press — 6

5 Adjust the ISO rating to 400.

6 Press the shutter release partway down to check shutter speed.

7 Focus on the most important element (such as the audience).

8 Press the shutter button all the way down to take the picture.

For More Details
See "Shooting in Dim Light," in Part 4, for more information on adjusting the ISO rating. See "Attaching Your Camera to a Tripod," in Part 6, for more information on using a tripod.

Wait for the Subject to Pause
You can't stop action with shutter speeds slower than 1/125 second, so make sure you wait for your subject to stop moving. It's relatively simple if they're intently concentrating on a speaker or performance.

Using a Tripod
If the shutter speed falls below 1/60 second, use a tripod to minimize camera shake.

Photographing Jewelry and Reflective Objects

Start

1. Place the jewelry or coin on a dark non-reflective surface.

2. Create a three-sided enclosure with card stock to reflect light.

3. Use a single incandescent or fluorescent lamp for lighting.

4. Turn on the camera and select **Manual mode** (to allow changes in white balance).

INTRODUCTION

Jewelry of any type can be difficult to photograph: Its shiny surface reflects the light, and if you're not careful, you can wind up being reflected on the piece you're trying to capture. Although professionals use elaborate multiple-light whiteboxes for their work, you can create a satisfactory substitute with white card stock and a single lamp. Here's how to use it to get good photographs.

7 **Image with no exposure adjustment**

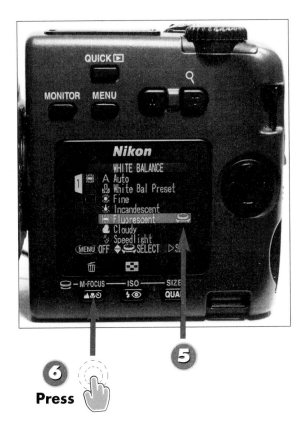

6 **Press**

5

8 **Image with -1 EV**

5 Select the correct white balance setting for the lighting you're using.

6 Select **Close-up mode**.

7 Take the picture after placing the enclosure and turning on the lamp.

8 Try another picture with −1 EV to compensate for the dark background.

End

Reminders
See "Adjusting White Balance Settings," in Part 4, and "Adjusting White Balance for Indoor Shooting," in this part, for details about adjusting white values. See "Using Exposure Compensation (EV Adjustment)," in Part 3, for details about adjusting EV values.

Photographing Coins
You can also use a flatbed image scanner to scan coins (see Part 8, "Scanning Old Photos," for details). You might find you prefer the results to using a digital camera.

Using Advanced Camera Features

Although digital cameras make taking pictures point-and-shoot easy, most models are capable of much more. Many models enable you to capture short movie clips, take properly exposed photos at night, set the shutter speed to capture fast action, adjust the aperture to control which areas are in sharp focus, capture a high-speed action sequence, and even create panoramic views. You can even put yourself in the photo with the self-timer. This part shows you how to use features like these to create more interesting photographs.

Advanced Camera Features

Photos selected
for stitching into
a panorama.

Original
photos taken for
panorama.

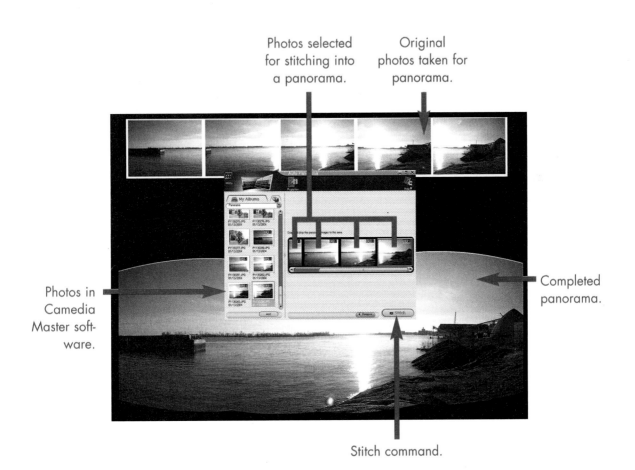

Photos in
Camedia
Master soft-
ware.

Completed
panorama.

Stitch command.

Shooting Panoramic Photos

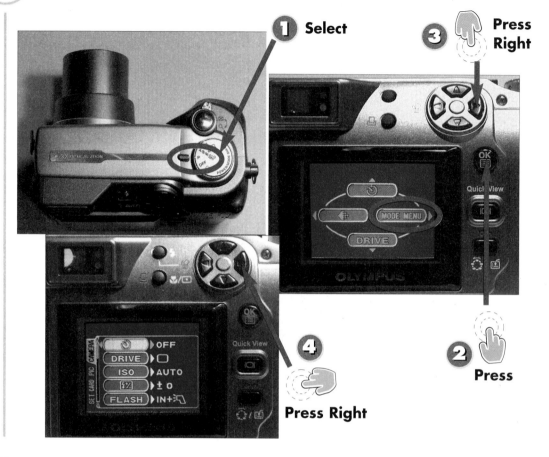

Start

1 Select

3 Press Right

2 Press

4 Press Right

1 Turn on the camera and select **P (program)** mode.

2 Press **OK** to activate the LCD menu.

3 Press the right arrow button to select the mode menu.

4 Press the right arrow button to select the camera menu.

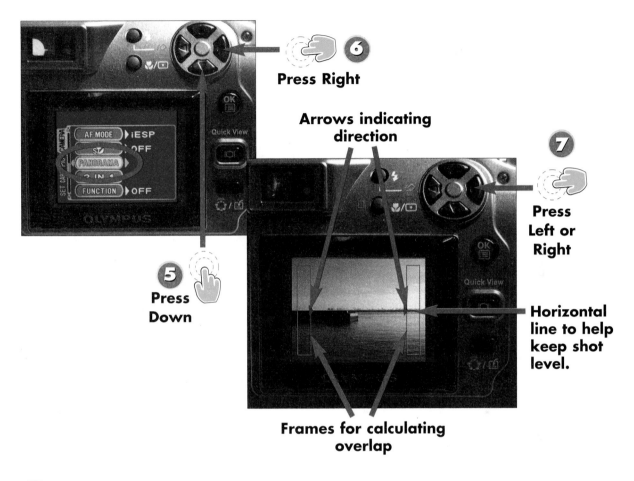

Press Right 6

Arrows indicating direction

7

Press Left or Right

Horizontal line to help keep shot level.

5 **Press Down**

Frames for calculating overlap

5 Press the down arrow button until Panorama is highlighted.

6 Press the right arrow button to select **Panorama**.

7 Press the arrow button that points to the direction you will swing the camera for the rest of the photos.

See next page

8

Press

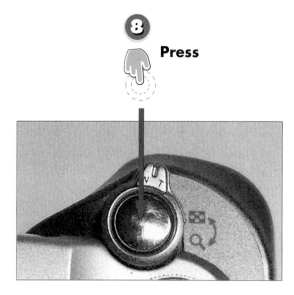

8 Take the first photo.

Getting Help from the Camera

The arrows in the LCD display point to the direction of your next shot. Use the framing marks inside the LCD display to help you line up your shot. The boxes on the sides, top, and bottom of the display help you shoot overlapping pictures.

Take up to Ten Photos

You can take up to 10 photos in a panorama sequence with this camera model. Check your camera manual for details.

Use a Tripod

Use a tripod to keep your camera level. See "Attaching Your Camera to a Tripod," (in this part) for details.

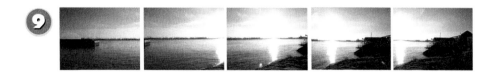

10 Select

9 Take additional photos to complete the panorama.

10 Turn off the camera.

End

HINT See Part 7, "Transferring Digital Photos to Your Computer," to learn how to copy your photos to the computer.

HINT See "Creating a Panorama from Your Photographs" (next task) to learn how to turn your photos into a single panoramic image.

Creating a Panorama from Your Photographs

Start

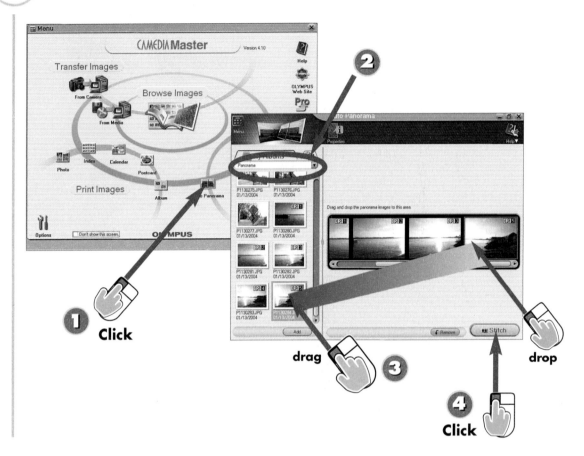

1 Click **Auto Panorama** from the Camedia Master main menu.

2 Select the album that contains the panorama photos.

3 Drag each piece of the panoramic image (noted with a [P] icon), starting with the first one, to the pasteboard.

4 Click **Stitch**.

INTRODUCTION

After you take pictures for a panoramic view, you need to stitch them together to finish the job. This is often performed with the software supplied with your camera. In this task, you learn how to turn the photos taken in panoramic view with the Olympus C-4000 into a panoramic picture using Camedia Master.

HINT

Create an Album First
Use the **Transfer Images from Media** option on the Camedia Master main menu to create an album if you transferred your photos using a card reader.

HINT

Panorama Software
If your camera doesn't offer this feature, see Panoguide.com's comparison and reviews of panorama-creating software at **http://www.panoguide. com/software/**.

5

Click

6

7

Click

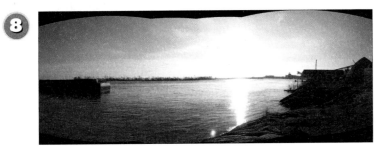

8

5 Click **Save** (or **Try Again** if the images didn't align properly).

6 Type a name for the file and select a file format.

7 Click **Save** to save the file to the current album.

8 Camedia Master creates the completed panorama.

End

Capturing Short Movies

Start

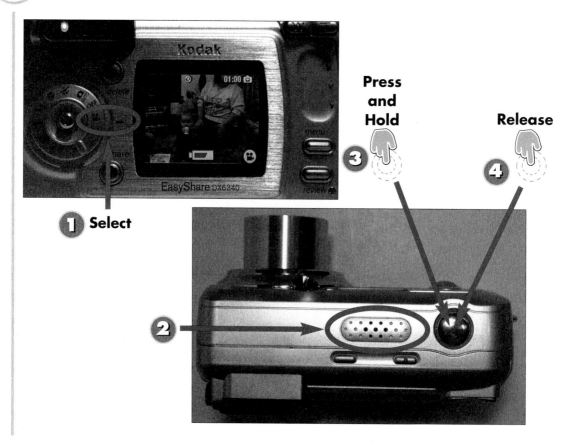

Press and Hold

Release

1 Select

1 Turn on the camera and select **movie** mode.

2 If available, make sure you don't breathe into or cover up the built-in microphone.

3 Press and hold the shutter release to capture the movie.

4 Release the shutter when you are finished with the movie.

INTRODUCTION

Most digital cameras now feature a movie mode that can be used to capture short full-motion video clips, sometimes including audio. Because most cameras capture video using a relatively low-quality setting (the video must be played in a window rather than full-screen), this should not be regarded as a substitute for a DV camcorder. However, in a pinch, this feature lets you capture the moment in a different way than still images do. This task shows you how to capture a short movie with a Kodak EasyShare digital camera.

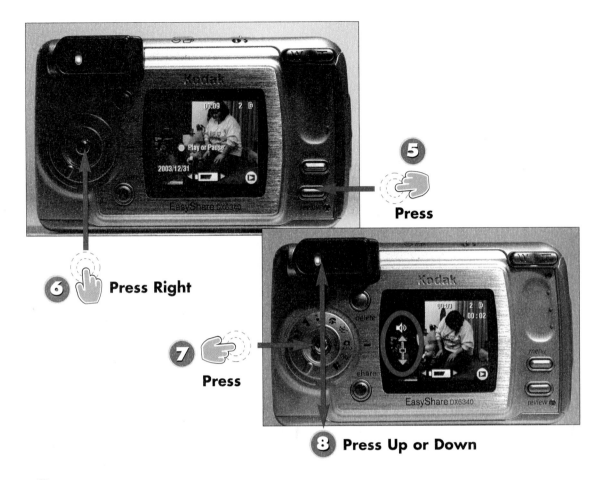

5 Press

6 Press Right

7 Press

8 Press Up or Down

5 To view the movie, press the **Review** button.

6 Push the joystick to the right until the movie you want to review appears.

7 Press the joystick in to play the movie.

8 Push the joystick up or down to adjust the audio playback level.

HINT

Movies and Storage
Although some digital cameras have internal storage, movies require so much storage space that a high-capacity flash memory card should be used for movies.

HINT

Transferring Movies
If you want to view your movies on your computer, you can transfer them as described in Part 7. Most digital cameras store movies as .MOV files that are played back using QuickTime (available from Apple at **http://www.apple.com/quicktime/download/**).

Using Shutter Priority to Capture Action

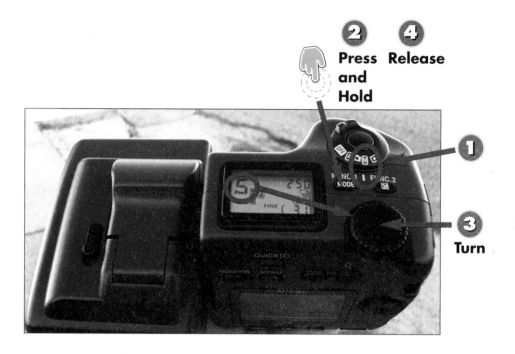

2 **4**

Press **Release**
and
Hold

1

3
Turn

1 Turn on the camera and select **M** mode.

2 Press and hold the mode button.

3 Turn the dial until S appears in the mode window.

4 Release the mode button.

Most digital cameras use program mode for normal shooting. Program mode sets both aperture (lens opening) and shutter speed automatically. However, most digital cameras also feature shutter priority automatic settings for greater control. Shutter priority lets you select the correct shutter speed to stop action, suggest motion, or other creative tasks. In this task you learn how to use shutter priority to capture a speeding train using a Nikon CoolPix 995.

HINT
With some digital cameras, you use the LCD menu display to select the shooting mode.

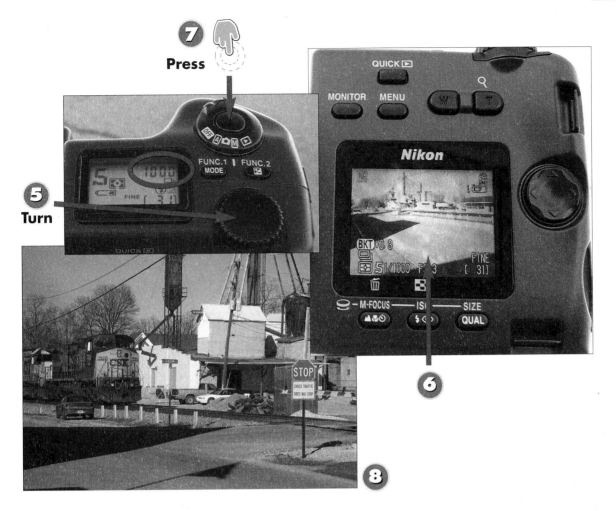

Press

Turn

5 Turn the dial until the shutter speed **1000** (1/1000 second) appears.

6 Compose the picture using the LCD display.

7 Take the picture as the fast-moving object (such as a train) moves into the frame.

8 The fast 1/1000 second shutter speed stops the action.

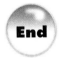

End

Slower Shutter Speeds
Use a slower shutter speed (1/125-second to 1/30-second) to capture moving objects, such as running water, with a bit of motion blur.

Try a Tripod
If you want to use shutter speeds of 1/60-second or slower, consider using a tripod to avoid camera shake. Use a tripod if you use 6x or longer zoom ratios to avoid the magnification of camera shake.

Help from the Camera
If the shutter speed chosen is too fast for the lighting conditions, most digital cameras will blink or flash the shutter speed setting to remind you to choose a slower speed.

Capturing a Photo Sequence

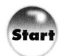
Start

Select
1

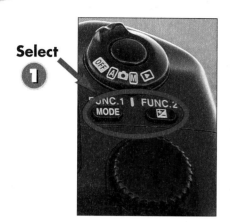

2 Press

3 Press Down

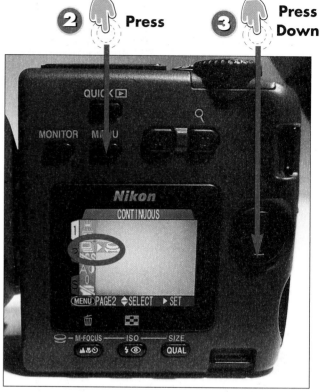

1 Turn on the camera and select **M** mode.

2 Press the **Menu** button.

3 Press the down arrow on the multi-control twice to highlight the Continuous option.

Many digital cameras have a continuous mode shooting option. Instead of pausing several seconds between shots, this mode uses buffer memory in the camera to record several shots (often three or more) as you hold down the shutter release. In this task, you learn how to select and use this option on a Nikon CoolPix 995 digital camera.

HINT

Especially if you are shooting a sequence of a moving object, you should use shutter-priority mode and select a fast shutter speed as discussed in the previous task.

INTRODUCTION

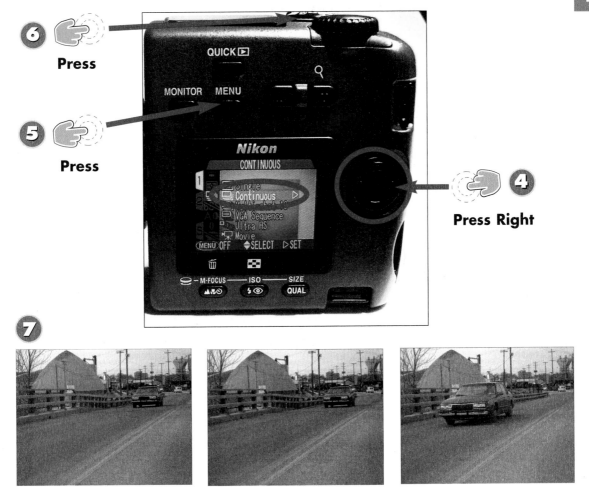

6 Press

5 Press

4 Press Right

7

4 Press the right arrow on the multi-control twice to select **Continuous** mode.

5 Press **Menu** twice to save your setting and close the menu.

6 To shoot the sequence, hold down the shutter button and release it after taking three pictures.

7 Each of these images was shot in sequence using the camera's Continuous mode.

Advantages of a Sequence
Shooting a sequence, like the moving car in this example, helps capture action even better than a single image and with higher quality than movie mode.

Using Aperture Priority to Adjust the Area of Sharp Focus

Start

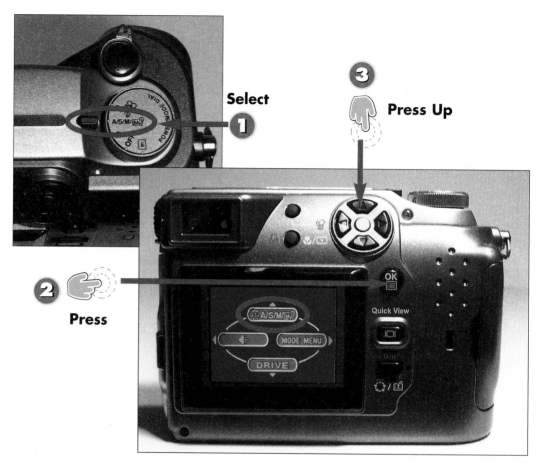

Select ①

③ Press Up

② Press

① Turn on the camera and select **A/S/M** mode.

② Press **OK** to display the menu.

③ Press the up-arrow to select the A/S/M menu.

In aperture-priority mode (if available on your camera), you select the aperture (also called the lens opening or f-stop) and the camera selects the shutter speed. By using a wide aperture (f2.0–f5.6), the area of sharp focus front to back in your picture isn't as deep as with narrower apertures (f8.0 and smaller). This task shows you how to adjust the aperture and use it to control the area of sharp focus in your pictures using an Olympus C-4000 digital camera.

TIP

Narrow Apertures
Most digital cameras in program mode (default) use narrower apertures (f5.6 and above) whenever possible. The viewfinders or status windows in most digital cameras display this information.

Press 4

Press 5

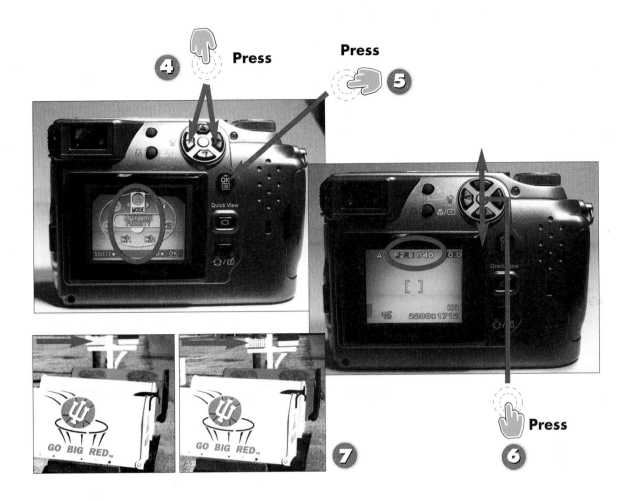

Press 6

7

(4) Press the left or right arrows until Aperture Priority mode is highlighted.

(5) Press **OK** to select **Aperture Priority** mode.

(6) To put the background out of focus, select a wide aperture (f2.0 through f5.6) with the up-down arrows.

(7) Wide aperture photo (left) versus narrow aperture photo (right).

End

Automatic Shutter Speed
Notice when you change the aperture size that the shutter speed automatically adjusts. In Step 6, an aperture of f2.8 has a shutter speed of 1/40 (as indicated on the LCD).

Auto-Reminder
If the aperture chosen is too wide (allows too much light) for the lighting conditions, most digital cameras will blink or flash the aperture setting to remind you to choose a slower speed.

Attaching Your Camera to a Tripod

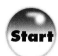

Start

Connect

①

②

③

Turn

④

① Locate the tripod screw hole on the bottom of the camera.

② Line up the tripod mounting screw with the screw hole.

③ Turn the tripod mounting screw until the camera is mounted to the tripod.

④ Adjust the tripod head and legs as needed.

End

INTRODUCTION

A tripod, whether full-size or table-top size, holds your camera securely in place. A tripod helps prevent camera shake for sharp pictures in dim light or when using maximum zoom. A tripod is also useful when you want to use a self-timer. This task shows you how to attach your camera to a mini tripod.

HINT

Turn the Tripod
If the table-top tripod doesn't have a freely turning mounting screw, simply rotate the tripod itself to screw the tripod into the camera.

Put Yourself in the Picture with the Self-Timer

Start

Press ②

Press ③

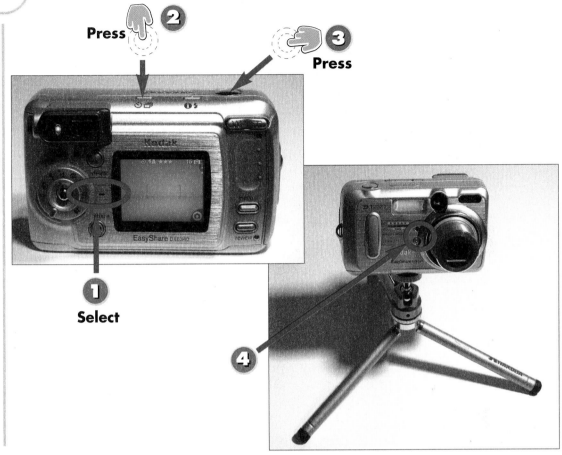

Select ①

④

① Turn on the camera and select **Auto** mode.

② Press the self-timer button on top of the camera.

③ Press the shutter release.

④ After the light on the front of the camera blinks slowly, then rapidly, the camera takes the picture.

End

INTRODUCTION

Most digital cameras feature a self-timer, which provides a time delay of about 10 seconds between the time the shutter button is pushed and the camera takes the picture, giving you time to get in the picture. This task shows you how to activate the self-timer on a Kodak EasyShare DX6340 digital camera.

TIP

Use a Wide-Angle Zoom
When you compose your picture, you might want to set the zoom lens to a wider angle than usual so you won't cut off your head or part of your body.

Transferring Digital Photos to Your Computer

Although you can view your digital photographs with the LCD panel built in to almost all digital camera models, you can't really enjoy or share your master-pieces until you move them from your camera to your PC. Whether you connect your camera directly to the computer, use a camera dock, or use a flash memory card reader, transferring your photos makes it possible to enhance them, print them, and store them for future use.

Data Transfer Hardware and Software

Nikon Browser photo management software

Kodak digital camera

Camera dock

Imation FlashGo! flash memory card reader

Windows XP Scanner and Camera Wizard

Compact flash memory card

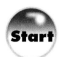
Connecting the Camera to a USB Port

Start

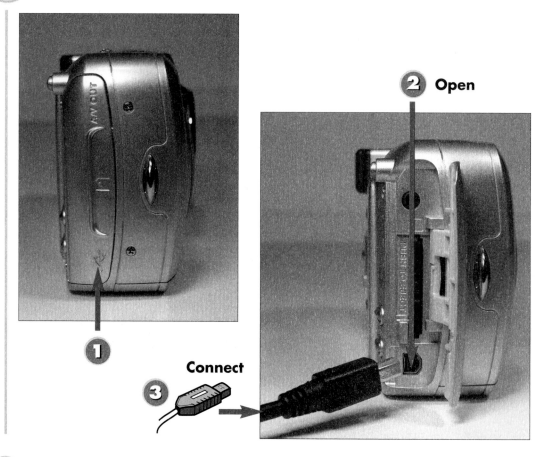

② Open

Connect

③

① Locate the digital camera's data transfer port (some ports are not covered).

② Open the cover and locate the port.

③ Connect the USB cable into the port.

INTRODUCTION

If your camera doesn't have removable flash memory, or you don't have a flash card reader, you need to connect your camera directly to your PC to transfer your photos. In this task, you learn how to use the special USB cable supplied with most cameras (such as the Kodak DX6340 used in this task) to make this connection.

TIP

USB Port Markings
The data transfer port cover might be marked with a pair of arrows or a term such as I/O digital as well as the fork-shaped USB symbol.

HINT

Keep Your Software Handy
You should also carry the data transfer software supplied with the camera so you can use any computer for picture transfer.

Connect

④ Locate an empty USB port on your PC.

⑤ Connect the cable into an empty USB port.

End

Locating Ports
Look for USB ports on the front of the computer or for an empty port on a USB hub connected to the computer to make connecting your camera easier.

Keep It Simple
If the USB ports on your computer are hard to reach and you always use the same computer with your camera, you might want to leave your data transfer cable plugged into the computer or buy an additional cable from the camera vendor.

Using the Scanner and Camera Wizard in Windows XP/Me to Transfer Photos

Start

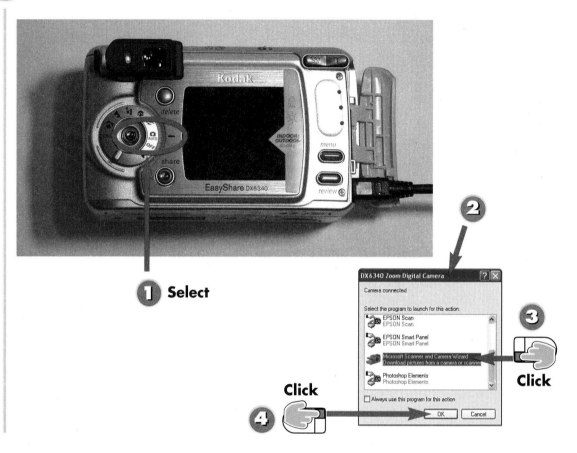

1 Select

Click

Click

1 After connecting the camera to the USB port, turn it on.

2 The Device Connect Autoplay dialog box appears on the Windows desktop.

3 Click the **Scanner and Camera Wizard** to select it.

4 Click **OK** to start the Scanner and Camera Wizard.

INTRODUCTION

Microsoft Windows XP and Windows Me feature the Scanner and Camera Wizard, a tool you can use to transfer photos from your digital camera or to scan photos. Most digital cameras can be used with this wizard. In this task, you learn how to use the Windows XP version of this tool.

Other Startup Options
You might need to select **Share**, **Connect** or a similar option when you turn on the camera to start the transfer process.

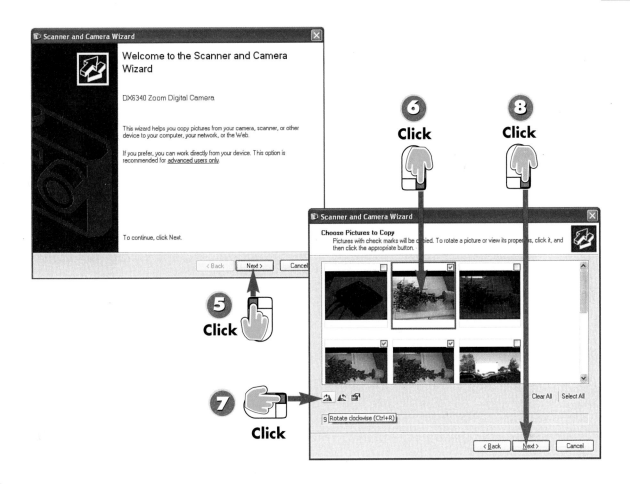

5 Click **Next** to display the photos in the camera.

6 Click a photo you want to rotate.

7 If necessary, click the **Rotate** tool to turn the photo upright.

8 Click **Next** when you have reviewed all the photos.

See next page

Skipping Photos
Clear the check box next to any photo if you don't want to copy it.

Rotating Photos
Some digital cameras automatically rotate photos for you. If not, it's easier to work with your photos later if you rotate them with the wizard before you copy them to your computer.

No Wizard?
If the Scanner and Camera Wizard doesn't detect your camera, install the software provided with the camera.

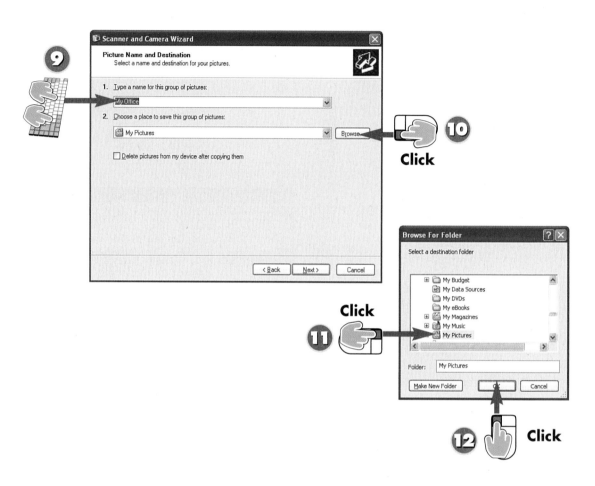

9 Type a name for the group of pictures.

10 To select a new folder for the photos, click **Browse**.

11 Click the folder you want to use for the photos.

12 Click **OK** to continue.

How the Wizard Names Photos
When the photos are copied, each photo is named with the group name plus a sequential number starting with 1.

Creating a New Folder for Photos
Click **Make New Folder** in the Browse for Folder dialog box to create a new folder for your photos. Click the plus (+) next to a folder to view its subfolders.

Making Room for New Photos
To free up room in your digital camera for more photos, click the box next to **Delete pictures from my device after copying them**.

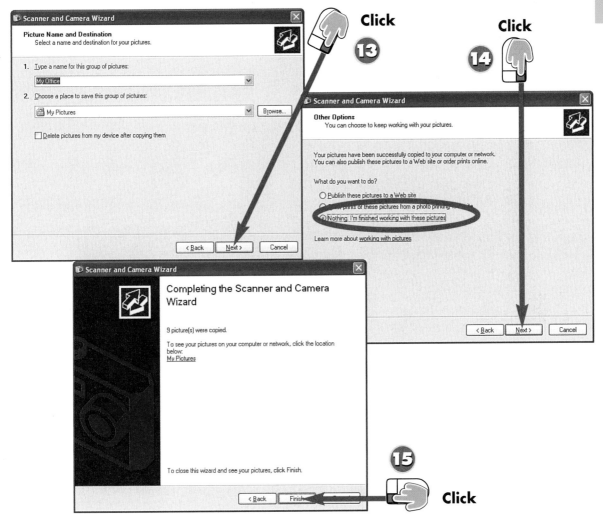

13 Click **Next** to copy the photos.

14 After the photos are copied, click **Next** to continue.

15 Click **Finish** to complete the wizard and view your photos.

End

Online Posting and Printing Options
You can also select **Publish these pictures to a Web site** or **Order prints of these photos from a photo printing Web site** if you have an online photo album or want to use an online photofinishing service.

Where to Go for More About Viewing Your Photos
To learn more about viewing your photos, see Part 9, "Viewing and Managing Your Digital Photos."

Using Vendor-provided Software to Transfer Photos

Start

1 Select

2

3 Click

FLASH GO! (G:)

Windows can perform the same action each time you insert
a disk or connect a device with this kind of file.

Pictures

What do you want Windows to do?

using Photo Printing Wizard

Edit pictures
using Adobe Photoshop Elements

Copy pictures to a folder on my computer
using Nikon View 6

Open folder to view files
using Windows Explorer

Take no action

☐ Always do the selected action.

OK Cancel

4 Click

1 Turn on the camera after connecting it to the computer.

2 The Windows XP Autoplay menu is displayed.

3 Click **Copy pictures...using Nikon View 6**.

4 Click **OK**.

Most digital camera vendors pro-
vide software that can be used to
transfer photos from the digital
camera to the computer after the
camera is connected to the USB
port. In this task, you learn how to
use the Nikon View 6.6.1 soft-
ware supplied with Nikon Coolpix
digital cameras to transfer photos
to a system running Windows XP.

**Install the Vendor's
Software**
Install Nikon View or other ven-
dor-provided software before
connecting the camera to the
USB port and turning it on.

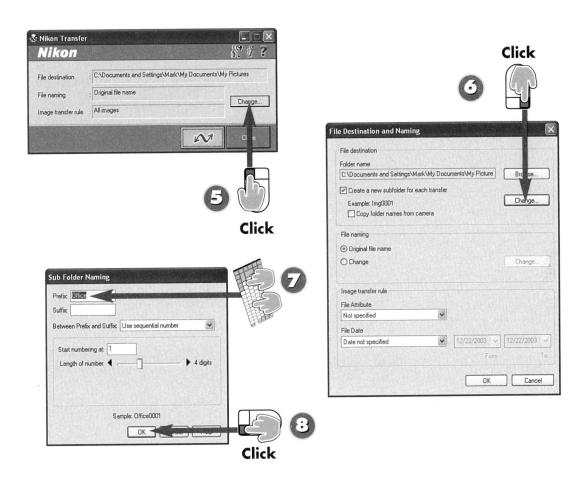

5 Click **Change** to review or adjust the default settings of Nikon Transfer.

6 Click the **Change** button to specify a new name for the group of images.

7 Type a descriptive name for the group of photos into the **Prefix** box.

8 Click **OK** to accept the new name for the group.

See next page

Selecting One Day's Photos

To transfer photos taken on a particular day, use the File Date menu. Be sure the camera's date and time are set correctly!

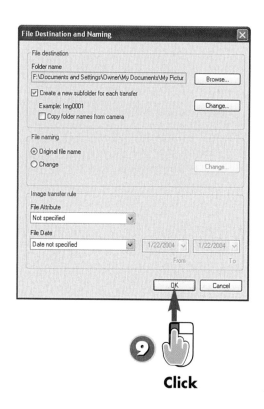

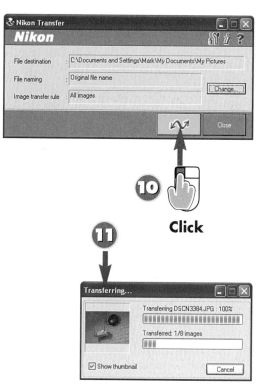

Click

Click

9 Click **OK** to return to the Nikon Transfer menu.

10 Click the **Transfer** button to start copying pictures.

11 Each photo is displayed as it is transferred.

Canceling the Transfer
If you decide to stop transferring photos (such as if you see that the pictures you need are already copied), click **Cancel** to stop the transfer process.

13 Drag

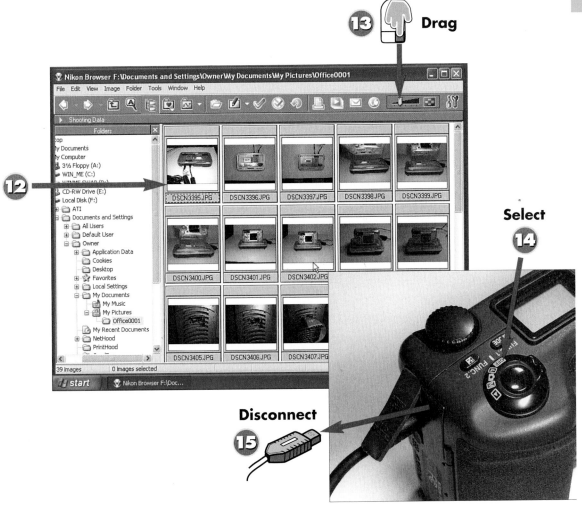

Select
14

Disconnect
15

12 The Nikon Browser program displays the photos.

13 You can adjust the preview image size by dragging the thumbnail slider to the left or right.

14 Turn off the camera.

15 Disconnect the USB cable from the camera.

End

Instant Access to Edit and Transfer Actions
Use the buttons above the photos to edit, print, email, and perform other actions.

Adjusting Thumbnail Size
Use the thumbnail slider at upper right to make the preview images larger or smaller (smaller displays more images per screen; larger makes each image easier to view).

Free Transfer/Edit Software
Most vendors provide photo transfer and editing software that is similar to the Nikon Browser software described in this section, such as Kodak EasyShare system or Sony's Image Mixer.

Using a Camera Dock to Transfer Photos

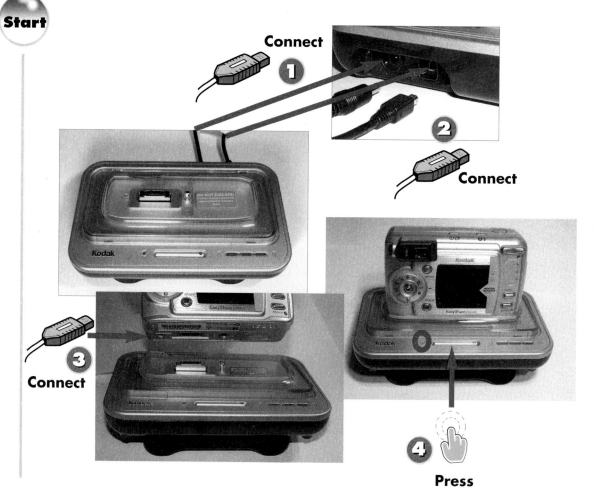

Start

Connect ①

② **Connect**

③ **Connect**

④ **Press**

① Connect the camera dock to a USB port on the computer using the cable included with the camera or dock.

② Connect the AC adapter to the camera dock and a power source.

③ Connect the camera into the data connector on the camera dock.

④ When the green light indicates a good connection, press the **transfer** button to start the process.

An increasing number of digital cameras can use a device called a cradle, docking station, or camera dock to transfer photos. In this task, you learn how to use a camera dock to transfer photos from a Kodak digital camera. Before starting this task, make sure the software provided with the camera is installed.

Line Up the Connectors
For easier docking, line up the rectangular connector on the camera with the matching connector on the camera dock. The alignment shaft on the camera dock fits into the tripod hole on the bottom of the camera.

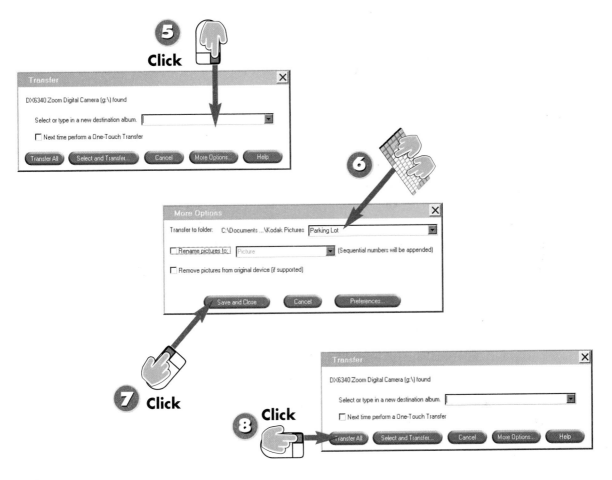

5 In Windows, the Transfer menu appears. Click **More Options**.

6 Type a descriptive name for the folder in the Transfer to Folder dialog box.

7 Click **Save and Close** to return to the previous menu.

8 Click **Transfer All** to copy the photos to your computer. When complete, the images appear in the EasyShare program.

Enabling One-Touch Transfer

If you don't want to set up special options for transferring your pictures, select the **One-Touch Transfer** option check box. It copies your photos for you as soon as you push the **Transfer** button.

Making Space for New Photos

To free up storage space in your camera, select **Remove pictures from original device** (this option might not work with some camera models).

Easy Photo Renaming

To rename the pictures with a descriptive name during transfer, click **Rename pictures to**: and type the name desired. Each picture will also be numbered sequentially.

Using a Flash Card Reader to Transfer Photos

Start

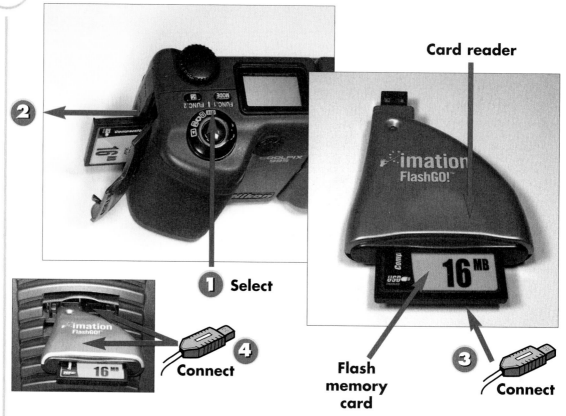

Card reader

2

1 Select

Connect 4

Flash memory card

3 Connect

1 Turn off the camera.

2 Remove the flash memory card.

3 Insert the flash memory card into the reader (if needed, insert the memory card into a card adapter first).

4 Connect the card reader to an open USB port on your computer.

A flash memory card reader looks like a removable-media drive to the computer. Although some flash memory cards activate a menu with various options when inserted into a card reader on some computers, this task assumes that the normal Windows XP file-management functions are being used to access the photos. This is usually the case if camera-specific software has not been installed on a particular computer.

When to Install Driver Software First

With versions of Windows older than Windows XP, you might need to install driver software before you connect the card reader.

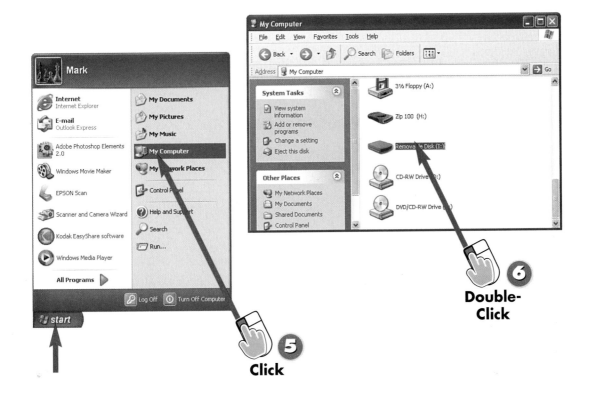

Double-Click

Click

5 Click **Start**, **My Computer** to display the drives available on your computer.

6 Double-click the **Removable Disk** drive to view its contents.

See next page

Opening My Computer on the Windows Desktop
If the My Computer icon is located on the Windows desktop, double-click it to open it.

Fast Access to Photos on Mini-CD or Floppy Disks
If your camera uses mini-CDs or floppy disks, as some Sony-brand digital cameras do, you can also use My Computer to access your files after you insert your media into the appropriate drive.

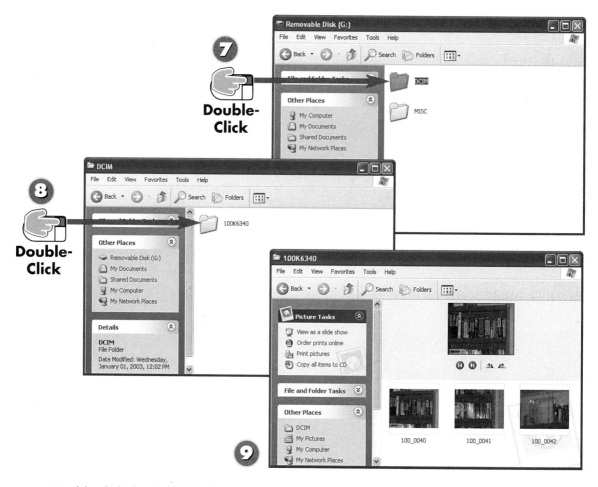

7 Double-click the **DCIM** folder (some digital cameras might use a different name for the folder).

8 Double-click the folder within the DCIM folder to see your photos.

9 The photos stored in the selected folder appear on screen.

The Picture Tasks Menu
Use the Picture Tasks menu to display your photos as a slide show, make prints, or perform other tasks.

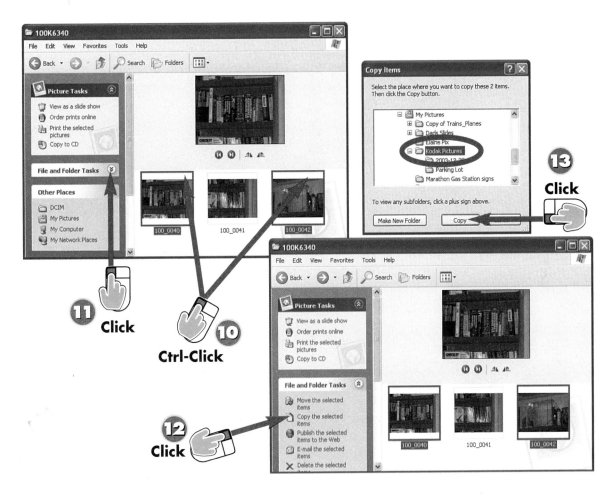

10 Hold down the **Ctrl** key and click each photo you want to copy to another drive.

11 Click the **down-arrow** next to My Computer Tasks to open its menu.

12 Click **Copy the selected items**.

13 Select the destination for the pictures, and click **Copy**.

End

Two Ways to Select All Photos
To select all the photos, press **Ctrl-A**, or click **Edit, Select All**.

Free Up Your Memory Card
To free up space on your flash memory card, choose **Move the selected items** instead of **Copy**. Moving deletes the files from the memory card after it transfers a copy to the selected destination.

Copying Your Photos to a PDA

Start

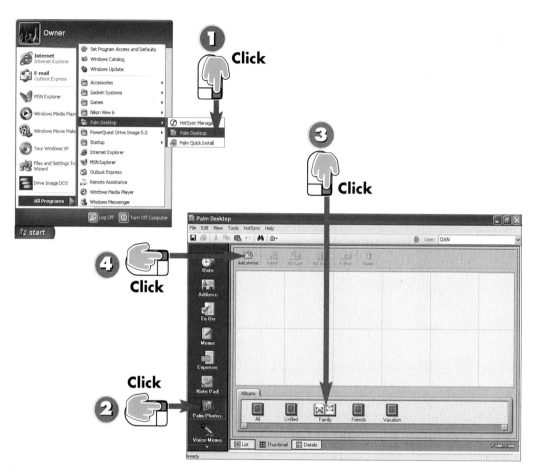

Click ①

Click ③

Click ④

Click ②

① Click **Start**, **(All) Programs**, **Palm Desktop**, **Palm Desktop** to start Palm Desktop.

② Click the **Palm Photos** icon.

③ Click to select a photo folder.

④ Click the **Add Photos** icon.

Glossy prints of photos are easy to carry around and show to people. Yet with digital cameras now outselling film-based models, many photos go from camera to PC without ever being printed. Instead, some personal digital assistants and cell phones can store and display images taken on a PC. Photos are transferred using any one of several image-management utilities. This task shows how to use the Palm Desktop software program to transfer files from a PC to a PDA running the Palm Operating System.

Viewing Photos with Pocket PC.
Most recent PDAs that use the Microsoft Pocket PC operating system include photo-viewing software. You can also download viewing software from **http://www.pocketpccity.com**.

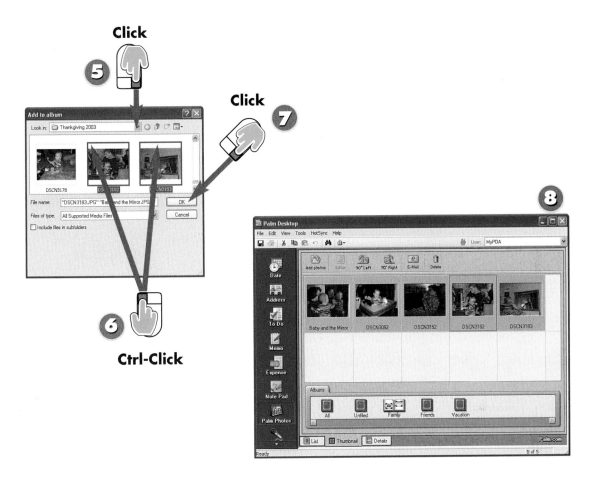

⑤ Click the **Look-in** field to select a folder.

⑥ Select one or more photos with Ctrl-Click.

⑦ Click **OK** to add your selected photos to the Photo Album.

⑧ The selected photos are added to the Palm Desktop Photo Album.

See next page

Changing to a New Photo Album
To move from one Palm Desktop photo album to another, scroll down to the bottom of Palm Desktop and click the icon associated with the folder you would like to view.

**Right
Click**

(9) Connect your PDA to a cradle connected to a USB port.

(10) Right-click the **HotSync Manager** icon in the system tray.

Connect

Starting HotSync Manager

Normally, HotSync Manager is running when the Palm Desktop is running. If you need to start it manually, open it from the Palm Desktop folder on the Start button.

Choose Your Favorite USB Port for Your PDA

You can plug your PDA's cable or cradle into a USB hub or extender cable as well as a USB port on the computer.

Click

Press

⓫ From the HotSync Manager menu, click **Local USB**.

⓬ Press the **HotSync** button on the cradle or cable to transfer the photos to your PDA.

End

Speeding Up PDA Photo File Copying

The more free random access memory (RAM) your PDA is equipped with, the faster your photo file transfer will be. You can free up RAM by temporarily moving some programs or folders from your PDA to a flash card installed in your PDA.

Scanning Old Photos

Now that you've made the move to digital photography, don't leave your old prints, negatives, and slides behind.

Today's scanners do more than simply convert your photo prints into digital photos you can use on your PC: They can also fix problems with color-shifting, poor exposure, and bad cropping of the original. Because traditional photos deteriorate over time, scanners can help stop the ravages of time and help make sure your favorite photos look as good as new, or even better.

This chapter shows you how to scan your prints, negatives, and slides with various types of software, how to use color-correction and exposure setting options found in many scanners, and how to save them to disk.

Using a Scanner

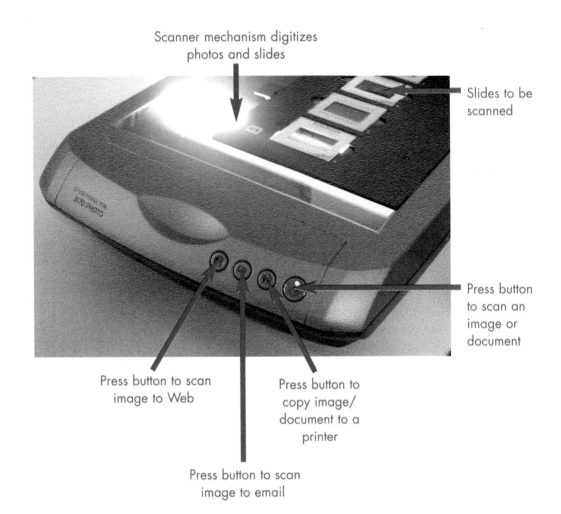

Scanner mechanism digitizes photos and slides

Slides to be scanned

Press button to scan an image or document

Press button to scan image to Web

Press button to copy image/ document to a printer

Press button to scan image to email

Using the Scanner and Camera Wizard to Scan Photos

Start

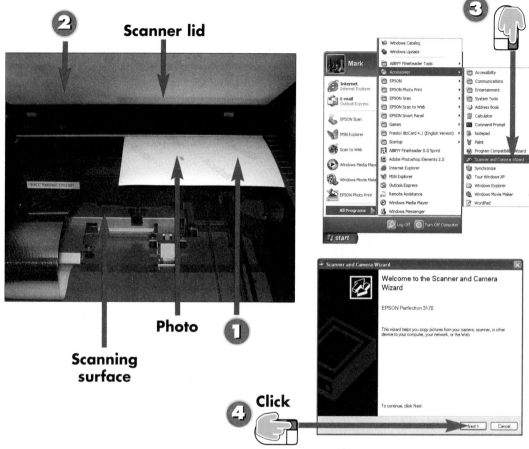

2 Scanner lid

3 Click

Photo

1

Scanning surface

4 Click

1 Open the scanner lid and place a photo on the scanner glass, face down.

2 Close the scanner lid.

3 Click **Start**, **All Programs**, **Accessories**, **Scanner and Camera Wizard**.

4 Click **Next**.

INTRODUCTION

Windows Me and Windows XP include a built-in scanning program known as the Scanner and Camera Wizard. Although this wizard lacks the advanced image quality and repair features of vendor-provided scanner programs, it works with almost any scanner connected to the USB port.

HINT

Check the Scanner
Make sure the scanner is connected to the computer and turned on before you try to scan photos with it.

TIP

In Windows Me
To start the Scanner and Camera Wizard in Windows Me, click **Start**, **Programs**, **Accessories**, **Scanner and Camera Wizard**.

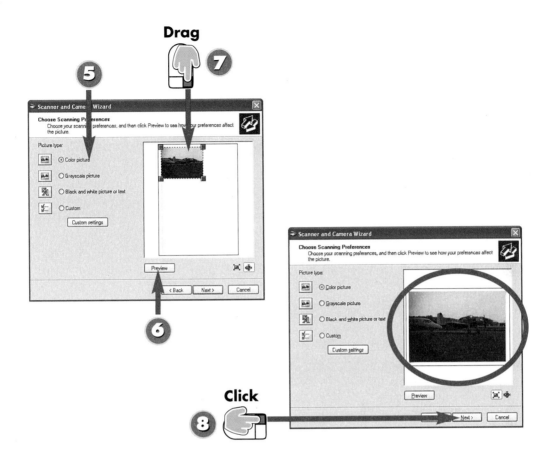

Drag

Click

5 Select a picture type.

6 Click **Preview**. After the scanner warms up, it makes a preview scan.

7 Drag the borders to reselect the picture area selected by the scanner if necessary.

8 Click **Next** to continue.

See next page

Custom Settings
The wizard scans at 150dpi (dots per inch). If you want to print enlargements larger than 5×7 inches or are scanning a portion of a snapshot, click the **Custom settings** button to choose a higher resolution, such as 300dpi.

Adjusting Brightness and Contrast
The Custom settings button also lets you adjust the brightness and contrast of the scan.

Zooming In on Your Scan
Click the button to the right of the Preview button to enlarge the selected area. Click the button at the extreme right to revert to full-screen view.

Click **Click**

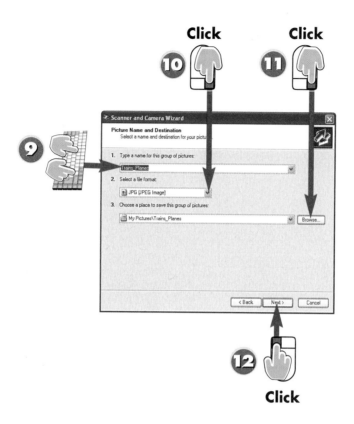

Click

9. Type a name for the group of pictures.

10. Click the down-arrow to select a file format.

11. Click **Browse** to choose a different location for the pictures if desired.

12. Click **Next** to scan your photo.

Names

The name you enter for the group of pictures is also used for the folder containing the pictures. If you scan more than one picture, each picture is sequentially numbered.

File Formats

Use TIF to save the photos with full detail. You can use a photo editor to change the file format and optimize the photo for emailing or Web use. Use JPEG to save photos using less disk space than TIFF. Photos saved using high-quality JPEG settings retain virtually all fine detail but use much less disk space than TIF files. Medium or low-quality JPEG settings discard varying levels of fine detail to use less disk space than high-quality JPEG.

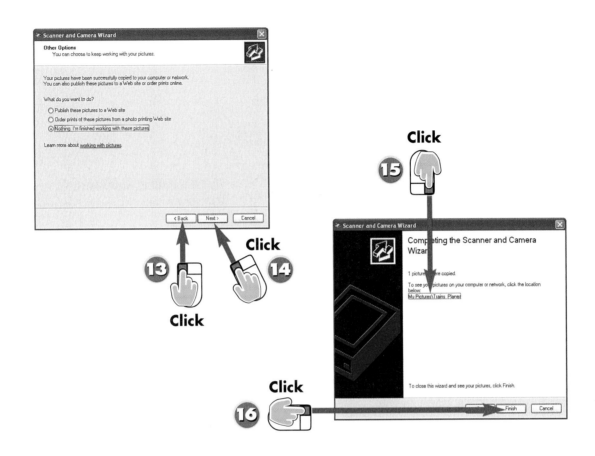

13 To scan additional photos, click **Back** and repeat steps 5 and beyond.

14 When you're done scanning, click **Next**.

15 To see your photos and leave the wizard open, click the underlined link.

16 To see your photos and close the scanner, click **Finish**.

Naming Photos
If you scan additional photos, you can keep the current settings for the group and location. Change them if you want to store additional photos with a different name or in a different folder.

Managing Your Photos
See Part 9 for information on viewing and managing your digital photos.

Internet Options
Click **Publish these pictures to a Web site** to transfer your photos to a Web site hosted by MSN Groups. Click **Order prints of these pictures from a photo printing Web site** to select from various online photo processors.

Using Vendor-Supplied Software to Scan a Photo to Disk

Start

Click

1

Click

3

Click

2

4 **Click**

1 Click **Start**, **(All) Programs**, **Epson Scan**, **Epson Scan**.

2 Click **Photo** as the document type.

3 Click **Color** as the image type.

4 Click **Printer** for the destination.

INTRODUCTION

Most scanners include scanning software that is made especially for a particular scanner, enabling you to select features such as automatic color correction and slide and negative scanning. In this example, I'll show you how to use the software supplied with the Epson Perfection 3170 Photo to scan a color photograph

High-Resolution Scans
When **Printer** is selected, the resolution is 300dpi. Use this setting to capture fine detail in the scan. Use a photo editor to reduce the size of the photo for emailing or the Web.

5 Click **Preview** to create a preview scan.

6 Adjust the **Brightness** slider if the scan is too dark or too light.

7 Adjust the **Contrast** slider if needed to bring out details.

8 When you are satisfied with the preview, click **Scan**. The File Save Setting window then opens.

See next page

Specific Adjustments
You can also adjust contrast and brightness by typing a number into the boxes next to the sliders. Positive numbers increase the setting; negative numbers decrease the setting.

Updating the Preview
Some scanner software, like in this example, immediately shows the result when you adjust contrast and brightness. However, with some scanners, you need to click the **Preview** button again after making changes to see the results.

More Scanning Options
Epson Scan offers a Professional Mode that lets you select a portion of the photo to scan and provides manual exposure control. Most scanning programs offer a similar choice of modes.

10

Click

9

11

12

File Save Settings

Location
C:\Documents and Settings\Mark\My Documents Browse...

File Name (Prefix + 3-digit number)
Prefix: Railcars Start Number: 002

Image Format
Type: TIFF (*.tif) Options...
Details: Byte Order: Windows
 Compression: None

☐ Overwrite any files with the same name
☑ Show this dialog box before next scan

 OK Cancel Help

9 Click **Browse** to select a location for the scans.

10 Type a name for the group of scanned photos in the **Prefix** box.

11 Select the **Start Number** you want the software to use when numbering your scans.

12 Select a file format. Select **JPG (JPEG)** unless you want to edit the photo; otherwise, select **TIFF**.

13 If you select JPG, click **Options** to open the Options dialog.

14 To create a high-quality image, slide the compression level control until 25 appears in the compression level window.

15 Click **OK** to close the Options dialog.

16 Click **OK** to scan the photo.

Check the Defaults
Epson Scan uses a high-compression, low-quality default setting for its JPEG scans. Other scanning software might use higher-quality settings. If you create a low-quality scan, you lose detail in your photo. Check the defaults, and alter them if necessary.

Convenient Scanning
Most scanner programs stay open after the first scan so you can insert a new photo into the scanner and keep scanning until you are finished.

Scanning Slides or Negatives

Start

Close

1. Install the slide adapter (included with the scanner) on the scanner.

2. Place or insert slides shiny side down into the adapter.

3. Remove the inside of the scanner lid to expose the light source.

4. Close the lid.

INTRODUCTION

Many recent flatbed scanners can also be used to scan slides or negatives. A flatbed scanner with a 3200dpi or higher optical resolution can do a decent job of digitizing your slides or negatives for moderate enlargements, snapshots, or email/Web uses. Here's how to use the Epson Perfection 3170 Photo to scan slides to make 4×6-inch prints.

HINT

Light Sources
Some flatbed scanners use a light source that plugs into the scanner and fits over the slides or negatives to be scanned.

TIP

Proper Slide Scanning
If you scan slides or negatives with the shiny side up, the scans will be reversed. You can fix this problem with a photo editor, but it's easier to scan the slides or negatives correctly to begin with.

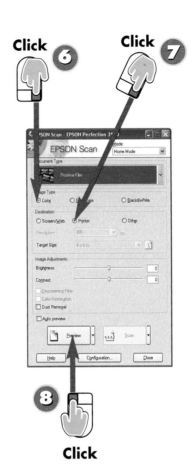

Click 6 **Click** 7

5 **Click**

8 **Click**

5 Start Epson Scan and select **Positive Film** as the **Document Type**.

6 Click **Color** as the **Image Type**.

7 Click **Printer** as the **Destination**. This selects the 4×6-inch print size automatically.

8 Click **Preview** to create a preview scan.

See next page

Negative Holders

TIP

Use a negative holder to scan a negative strip. If your scanner doesn't include one, you can use a piece of clear glass to hold the negatives flat.

Scanning Color Negatives

TIP

If you are scanning negatives, choose **Color Negative Film** instead. This setting reverses the colors and removes the orange cast used by color negative film.

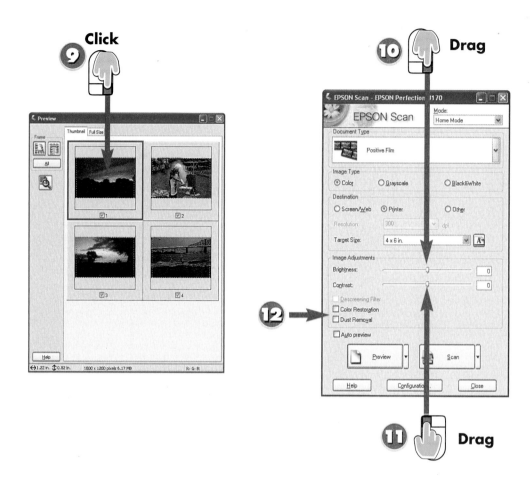

9 If not selected by default, click the slide you want to adjust.

10 Adjust **Brightness** for the selected slide if desired.

11 Adjust **Contrast** for the selected slide if desired.

12 Enable dust removal or color restoration options if needed.

Image Cleanup

Although some photo editors also feature dust and scratch removal or color restoration features, scanner-based options are usually more powerful and work more quickly.

Individual Slides

This scanner and many others will scan all the slides in sequence. Make sure you adjust the contrast and brightness setting for each slide before starting the scan process.

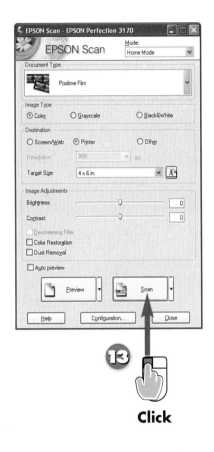

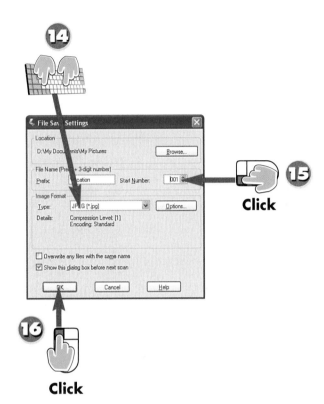

Click

Click

Click

13 After selecting and editing remaining slides, click **Scan** to open the File Save Settings window.

14 Type a name for the group of scanned slides in the **Prefix** box.

15 Select the **Start Number** to use to number your scans.

16 Click **OK** to scan the slides.

End

Slide Formats

Slide scans can use a lot of disk space, so you should select JPEG as the file format. For maximum quality, click **Options** and select **High Quality (1)** as the compression Level.

Bigger Targets, Higher Resolution

If you want to print 8×10-inch or larger prints, close the Preview window, select **Other** for Destination, and enter a scanning resolution of 600dpi to provide adequate detail. Use higher resolutions if you want to crop your slides.

Color-Correcting Your Scans

Start

Click ①

Click ②

Click ③

Click ④

① To start Adobe Photoshop Elements, click **Start**, **(All) Programs**, **Adobe Photoshop Elements**.

② From within Photoshop Elements, click **File**, **Import**, and select **Epson Perfection 3170** to start Epson Scan.

③ Select the Document Type (Photo in this example).

④ Click **Preview**.

Some scanner software features the capability to automatically color-correct scans when necessary. This feature is very useful for fixing faded color prints, color distortion caused by aging negatives or slides, or color shifts caused by incorrectly matching the film type to the lighting conditions used to take the picture. In this section, I show you how to use this feature with the Epson Perfection 3170 Photo scanner and Adobe Photoshop Elements.

No color correction

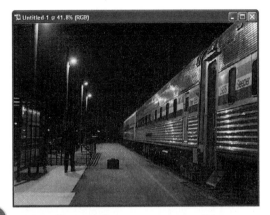

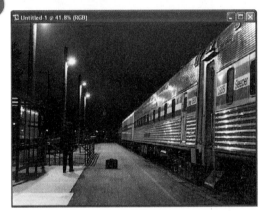

6

8

Click

5

Click

7

Click

Color Correction

5 Click **Color Restoration**. The preview changes immediately to show the effect.

6 If the picture quality is satisfactory, click **Scan** to scan the photo into the Adobe Photoshop Elements workspace.

7 When you are finished scanning, click **Close** to return to Adobe Photoshop Elements.

8 Here you can see the scanned photo with and without color correction.

End

Other Software
With some scanner software, you might need to switch from the simple menu to the advanced menu to enable color-correction or other advanced features.

When to Correct
You might want to scan a photo with and without color correction, as I've done here, to see which version you prefer. In some cases, the uncorrected version might better match the mood of the scene.

No Color Correction
If your scanner doesn't support automatic color correction, you might be able to adjust color balance manually during the scan. Otherwise, use an image editor such as Adobe Photoshop Elements (see Part 10, "Enhancing Your Digital Photos," for details).

Saving the Scan in Adobe Photoshop Elements

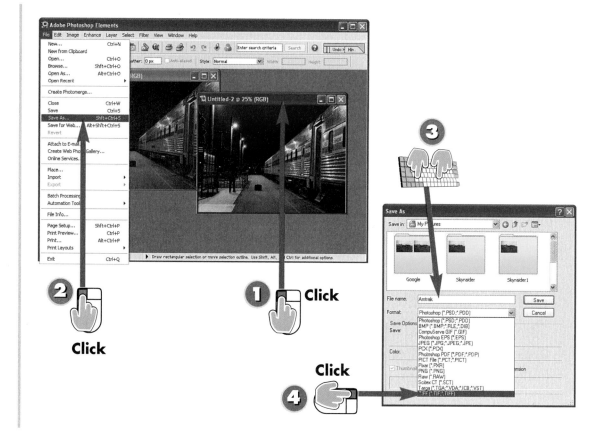

Click

Click

Click

1 Click the photo you want to save.

2 Click **File**, **Save As**.

3 Type the filename you want to use.

4 Click **TIFF** if you want to edit the file later.

Although photo editors such as Adobe Photoshop Elements use the Scanner and Camera Wizard or the scanning software supplied with the scanner to scan images, there's one big difference when the photo editor starts the scanner: The scans aren't saved to disk until you do it yourself. In this section, I show you how to save your scans.

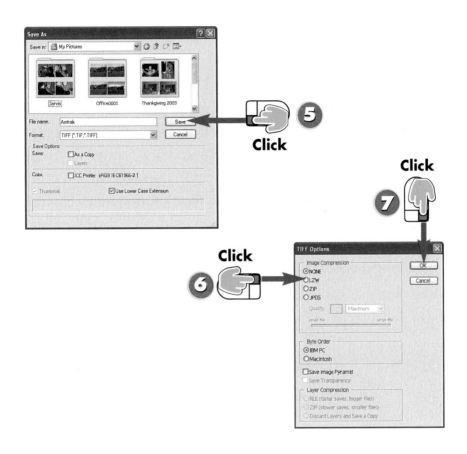

Click

Click

Click

5 Click **Save**.

6 Select **LZW** compression to use much less disk space when saving your photo than with **NONE**.

7 Click **OK** to save your file to disk.

End

Close the File
The file stays onscreen after you save it in case you want to edit it. To close the file, click the **X** in the upper-right corner of the file window, or click **File**, **Close** on the menu.

Viewing and Managing Your Digital Photos

After you scan or copy digital photos to your system, you will want to view them. Although earlier versions of Windows offered limited tools for enjoying digital photos, Windows Me and especially Windows XP contain a wide variety of built-in features you can use to view and manage your digital photo collection. In this part, I show you how to use the My Pictures folder, how to view your photo files, how to name and rename them, and how to delete them using Windows XP and Me. Windows XP also features a built-in slideshow feature, and I show you how to use it to preview your photos.

The My Pictures Folder

The Picture Tasks window pane menu gives you easy access to common uses for your picture files.

The File and Folder tasks menu allows you to manipulate the file.

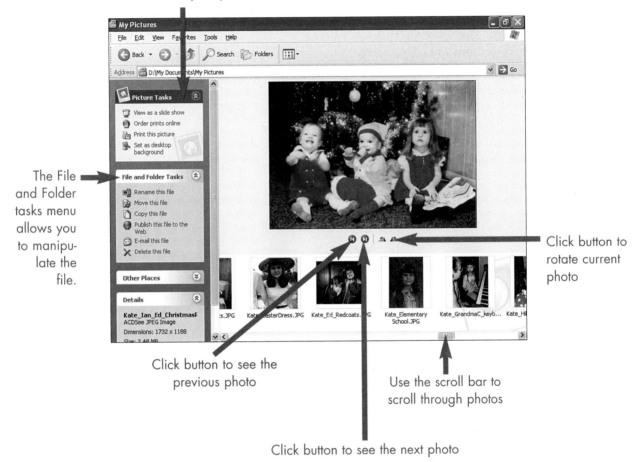

Click button to rotate current photo

Click button to see the previous photo

Use the scroll bar to scroll through photos

Click button to see the next photo

Using the My Pictures Folder in Windows Me

Start

Double Click

Double Click

1 Double-click the **My Documents** icon on the Windows desktop to open it.

2 Double-click the **My Pictures** folder to open it.

INTRODUCTION

Windows Me and Windows XP's My Documents folder contains a My Pictures folder. This folder is more than a convenient place to store photos: it has special features designed to make working with your digital photos and scans easier and more fun. This part shows you how to use the special features of the My Pictures Folder in Windows Me.

TIP

Locating My Documents
If the My Documents folder is not visible on the Windows Desktop, open **My Computer** from the desktop or start **Windows Explorer** or **My Computer** from the **Start** menu. My Documents is available from both Windows Explorer and My Computer.

Click **Click**

6 3

Click

4

Click

5

3 Click a photo to see it in the preview window.

4 Click the **Zoom In** button to zoom in on the photo.

5 Click the **Full Screen Preview** button to display a larger preview.

6 Click the **Print** button to print the photo.

End

Photo Information
The name, size, type, dimensions, date, and time the picture was created or last edited is shown above the preview window.

Small Photos
A photo that's larger than 640×480 will take a long time to email and is too big to use on a Web site. See Part 10, "Enhancing Your Digital Photos," to learn how to make the photo smaller for email or Web use with Adobe Photoshop Elements.

Using the My Pictures Folder in Windows XP

Start

Click

Click

1. Click **Start, My Pictures** to open the Windows XP My Pictures window.

2. The folder shows thumbnail views of some photos in folder.

3. Click the **Views** button and then **Filmstrip** to switch to Filmstrip view.

INTRODUCTION

Windows XP's My Pictures folder, shown at the beginning of this chapter, offers even more options than Windows Me's version. In this section, I show you how to use its new and enhanced features.

HINT

Special Features in Subfolders
All folders stored in the My Pictures folder in Windows XP or Windows Me also have the same special features as the main My Pictures folder.

TIP

Size and Other Details
To see the size and other information about all photos in the My Pictures folder, select **Details** from the **View** menu.

4 Click a photo to select it for large filmstrip view.

5 Right-click a photo to display its menu.

6 Click **Preview** to see the photo in a larger window.

7 The selected image appears in the Windows Picture and Fax Viewer window.

Rotating Pictures
You can also rotate pictures with a photo editor such as Adobe Photoshop Elements.

Previewing Photos with Windows Picture and Fax Viewer

Start

Click ④

Click

Click ③

Click ①

Click ②

① To send a file to the Recycle Bin, click the **Delete** button.

② To save a copy of the file with a name and file type you choose, click the **Copy To** button.

③ To open a file for editing in the default picture editor, click the **Edit Picture** button.

④ To open the Windows Picture and Fax Viewer Help file, click the **Help** button.

End

INTRODUCTION

When you select a photo for preview with Windows XP, Windows uses the Picture and Fax Viewer to open the photo. This task shows you how to use Windows Picture and Fax Viewer to help manage your photos. To learn more about the file types supported by Windows Picture and Fax Viewer, see Part 8, "Scanning Old Photos."

HINT

Using Copy To
If you want to edit a photo without risking losing the original, make a copy of it with the **Copy To** button and edit the copy.

TIP

Moving Through the Folder
To view other photos in this folder, click the blue arrows at the left side of the controls to move through the folder.

Running a Slideshow in Windows

Start

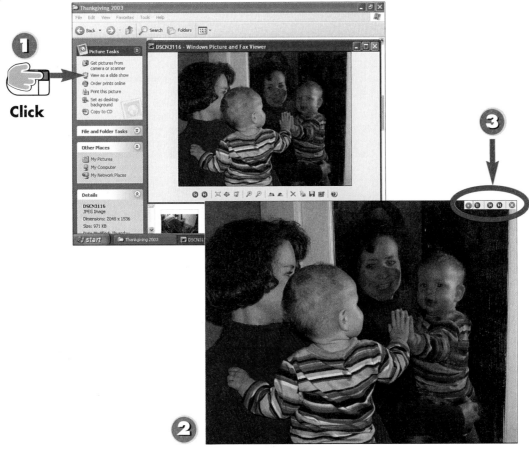

①

Click

③

②

1 From My Pictures, click the **View as a slide show** link.

2 The slideshow starts.

3 Move the mouse to the top right corner of the screen to display buttons that control the slideshow.

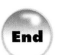

End

PART 9

Renaming Your Images in Windows XP

Start

Right Click ②

Click ③

④

① Open the folder containing your photos.

② Right-click the file you want to rename.

③ Click **Rename**.

④ Type a new name over the old name in the name box below the picture.

End

INTRODUCTION

Digital cameras name files with an alphanumeric code that doesn't identify the subject. You will probably want to rename your best photos to make them easier to find and organize. Windows XP makes it easy to rename individual files.

TIP

Don't Change File Extensions
If My Pictures is configured to show file extensions such as .jpg or .tif for your photo files, make sure you don't change or delete these extensions. Windows uses the file extension to determine which program to use to open the file.

HINT

Descriptive Filenames
When you name or rename your file, incorporate the name of the people, object, or place into the photo title. Doing so makes it easier for you to locate your photos on your PC.

Deleting Your Images in Windows XP

Start

Right Click

Click

Click

1 Open the folder containing the photo you want to delete.

2 Right-click the file to display a task menu.

3 Click **Delete**.

4 Click **Yes** to send the selected file to the Recycling Bin.

End

Enhancing Your Digital Photos

No matter how skilled a photographer you are, few photos are good enough to print as is. Whether you're shooting brand-new digital photos or scanning old photos, the pictures you take might be too dark, be too light, need color adjustment, have problems with red-eye, or need other types of repairs. In this part, I show you how to use Adobe Photoshop Elements, a low-cost but powerful photo editor, to repair and enhance your digital photos.

A 30-day trial version of Adobe Photoshop Elements is included on the CD-ROM packaged with this book. Many scanners also include this software.

The Adobe Photoshop Elements Interface

Context-sensitive menu area changes as you use a particular tool.

Shortcuts to the most common commands.

Click tabs to open special task menus and get hints.

Use the Tools menu to edit your photo.

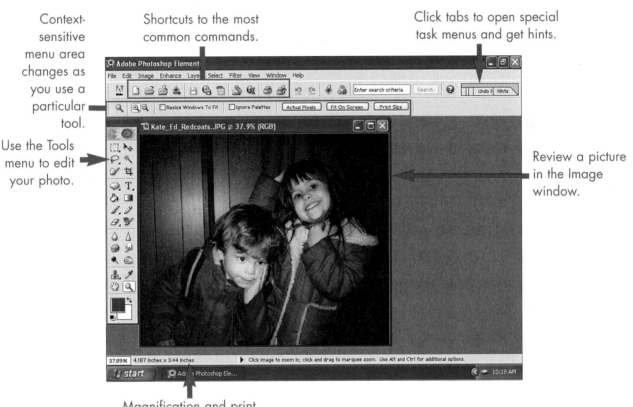

Review a picture in the Image window.

Magnification and print size of current image.

Opening a Photo

Start

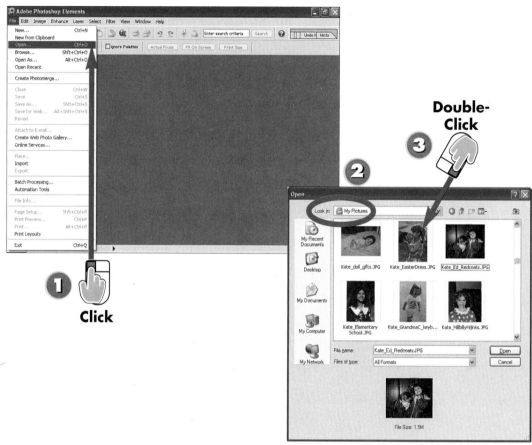

Click

Double-
Click

1 Click **File**, **Open**.

2 Use the **Look in** field to navigate to the folder containing your photos.

3 Double-click a photo to open it.

End

INTRODUCTION

Before you can repair a photo, you need to open it. The File menu in Adobe Photoshop Elements enables you to select a file and bring it onto the work area.

Selecting Multiple Photos
If you want to work on more than one photo at a time, click the photos while holding down the **Shift** key, and then click **Open**.

Where Elements Looks for Photos
Adobe Photoshop Elements "remembers" the last folder location you used for storing a photo. It opens that folder automatically when you click **File**, **Open**.

Rotating a Photo

Start

Click 1 **Click** 2 **Click** 3

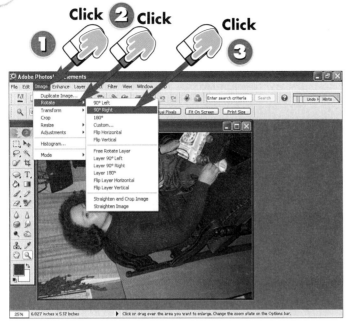

4

① Click **Image**.

② Click **Rotate**.

③ Click **90° Right** to rotate the left edge to the top (or **90° Left** to rotate the right edge).

④ Now the vertical image is oriented properly.

End

INTRODUCTION

When you shoot a vertical photo with a digital camera, you have to hold the camera at a 90-degree angle to take the photo. Consequently, the photo needs to be rotated 90 degrees to look right. This task shows you how to rotate vertical photos so they're oriented correctly.

HINT

Flipping an Image
Click **180°** to rotate the image top-to-bottom. You can also flip (mirror-image) the photo horizontally or vertically with this menu.

HINT

Custom Rotation
Use the **Custom Rotation** option to rotate a photo by the number of degrees and direction you specify. It's useful for straightening out a crooked photo or for special effects.

Cropping a Photo

Start

Click ① ②

Click & Drag

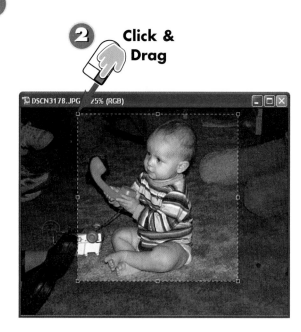

1 Click the **Crop** tool.

2 Click and drag the mouse to highlight the parts of the photo you want to keep.

Photos often have distracting backgrounds that detract from the actual subject, or you might not have been able to zoom in on a distant subject to make it as large as you'd like. The cropping feature in Adobe Photoshop Elements helps you cut away the distractions and focus the viewers' attention on the most important parts of the photo.

TIP

Cropping to Switch Photo Layout
As this example demonstrates, you can crop a vertical section from a horizontal photo, or a horizontal section from a vertical photo.

HINT

Using the Marquee Tool to Crop
You can also use the rectangular marquee tool to select the area to crop first, and then select **Crop** from the Image menu. However, it doesn't highlight the area that remains the way the Crop tool does.

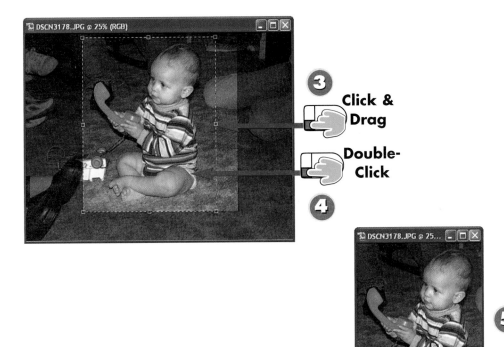

Click & Drag

Double-Click

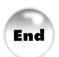

③ To fine-tune the crop area, click and drag the borders to adjust the cropping marks.

④ Double-click the photo to crop it.

⑤ Photoshop Elements displays the cropped version.

End

Moving Your Photo Onscreen
HINT
If the photo you open in Adobe Photoshop Elements is behind the floating toolbar, you can drag the photo to the right so it's no longer "hiding." You can also drag the toolbar to the right if you prefer.

Saving Your Changes
TIP
To save the cropped photo, see "Saving Your Changes While Keeping Your Originals," **p.179**, this part.

Enlarging Your View
HINT
To make the photo as large as possible (and still fit in the borders of your screen), click **View**, **Fit on Screen**, or hold down the **Ctrl** key and press **0**.

Adjusting Photos That Are Too Dark or Too Light

Start

Click

1 Click **Enhance**, **Auto Levels** to have Photoshop attempt to fix the photo.

2 In this case the photo needed to be lightened, which is just what Photoshop did.

End

INTRODUCTION

One common problem with digital photos, especially photos taken indoors, is that they're too dark or too light. This usually happens because the flash didn't go off, the camera batteries were running low, or the auto-exposure feature was fooled. Fortunately, Adobe Photoshop Elements's Auto Levels feature can fix these photos.

TIP

Quick Fix Provides a Preview
You can also preview the changes to brightness, colors, rotation, and other common problems before you make them by clicking the **Quick Fix** menu item.

HINT

Adjust Brightness/Contrast
If the photo is moderately dark or light, it's better to fix the photo with the Adjust Brightness/Contrast option on the Enhance menu. Use **Auto Levels** to fix very dark or very light photos as shown here.

Fixing Photos That Look "Flat"

Start

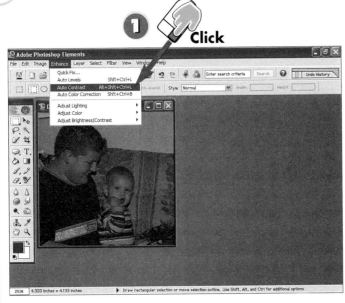

1 Click

2

1 Click **Enhance**, **Auto Contrast** to improve the contrast.

2 The fixed photo is now considerably clearer and not nearly as dull to look at.

End

INTRODUCTION

Photos that don't have a full range of tones (light to dark) are usually dull to look at and don't print well. Adobe Photoshop Elements can put the excitement back into these flat-looking photos with its Auto Contrast tool.

TIP

Choosing the Right Repair Option
Sometimes the Auto Levels tool is a better choice than Auto Contrast to fix a photo that doesn't have enough contrast. Use the **Quick Fix** menu option to preview your changes.

HINT

Reversing Your Changes
If the photo doesn't look better after you select this option, click **Edit, Undo** to reverse the changes.

Removing Color Casts

1. In Photoshop Elements, click **Enhance**, **Adjust Color**.

2. Click **Color Cast**.

3. Click a gray, white, or black area in the photo and observe the change in color.

4. Click **OK** when you are satisfied with the improved colors.

INTRODUCTION

The human eye is able to compensate automatically for variations in the color of light. Unfortunately, digital cameras aren't that smart. Although incandescent bulbs have a much warmer (redder) light than daylight, you might not notice the difference—until you look at digital photos taken with the wrong white balance setting.

Scanned photos that were taken using the wrong kind of film for lighting conditions, or were scanned from photos that are beginning to deteriorate, might also look too red or too blue. Whatever the cause, Adobe Photoshop Elements can restore the correct colors to your photos with just a little effort on your part.

TIP

Adjusting White Balance
To learn how to adjust your digital camera for different lighting conditions, see "Adjusting White Balance Settings," **p. 58** (Part 4) and "Adjusting White Balance for Indoor Shooting," **p. 76** (Part 5).

Click

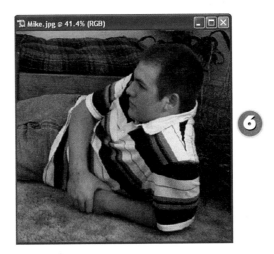

5 Click **Enhance**, **Auto Color Correction** to complete the process.

6 The photo now has truer color (note the white stripes in the shirt).

Selecting an Area
Although the Color Cast Correction dialog states that you can select an area of the photo that should be gray, white, or black, selecting an area that should be white generally works best.

Try, Try Again
If the first area you select doesn't improve the color (or makes it worse), click another area until you like the results.

Using Color Variations
You can make further color adjustments by clicking the **Color Variations** tool in the **Enhance**, **Adjust Color** menu. It displays a range of color adjustments you can click to see an immediate preview.

Fixing Red-Eye

Start

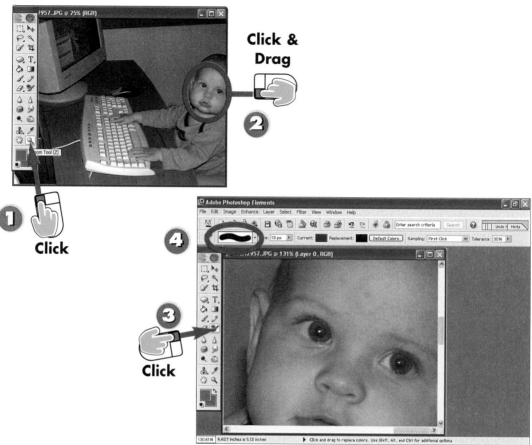

Click &
Drag

Click

Click

1 In Photoshop Elements, click the **Zoom** tool.

2 Click and drag the cursor around the red eyes to zoom in on them.

3 Click the **Red-Eye Brush** tool.

4 Choose a brush from the pop-up palette.

Click

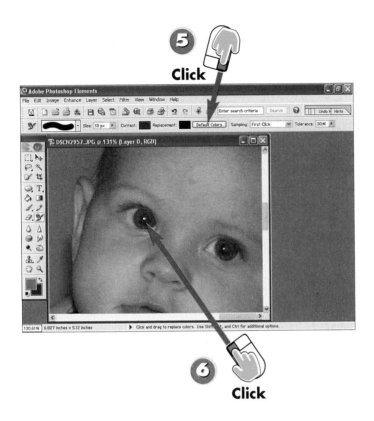

Click

5 Click **Default Colors** in the Options bar.

6 Position the Red-Eye Brush tool over the red eye in the photo and click until the red eye is removed.

End

Finishing the Job
Move the brush over the red areas in each eye as you click to ensure complete removal of red-eye.

TIP

Removing Dust and Surface Damage

Start

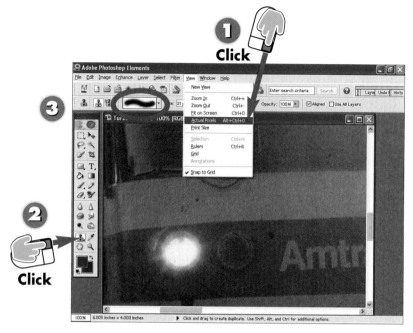

1. Click **View**, **Actual Pixels**. This increases the display size of the image you are viewing.

2. Select the **Clone Stamp** tool.

3. Select a brush from the **Brushes** pop-up palette.

TIP

Brush Selection
When using a brush, it is generally more efficient to select a soft-edged one. Generally, soft-edged brushes tread more lightly on the photo you are repairing, and you are less likely to smudge the image while editing it.

TIP

Zooming for Better Views
If Actual Pixels doesn't magnify the image enough, use the **View**, **Zoom In** menu option to increase the size of the damaged area onscreen for easier editing.

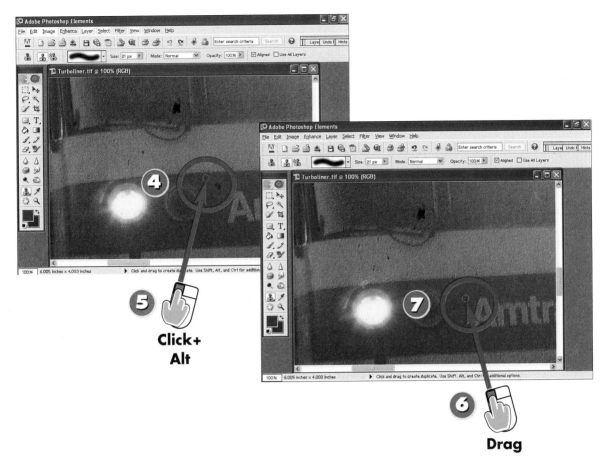

**Click+
Alt**

Drag

④ Position your cursor over an undamaged area of the photo that most closely resembles the damaged area you are fixing.

⑤ Hold down the **Alt** key as you click the mouse to select this area.

⑥ Drag your cursor over the damaged area.

⑦ Paint over the damaged area until the spots disappear.

TIP

Short Strokes for Realism
When you are painting over an image, Adobe recommends using short strokes to make the repair look realistic and not like a special effect.

HINT

Don't Clone Problems
The area used by the Clone Stamp tool to replace the damaged area is indicated by a + (plus-sign) shaped cursor. If you move this cursor over the damaged area, you will clone the damage to another part of the photo.

PART 10

Sharpening Your Photos

Start

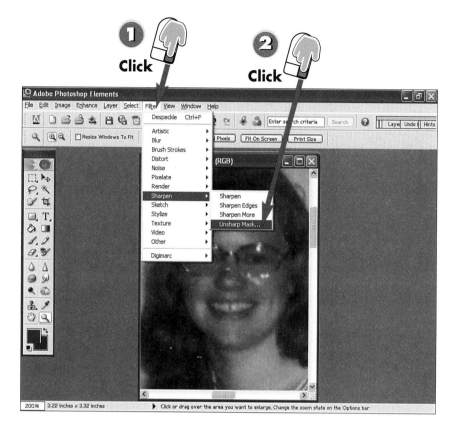

Click

Click

1 Click **Filter**, **Sharpen**.

2 Click **Unsharp Mask** to open the Unsharp Mask dialog.

INTRODUCTION

You can improve the sharpness of a slightly out-of-focus or despeckled photo (see "Removing Speckles with the Despeckle Feature," **p.178**, [this part]) with the Unsharp Mask tool. As you see in this task, you can control the sharpening effect.

HINT

Avoiding Sharpen/Sharpen Edges
The Sharpen or Sharpen Edges options don't have adjustments, so they often oversharpen an image.

Click

⑤

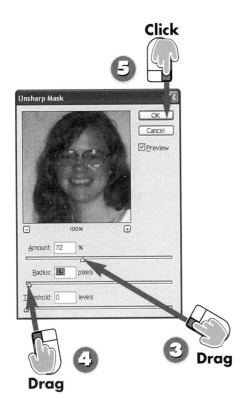

Unsharp Mask

OK
Cancel
☑ Preview

100%

Amount: 72 %

Radius: 0.5 pixels

Threshold: 0 levels

④ **Drag**

③ **Drag**

⑥

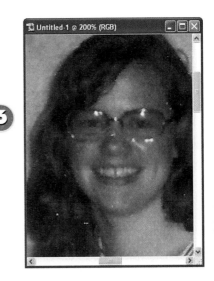

Untitled-1 @ 200% (RGB)

③ Drag the **Amount** slider to control the percentage of sharpening.

④ Drag the **Radius** slider to adjust the width of the affected area.

⑤ Click **OK** when finished.

⑥ The photo is sharper.

End

HINT
Moving the Dialog
Drag the Unsharp Mask dialog to one side of your photo to see a real-time preview in the main workspace as you make adjustments.

TIP
How Much to Sharpen
I like to use a sharpening amount of around 75%–100%. Higher settings can create halos around small details and might bring back speckles.

TIP
Improving Fine Detail
The default radius is 1 pixel, but I like to adjust this down to 0.5 pixels to improve the fine detail in the photo.

Using Special Effects

Start

1 Click **2** Click

1 Click **Filter**, **Artistic**.

2 Click **Watercolor**.

3 The Watercolor preview box opens.

INTRODUCTION

Sometimes a regular photograph isn't the way you want to record a special subject or event. However, if you're not an artist, you can choose from a variety of special-effects filters in Adobe Photoshop Elements to give an ordinary photograph the look of fine art.

Salvaging Photos with Watercolor

HINT

The Watercolor filter used here is also an excellent way to salvage a photo that is not sharp enough to be useful as an ordinary photo.

Lighter Is Better

HINT

The Watercolor filter tends to darken the colors in your original photo. Consequently, you might want to use the **Enhance** menu's **Adjust Brightness/Contrast** option to lighten your photo before applying it.

Click

Click

Drag

4 Adjust the Preview size by clicking the **+** or **−** button.

5 Drag the slide bars to customize the watercolor.

6 Click **OK** when you are satisfied with your watercolor.

7 Your photo now resembles a watercolor.

Stepping Backward
Although it is possible to go back one step by clicking **File**, **Undo** menu, it is more efficient to retrace your editing steps by clicking the **File**, **Step Backward**. With this feature, you can go back through multiple steps.

Using the Preview Window
The Brush Detail, Shadow Intensity, and Texture settings used in this example maintain a reasonable level of overall detail. The preview window shows you in real time what happens as you adjust any or all of them.

PART 10

Removing Speckles with the Despeckle Feature

Click **Click**

(1) Click **Filter**, **Noise**.

(2) Click **Despeckle**.

(3) The image softens, making the dust less noticeable.

End

INTRODUCTION

Scanned photos, particularly those made from textured paper, sometimes contain small speckles or tiny scratches. Adobe Photoshop Elements features a handy Despeckle tool that can remove these imperfections.

TIP

Alternatives to Despeckle
Because the Despeckle feature tends to detract from focus and clarity, you might not want to use it for photos of close-up objects in which clarity is critical. Consider using the Clone Stamp tool instead.

TIP

Sharpening the Photo
Use the **Unsharp Mask** command to improve the clarity of your photo after despeckling. See "Sharpening Your Photos," **p.174** [this part].

Saving Your Changes While Keeping Your Originals

Start

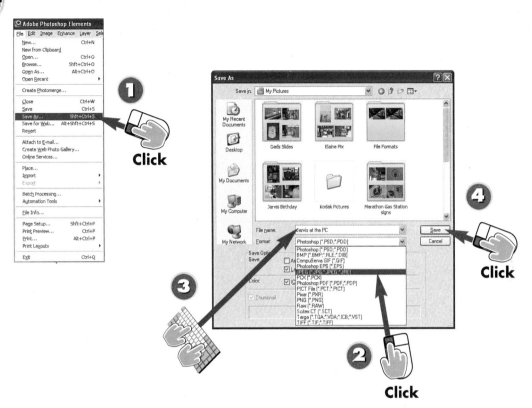

Click

Click

Click

1. Click **File**, **Save As**.

2. Select a file **Format**.

3. Type a new **Name** for the photo.

4. Click **Save**.

End

After you enhance your photos, it's time to save them. It's very easy to click File, Save as you work, but *don't do it!* This type of save overwrites the original with the changed version, which prevents you from starting over. In this task, I show you how to save your enhanced images without losing your original photos.

TIFF Versus JPEG

TIP

If you want to edit the photo again, select **TIFF**. If you want to save space on your hard disk, select **JPEG** (which uses less disk space).

Maximum JPEG Quality

HINT

If you select **JPEG**, I suggest choosing a quality setting of **Maximum** on the dialog that appears before you click **Save**. This preserves maximum detail in the photo in case you want to make changes to it later.

Resizing the Photo for Email or Web Use

Start

Click

Click

① Click **File**, **Save for Web**.

② Click the **Zoom** control and select the desired magnification for the preview.

③ The left window displays the original and the right window previews the changes you make.

INTRODUCTION

After saving your photo, you can resize it to make it easier to email or for use on the Web. You can use a separate software program as discussed in Part 12, "Presenting and Sharing Your Photos," but as outlined here Adobe Photoshop Elements has built-in tools you might prefer to use.

TIP

Adjusting the Preview Window
Use the hand icon to drag the preview inside either window to an important part of the picture.

HINT

Checking the Details
I recommend using 100% or larger magnification. This enables you to see whether important detail would be lost as you preview selected changes.

Click **4**

Click **5**

Type **6**

7

4 Click **Settings** and select both **JPEG** and **Medium** to reduce its size on disk.

5 Click **Width**.

6 Type **600**.

7 The preview in the right window shows the size reduction from the changes you entered.

See next page

Saving Without Resizing
TIP
If you want to send the photo without reducing its dimensions, click OK after step 5 to bring up the Save dialog.

Easy Viewing for Recipients
HINT
Many recipients will view an emailed photo in their Web browser. A photo wider than 800 pixels will require some users to scroll the photo to see all of it. I recommend 600 pixels.

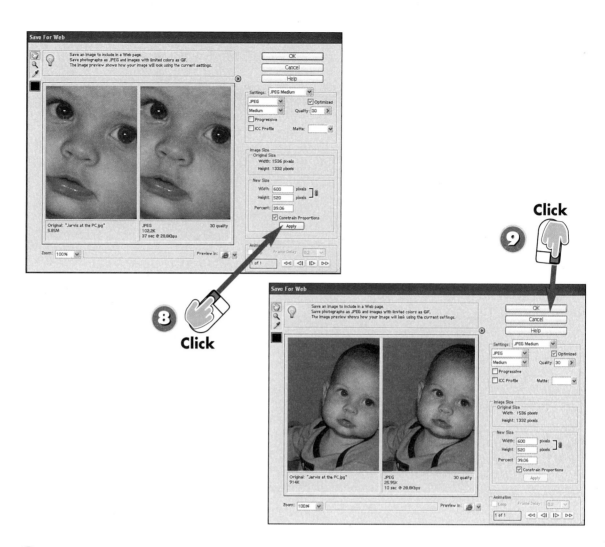

8 Click **Apply** to accept the settings.

9 Click **OK** to display the Save dialog.

TIP

Smaller Is Faster
Reducing the quality setting and the width of the photo can reduce the file size of a typical digital photo (from 914KB of disk space to just 26KB in this example) so that it's quick and easy to send via email, even with a dial-up connection.

Click

10 Click **Save** to save the optimized version.

End

Printing Your Digital Photos

There are more choices than ever before for when it's time to print your pictures. Whether you prefer to use a general-purpose inkjet printer, a specialized photo printer, or a printer dock, you can produce great-looking prints at home. Some printers even let you print without turning on your PC! This part shows you how to print snapshots and enlargements using a variety of printers.

Photo Printing Options

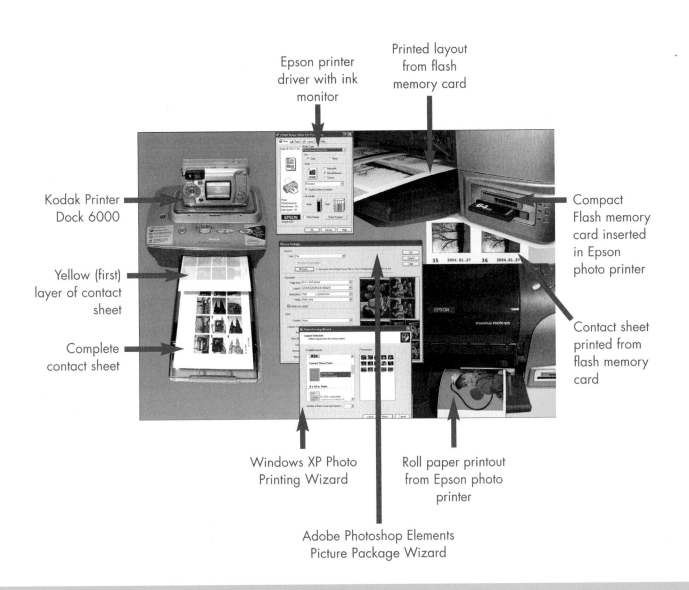

Epson printer driver with ink monitor

Printed layout from flash memory card

Kodak Printer Dock 6000

Yellow (first) layer of contact sheet

Complete contact sheet

Compact Flash memory card inserted in Epson photo printer

Contact sheet printed from flash memory card

Windows XP Photo Printing Wizard

Roll paper printout from Epson photo printer

Adobe Photoshop Elements Picture Package Wizard

Configuring the Printer for Glossy Photo Paper

Start

Right Click

Click ②

Click ①

Click ③

Click ④

① Click **Start**, **(All) Programs**, **Printers and Faxes**.

② Right-click your printer and click **Properties**.

③ Click the **Printing Preferences** button.

④ Click the **Paper/Quality** tab.

Click

7

Click
5

Click
6

Click
8

Click

5 Click the **Media** pull-down menu and select **Photo Quality Glossy Film**.

6 Click **Best** under Quality Settings.

7 Select **Color** if necessary.

8 Click **Apply**, then **OK** twice to close the preferences and main printer dialog.

Paper or Film?
With some inkjet printers, you should select Photo Quality Glossy Film instead of Glossy Paper. Check the printer manual or photo paper data sheet to see what's recommended for your printer.

When to Use Apply and OK
Clicking **Apply** and then **OK** saves the settings as the defaults for printing. If you click **OK** only, Windows uses these settings for the current print job only.

Closing the Printers and Faxes Folder
Click the red **X** at the upper-right side of the Printers and Faxes folder to close it.

Printing with Windows XP's Photo Printing Wizard

Start

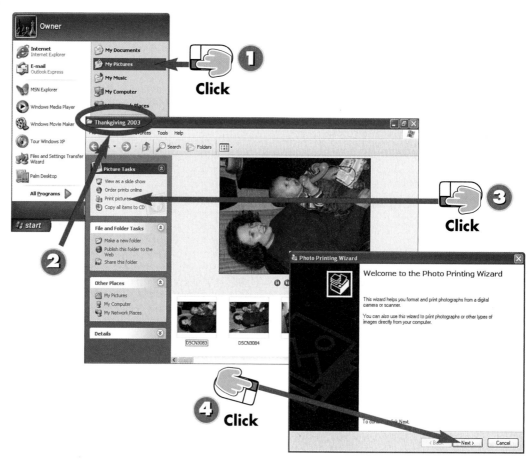

Click ①

Click ③

Click ④

① Click **Start**, **All Programs**, **My Pictures**.

② Open the folder that contains your photos.

③ Click **Print pictures** to start the Photo Printing Wizard.

④ Click **Next**.

INTRODUCTION

Windows XP's Photo Printing Wizard makes it easy to select the photos you want to print and print them to an inkjet or other printer type installed in Windows. In this task, you learn how to use the wizard to print your choice of print sizes to a typical inkjet printer.

Click

Click

Click

5 To print selected pictures only, click **Clear All**.

6 Click each photo you want to print.

7 Click **Next**.

The Printing Preferences Menu

Select options for paper and print quality in the printing preferences menu as discussed in the previous tasks.

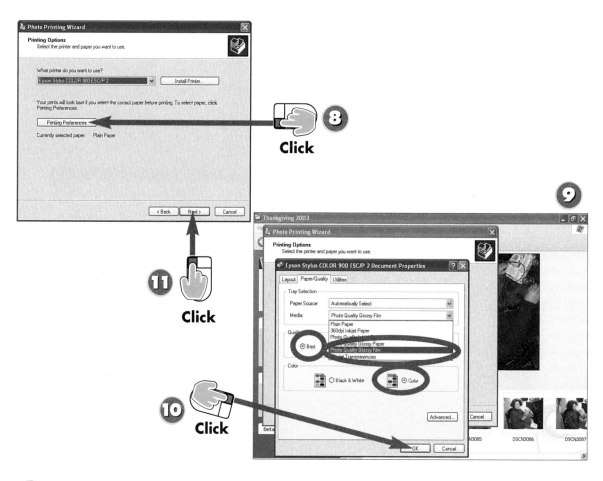

Click

Click

Click

8 Click **Printing Preferences** to set print quality and paper type.

9 Select the paper type, ink color, and quality settings from the menu.

10 Click **OK**.

11 Click **Next**.

The Paper Source Menu
Use the Paper Source menu if
you use roll paper or a different
paper tray than the printer's
normal paper tray.

Choose the Best Printer
If you have more than one
printer, you can select the
printer you want to use with the
pull-down printer selection
menu. Click **Install Printer** to
install drivers for a new printer
if necessary.

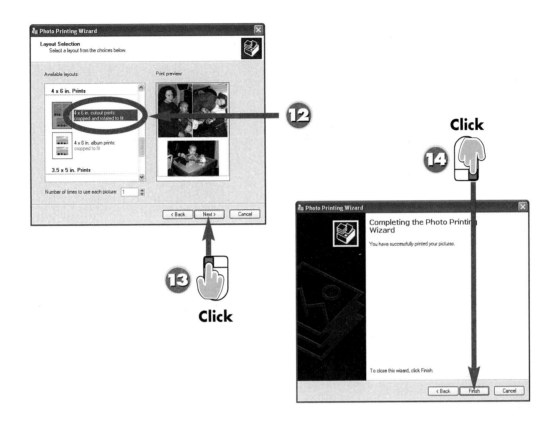

Click

Click

12 Select the layout.

13 Click **Next** to print your photos.

14 Click **Finish** if you're done printing photos.

End

Printing On Pre-scored Paper
Some 8.5×11-inch photo paper is pre-scored to enable you to punch out the prints when you're done. I suggest you run a test print on plain paper to make sure the prints line up correctly with the punch-out sections.

Choose the Right Paper
Make sure you remove regular paper and insert the paper type you specify when you print photos. In many cases, you might need to insert one sheet at a time.

Special Paper Trays
Many printers have a special paper feed tray or bin for special paper. You can use it for photo paper and leave your regular paper in the regular paper tray. Just choose the special tray as the paper source when you print photos.

Printing Contact Sheets with Adobe Photoshop Elements

Start

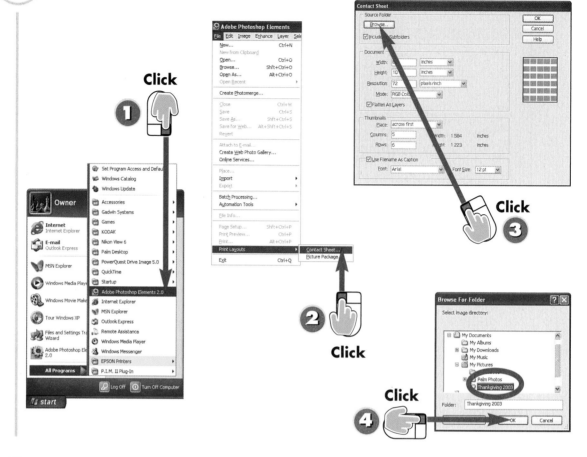

Click ①

Click ②

Click ③

Click ④

① Click **Start**, **(All) Programs**, **Adobe Photoshop Elements** to start the program.

② Click **File**, **Print Layouts**, **Contact Sheet**.

③ Click **Browse** to select the folder that contains your photos.

④ Select the folder and click **OK**.

INTRODUCTION

Contact sheets have long been used by film processors to show the contents of a roll of film. A film processor creates a contact sheet by laying strips of negatives on an 8×10-inch sheet of photo paper and contact-printing the negatives. Adobe Photoshop Elements takes your digital photos and scans them into the twenty-first-century version of a contact sheet, the index print, with its contact sheet printing option.

HINT

Photos per Contact Sheet
Photoshop Elements puts six rows of 5 photos each on a contact sheet (a total of 30 photos per sheet). You can adjust this to create larger thumbnails (use smaller numbers for row/column) or to put more photos on a page (use larger numbers).

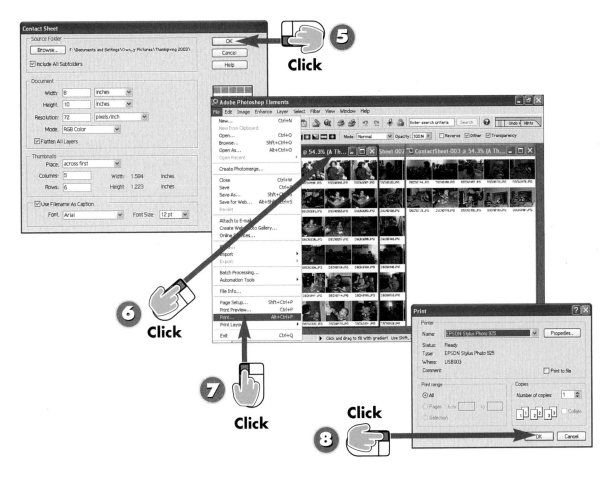

Click

Click

Click

Click

5 Click **OK** to create the contact sheet(s).

6 If more than one contact sheet is created, click one to select it for printing.

7 Click **File**, **Print**.

8 Click **OK** to print the contact sheet.

End

Selecting the Right Paper
Click the **Properties** button in the Print dialog to select a paper type and quality setting. See "Configuring the Printer for Glossy Photo Paper" earlier in this part for details.

Saving the Contact Sheet
Use the **File**, **Save** dialog to save each contact sheet so you can refer to it in the future if desired. See Part 10, "Enhancing Your Digital Photos," for details.

Sharing the Contact Sheet
If you want to email the contact sheet or burn it to a CD to share with others, save the contact sheet in JPEG format. See Part 10 for details.

Start

Creating Picture Packages with Adobe Photoshop Elements

Click　　**Click**

Click

1. With Adobe Photoshop Elements running, click **File**, **Print Layouts**, **Picture Package**.

2. Click **Browse** to select the picture you want to print.

3. Select the file and click **Open**.

Whether you need to print a pair of 5×7-inch enlargements or a sheet of wallets, Adobe Photoshop Elements's Picture Package feature can do the job for you. This task shows you how to create a sheet with a mixture of picture sizes using this option.

Printing a Folder's Worth of Layouts

If you select Folder instead of File, you can create a customized layout of all the photos in a folder. If you want to use this feature, create a folder and copy the photos you want to print into the folder.

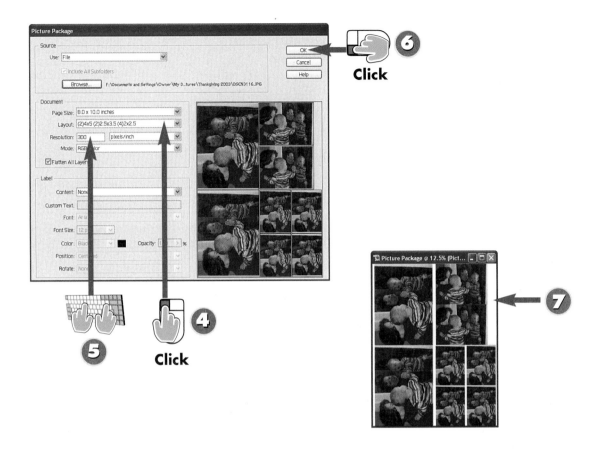

Click

Click

Click **Layout** and select the desired layout.

Type the resolution recommended by your printer vendor into the **Resolution** box.

Click **OK** to create the layout.

The picture package document is displayed onscreen.

End

Cutting Photos with a Rotary Cutter
If you choose a print layout that places multiple snapshots on a single page as in this task, consider using a rotary cutter to separate the prints. A rotary cutter makes a better cut than scissors and provides precise trimming of paper edges.

Boost the Resolution
The 72dpi default resolution used for the Picture Package option is too low for quality prints. You should use a resolution of 240 to 300dpi with most inkjet printers. Check your printer manual for specific recommendations.

Printing and Saving a Package
See "Printing Contact Sheets with Adobe Photoshop Elements" (this part) to learn how to print your picture package. See "Saving Your Changes While Keeping Your Originals" (in Part 10) to learn how to save your picture package.

Printing Photos on Roll Paper

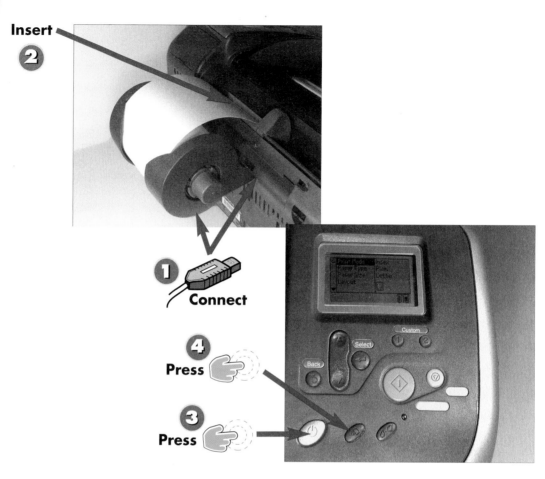

Insert

2

1 **Connect**

4 **Press**

3 **Press**

1 Attach the roll paper and holder to the rear of the printer.

2 Insert the end of the paper into the printer.

3 Press the printer power button to turn it on.

4 Press the roll paper button to feed the paper into the printer.

Give the Roll Paper a Hand
To ensure that the roll paper feeds correctly, push the end of the roll down into the printer gently as you push the roll paper button.

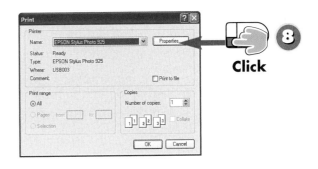

5 With Adobe Photoshop Elements running, click **File**, **Open**.

6 Select a file and click **Open**.

7 Click **File**, **Print**.

8 Click the **Properties** button.

See next page

Changing Printers
Click the **Printer** pull-down menu next to the Properties button to change printers. This is helpful if you prefer to use a laser printer as your default printer but a photo printer for photo printing.

Use Any Photo App You Want
Although I'm using Adobe Photoshop Elements in this task, you could use any Windows-based photo editor, including those bundled with color printers and scanners.

Click **Click**

⑨ ⑩

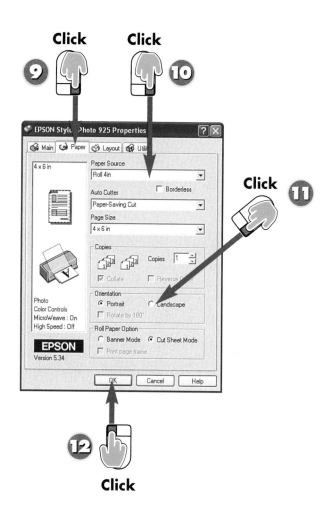

Click ⑪

⑫ **Click**

⑨ Click the **Paper** tab.

⑩ Select **Roll 4in** from the Paper Source menu.

⑪ Select **Landscape** for a horizontal photo; **Portrait** for a vertical photo.

⑫ Click **OK** to close the Paper dialog.

Making a Banner
Select **Banner Mode** under the Roll Paper Option section if you want to cut your photos apart later or want to use multiple photos or graphics to make a banner.

Selecting Borderless
You can choose borderless prints, but most digital cameras don't provide the 3:2 horizontal/vertical ratio needed to provide borderless prints without cropping part of the image. If you want to use this option, select the 3:2 setting in camera setup, if possible.

Click

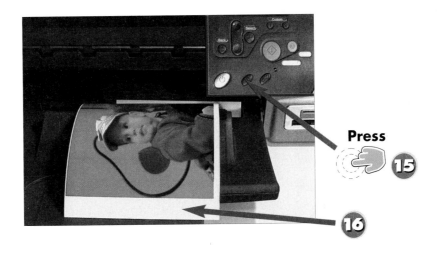

Press

13 Click **OK** to start the print job.

14 The print monitor displays printing progress and ink levels.

15 Push the roll paper button on the printer (inset) when the print is completed.

16 The print is cut and ejected.

Storing Roll Paper After Use

Follow the vendor's instructions for removing the roll paper. With the Epson Stylus 925 Photo, press the roll paper button for 3 seconds to rewind the paper. Store the paper in the original carton between uses.

Printing Direct from a Flash Memory Card

Start

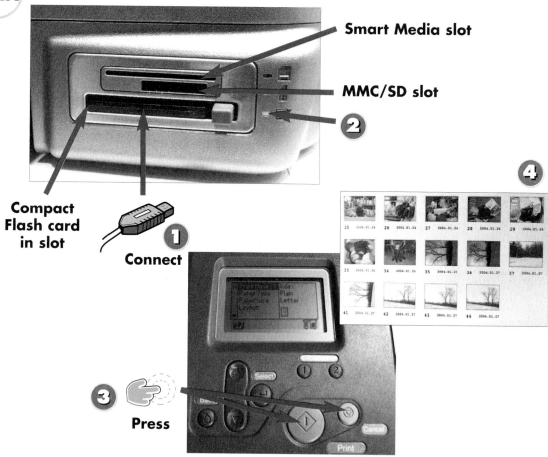

Smart Media slot

MMC/SD slot

2

4

Compact
Flash card
in slot

Connect

1

3 **Press**

1 Insert the flash memory card into the printer.

2 When the green light comes on, the card is recognized.

3 Press the **Cancel** button to clear previous settings, and then press **Print** to print an index page.

4 When printed, each photo is numbered sequentially.

Many photo printers now have flash memory slots so you can print photos without using the computer. This task shows you how to select and print a particular photo directly from flash memory using the Epson Stylus Photo 925 printer.

Green Doesn't Mean Go
Don't remove the flash memory card while the access light is flickering; this indicates the printer is reading the card's contents.

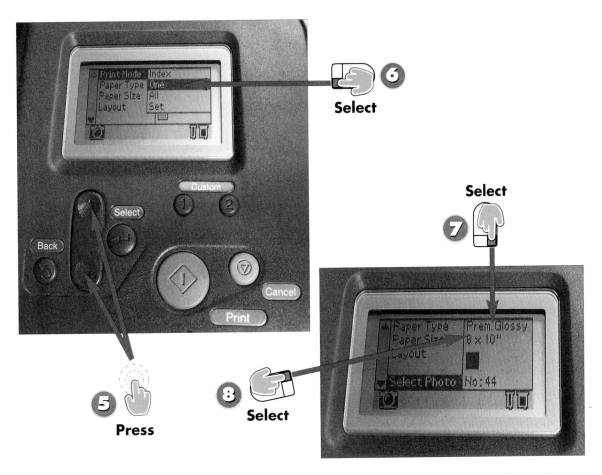

Select 6

Select 7

Press 5

Select 8

5 To highlight an option, press the up/down arrow keys; to select it, press the **Select** key.

6 To print a single picture, highlight **Print Mode** and select **One**.

7 Select the paper type.

8 Select the paper size.

See next page

Saving Money
If you're using the index print just to select a photo for high-quality printing, use plain paper. This is the default for many printers. However, don't forget to specify which type and size of high-quality photo paper you will use for final prints.

Look for Monitor-Equipped Printers
Some photo printers now have built-in LCD monitors that can be used to select, preview, and perform minor editing functions on photos. Some, such as the Epson Stylus Photo 925, can be equipped with an optional LCD monitor.

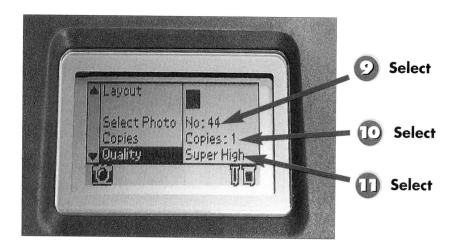

9 Select

10 Select

11 Select

Select **12**

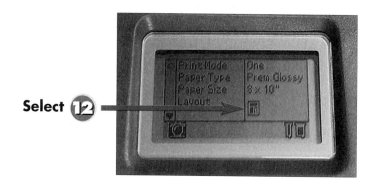

9 Select the number of the photo you want to print.

10 Select the number of copies.

11 Select the quality.

12 Select **Layout**. You can print multiple sizes, multiple prints of the same size, or a single print on a sheet.

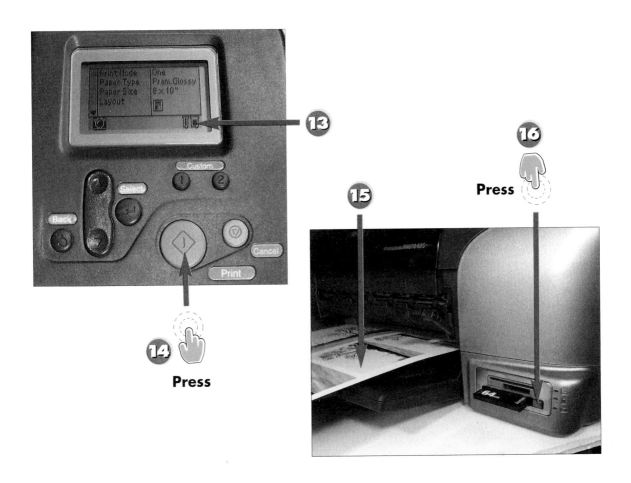

Press

Press

13 Check the ink levels.

14 Load the printer paper and press the **Print** button.

15 The selected photo is printed.

16 Press the **Eject** button to remove the Compact Flash memory card.

End

Ejecting the Card Safely
If the printer is connected to a computer, use the **Eject Hardware Safely** option in the Windows System Tray to stop the card before you remove it from the printer.

Removing Flash Memory Cards
If you use Smart Media, MMC/SD, Memory Stick, or xD-Picture cards, these cards usually push into place. To remove them, push in a bit to release the internal lock, and then pull the card out.

Printing Photos with a Printer Dock

Start

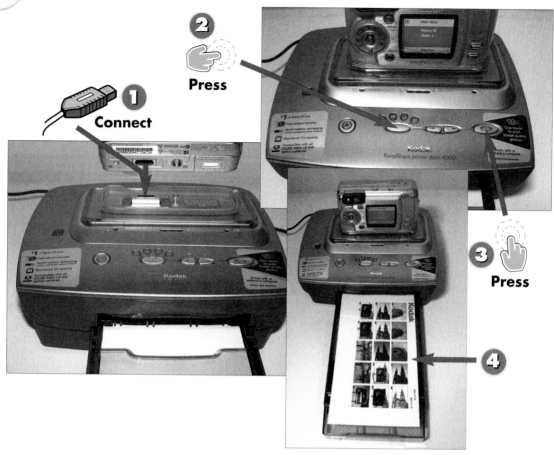

②
Press

①
Connect

③
Press

④

① Connect your camera to the printer dock.

② Press the selection button until the Index Print light appears.

③ Press **Print**.

④ The printer produces an index print (each print displays 15 photos).

A printer dock combines the data-transfer features of a camera dock (see Part 7, "Transferring Digital Photos to Your Computer," for details) with a continuous-tone dye-sublimation printer for 4×6-inch snapshots. This task shows you how to print index prints and selected snapshots from a Kodak EasyShare camera using a Kodak Printer Dock. Some vendors' dye-sublimation printers use a cable direct from the camera or accept flash memory cards instead of using a docking connection. However, the basic four-pass print feature is true with any type of dye-sublimation printer.

TIP

Save Money with Digital Printing
Many photofinishers can now make prints directly from flash memory cards or recordable CDs. You can also order prints from online photofinishers such as Snapfish (see Part 12, "Presenting and Sharing Your Photos").

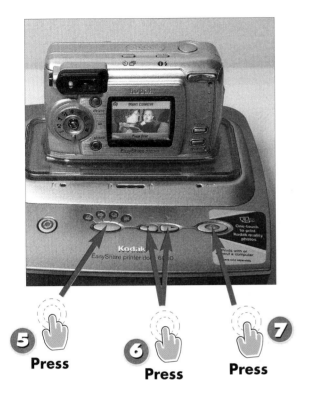

Press

Press **Press**

5 Press the selection button until the camera (single print) icon lights up.

6 Use the left and right arrows to display the photo you want to print.

7 Press the **Print** button to print the photo.

8 The printer prints the photo.

End

Four Passes to Beautiful Prints
Dye-sublimation printers like the one built in to the Kodak Printer Dock make separate passes for yellow, magenta, and cyan, and a final pass to put a protective coating over the photo.

Borderless Prints Without Cropping
Use Kodak EasyShare digital cameras' setup menus to select high quality mode with a 3:2 ratio for true borderless printing. The white edges shown on the prints are used to feed the paper; they snap off after printing is complete.

Using the Printer Dock As a Printer
To use the printer dock as a conventional photo printer to print photos already on your system, install the printer driver supplied with the printer dock and connect it to your PC with the USB cable supplied with your camera or the dock.

Presenting and Sharing Your Photos

Digital photography is easy, fun, and carefree, but as much fun as it is to *take* digital photos, it's even more fun to *share* digital photos. Whether you want to share the photos you shot at a birthday party the preceding week or the 50-year-old family photos you just scanned, you can use your photos to enhance email messages, create auto-advance slide shows, or improve PowerPoint presentations.

You can even use digital photos to illustrate a sales listing on auction sites such as eBay or to add interest to a Microsoft Word or other document. Use the tips and methods that follow to help family and friends enjoy your photos as much as you do.

Ways to Share Photos

Attaching a photo to an email message

Windows XP Resize Pictures utility

Snapfish online photo album after uploading

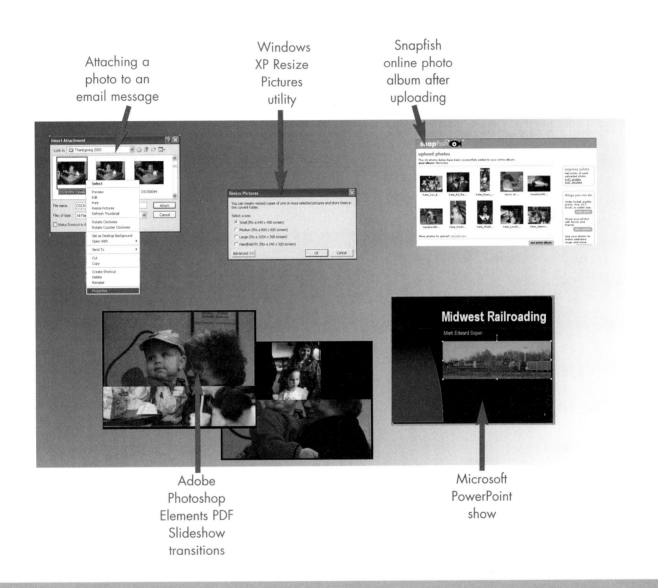

Adobe Photoshop Elements PDF Slideshow transitions

Microsoft PowerPoint show

Reducing Your Photo File Size

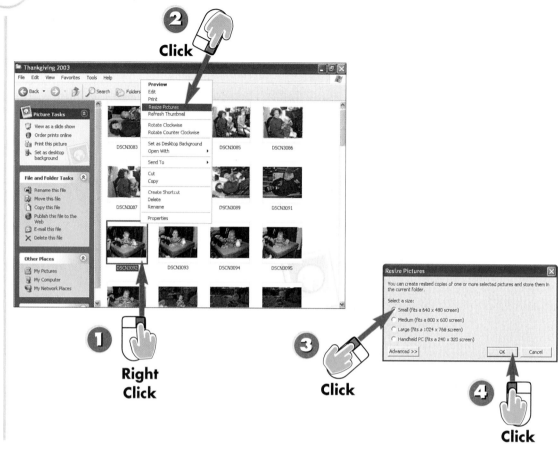

Start

Click

Right Click

Click

Click

1. Right-click the photo you want to shrink.

2. Select **Resize Pictures**.

3. Select a size from the menu.

4. Click **OK**.

INTRODUCTION

Although taking photos at high resolution and quality settings improves photo quality, full-size digital photos can be difficult to share with friends and family. These files can use so much disk space that emailing them as attachments could exceed the maximum message size that an email provider allows. Large files can also take a long time to transfer and can be difficult to view in a Web browser. You can use the free Image Resizer Powertoy from Microsoft (Windows XP only) to reduce your image file sizes.

TIP

Getting Image File Resizer
Download Image File Resizer for Windows XP free from the Microsoft Web site:
http://www.microsoft.com/windowsxp/pro/downloads/powertoys.asp.

5 Click **View**, **Refresh** to re-sort the folder.

6 The reduced-size photo is displayed next to the original.

7 To see the difference in size, click **View**, **Details**.

8 The new version is less than 1/20th the size of the original.

End

Selecting the Best Size
Choose **Small** for a photo you want to email. **Medium** and **Large** are good choices for slideshows. Select **Handheld PC** for photos you want to copy to a Palm or Pocket PC PDA.

Resizing a Group of Photos
To resize a group of photos, select them, right-click the group, and select **Resize**. Select the desired size and all photos will be resized.

Emailing Photos

Start

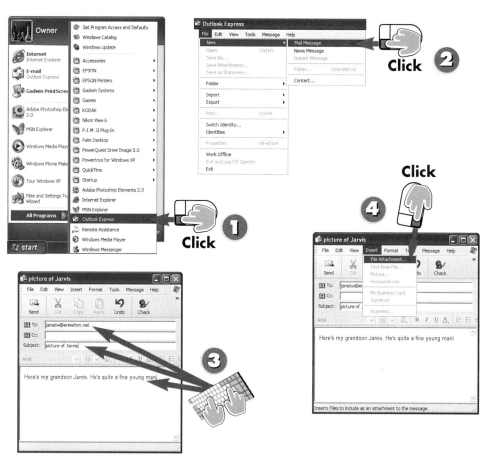

1. To start Outlook Express click **Start**, **All Programs**, **Outlook Express**.

2. Click **File**, **New**, **Mail Message**.

3. Type your recipient's email address, email subject, and message text.

4. On the **Insert** menu, click **File Attachment**.

The most convenient way to send photos to another recipient is via email, usually as an attachment to the message. Email programs such as Outlook Express, shown in this task, make the operation easy.

Add Message Text

To encourage your recipient to open the attachment and view the photo or photos you are sending, it is always a good idea to incorporate some descriptive information into the body of your email.

Preemptive Email

If you don't usually send attachments to friends and family, you might want to send a preliminary message first to indicate that a photo is coming in a separate message. Some email users routinely delete unexpected attachments to avoid viruses.

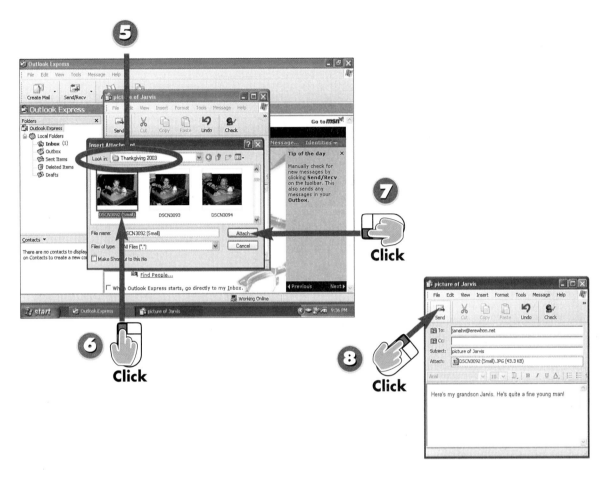

5 Select the folder that contains the photo you want to attach.

6 Click the photo you want to attach.

7 Click **Attach**.

8 Click **Send** to deliver your email.

End

Smaller Is Better
A file with a file size less than 100KB is easy to email, even with a slow dial-up connection. It's also easy for the recipient to receive and view. To check a file size, right-click the image and click **Properties**.

Send Multiple Emails
Photo files can be large and can exceed your Internet provider's maximum message size (often as little as 2MB). If you have several large photos to send, try sending multiple email messages with one or two different photos attached to each.

Signing Up for an Online Photo Album Service

Start

① **Click**

②

③ **Click**

① Click **Start**, **All Programs**, **Internet Explorer** (or third-party browser) to open your Web browser.

② Type **www.snapfish.com** in the address line and press **Enter**.

③ Click the **start using Snapfish** button.

Online photo albums let you share your pictures anywhere you can access the World Wide Web. Some services make your photos available to all Web users, while others let you restrict access to invited guests.

Most online photo album services are provided by companies that also offer online photo printing, enlargements, and other services. In this task, you learn how to set up an online photo album with a typical online photo finishing company, Snapfish.

Other Online Albums
Other popular online album/photo finishing services include Ofoto, Yahoo! Photos, Sony ImageStation, and ClubPhoto.

TIP

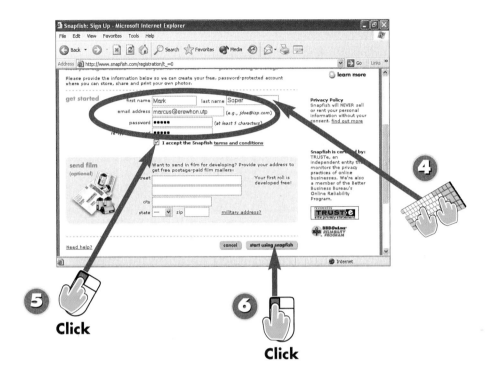

Click **Click**

4 Type in the requested information for first name, last name, email address, and password.

5 Select the **I accept the Snapfish terms and conditions** check box.

6 Click the **start using snapfish** button.

End

Uploading Photos for an Online Photo Album

Start

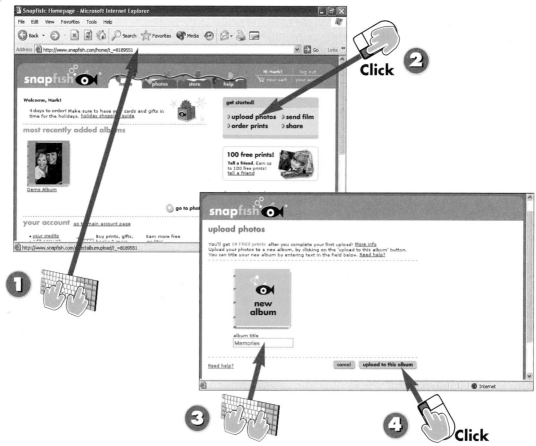

1 Open your Web browser and go to the Snapfish Web site.

2 Click **upload photos**.

3 Type a new name for your album in the **album title** field.

4 Click **upload to this album**.

INTRODUCTION

As soon as you sign up for an online photo album, you can start the process of sharing your photos online. In this task, you learn how to upload photos stored in the My Pictures folder and turn them into a photo album using the Snapfish service.

TIP

Be Sure to Log In
If Snapfish doesn't greet you by name, click the **log in** button and enter your email address and password to get started.

HINT

Use Full-Size Photos
Even if you have created smaller photos for emailing or Web site use, you should upload the full-size versions, especially if you want to order prints.

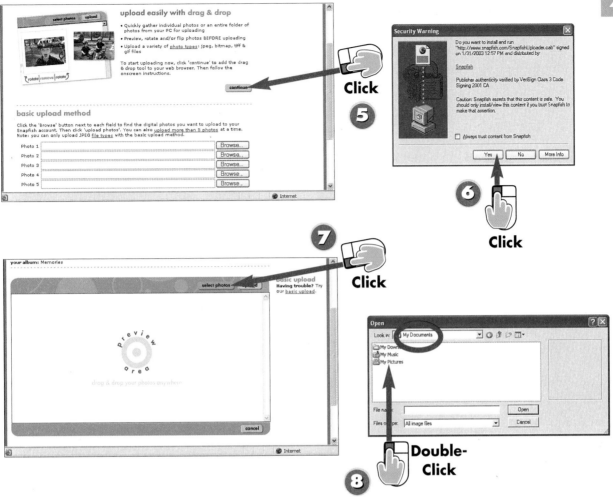

5 Click **continue** to install the Drag & Drop uploader.

6 Click **Yes** to complete installation of the Drag & Drop uploader.

7 Click **select photos**.

8 Select **My Documents** from the **Look in** field and double-click the **My Pictures** folder.

See next page

Use the Browse Button

If you cannot use the Drag & Drop uploader, click a **Browse** button to select a JPEG (.JPG) for uploading. You can upload five photos at a time with the browse tool.

Finding Pictures

If your photos are located in a drive or folder other than My Documents/My Pictures, click **Look in** and select the drive or folder from the list.

9 Hold down the **Ctrl** key and click each photo you want to upload.

10 Click **Open** to upload them.

11 Review the photos in the preview window and click **upload** to send the photos to your album.

12 A preview window displays the photo being uploaded and each photo is checked off as it is uploaded.

Rotating Pictures
Use the **rotate** buttons if a photo is sideways or upside down. Use the **remove** button if you decide not to upload a particular photo.

Interrupting an Upload
If you need to interrupt the process (for example, if you need to make a phone call), click the **stop upload** button. You can continue the upload later.

13 Click **share photos**.

14 To let people know your album is online, type the email addresses of friends and family.

15 Type a new subject and message for the emails.

16 Click **share album now** to send your message.

End

Adding to an Album
If you are adding photos to an album you have already created, click **see entire album** to see all the photos.

Full or Restricted Access
Both full and restricted access lets viewers order reprints. Full access also allows additional options such as ordering PhotoCDs. Select the appropriate access for your needs.

Accessing the Album
Viewers will need to sign up with Snapfish (it's free) to view your album. The email Snapfish sends includes a link that displays a sign-up form and a login prompt.

Creating a Slideshow with Adobe Photoshop Elements

Start

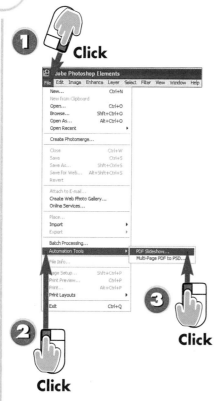

1 **Click**

2 **Click**

3 **Click**

4 **Click**

1 Click **File**.

2 Click **Automation Tools**.

3 Click **PDF Slideshow**.

4 Click **Browse** to locate folders and files for your slide show.

A single photo captures a moment, but it takes several photos to provide the full flavor of an event, a vacation, or a family reunion. Instead of passing around a photo album, you can use your computer to create a slide show that plays in most computers. This task shows you how to build a slide show with Adobe Photoshop Elements.

Other Slideshow Software
Other software products that offer slideshow creation capability include (**www.aliu.com/**), DMagix Showmaker (**www.dmagic.dk/showmaker/**), Digital Photo Slide Show (**www.digitalphotoslideshow.com**), Easy Slide Show Creator (**www.programmingart.com**), and ProShow Slide Show Creator (**www.photodex.com**).

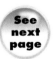

5 Select the folder that contains the photos you want to use.

6 Hold down the **Ctrl** key and click each photo you want to use in the show.

7 Click **Open**.

See next page

What's a PDF?

PDF stands for *Portable Document Format,* a popular format accessible to anyone with the free Adobe Reader on their PC. You can download Adobe Reader from the Adobe site at **www.adobe.com/ products/acrobat/readstep2.html**.

Drag ⑧

Click ⑩

⑨

⑧ Drag the scroll bar for the source files window to the right to review the photos.

⑨ Use the Slide Show Options section to customize playback options.

⑩ Click **Choose** to continue.

Removing a Photo
To delete a photo from the slide show you are building, click the filename and click **Remove**.

Pacing Slides
To adjust the amount of time each slide stays onscreen, enter a value (in seconds) in the **Advance Every** field under **Slide Show Options**.

Special Effects
Click the **Transition** pull-down menu to choose which effect appears as one slide changes to another. You can choose from wipes, sparkles, and other effects.

Click

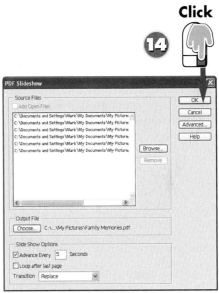

Click

11 Click to select a folder to store your slide show.

12 Enter a filename for your slide show.

13 Click **Save**.

14 Click **OK** to create the slide show.

End

Closing the Process
Click **OK** to close the prompt indicating the slideshow creation was successful when it appears.

Distributing Slideshows
The size of your slide show increases as you use larger photos or more photos. If you want to email your show but it's larger than 2MB (2,000KB), reduce the file size of your photos and re-create the show, or make a CD to share your photos.

Viewing Your Slideshow
To view the slideshow on any system with Adobe Reader or Adobe Acrobat Reader installed, double-click on the slideshow icon in Windows Explorer. The show starts and runs automatically using the settings specified when the show was created.

Embedding Your Images in a Microsoft Word File

Start

1 In a new Word document, type some text and press **Enter**.

2 Click **Insert**.

3 Click **Picture**.

4 Click **From File**.

INTRODUCTION

By any measure, Microsoft Word is far and away the most popular word-processing software program. In this task, you learn how to embed digital photos into your document to put some added pizzazz to family letters or business documents.

TIP

Starting Word
To start Microsoft Word, click **Start**, **(All) Programs**, **Microsoft Word**. If a Microsoft Word icon isn't listed in the Programs menu, look for it in a folder labeled **Microsoft Office**.

5 Open the folder that contains the photo.

6 Click to select the image.

7 Click **Insert**.

8 Word inserts the selected photo into your document.

End

Using a Text Box
To make it easier to position your photo, create a text box (Insert, Text Box) and place your photo inside it. You can drag the text box and its contents around as needed.

Saving Your Document
To save your document, click **File**, **Save As**, specify the name and location of your file, and click **Save**.

Embedding Your Images in a Microsoft PowerPoint Presentation

Start

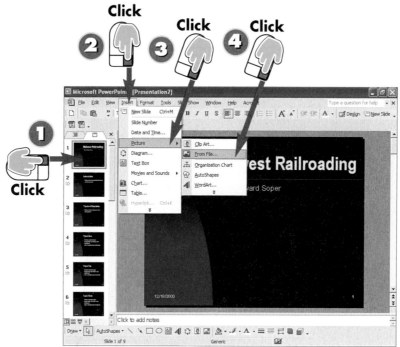

1 Start a presentation and click the slide where you want to place the photo.

2 Click **Insert**.

3 Click **Picture**.

4 Click **From File**.

INTRODUCTION

PowerPoint is the most popular presentation program. Although a presentation can include text, graphics, sounds, and animation, some users are content to use the clip art and prepackaged designs included with the program. In this task, you learn how to add your own digital photos to an existing presentation.

TIP

Creating a Presentation
You can create a presentation using the AutoContent Wizard, a design template, or use your own design.

HINT

Selecting a Slide
To select a slide, scroll through the slides on the left side of the screen and click the slide you want to use.

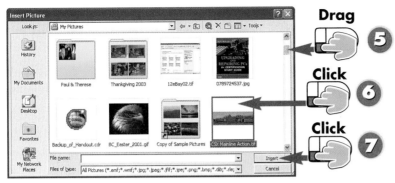

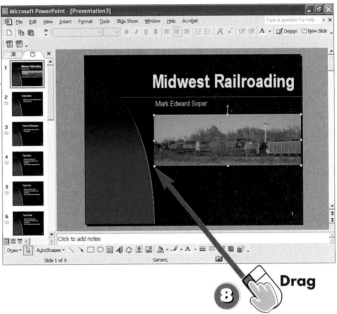

5 Review your photos by dragging down the right slider bar.

6 Click to choose a photo for your PowerPoint slide.

7 Click **Insert**.

8 Drag the photo to the appropriate location on your slide.

End

Changing Folders
Use the **Look in** menu or **Browse** button (depending on the version of Windows you use) to change to a different folder.

Avoiding Clutter
To avoid cluttering up your slide, use one photo per slide. Use the scroll bar on the left side to advance to another slide that needs a photo, and repeat the steps for this task.

Saving Disk Space
Use **File**, **Save As** and specify a new name to save your presentation after you add your photos. This method of saving the presentation uses less disk space than using **File**, **Save**.

Storing Your Digital Photos

After you've worked hard to create photographic masterpieces with your digital camera or scanner, don't let user error, hardware failure, or software failure take them away. To keep them safe, create backups you can access in case you lose the original files.

At some point, you'll probably want to move the photos from your hard disk to archival storage to free up space for more photos. Whether you prefer recordable CD or DVD, removable-media or external hard disks, it's essential to keep your photos well-organized so you can find the photos you want as quickly as possible.

This chapter shows you how to make backups of your photos, how to transfer them to archival storage, how to organize them for easy access, and how to recover from damage to a CD containing photos.

The My Pictures Folder

Right-click menu

Selected photo
in My Pictures
folder
(Windows XP)

Preview of
photo

Destination
options for
Send To
command

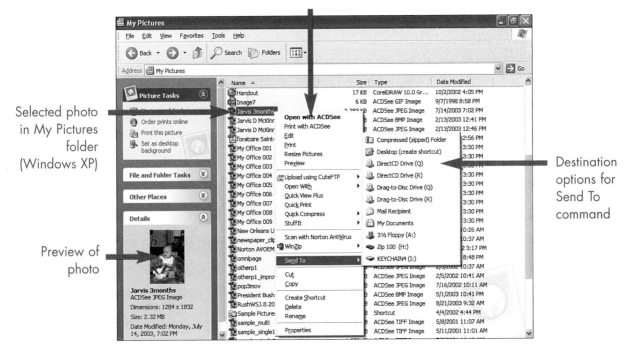

Using Windows XP's CD Burning Feature

Press ①

Insert
②

③
Press

① Press the eject button to open the rewritable CD or DVD drive.

② Insert a blank CD (CD-R or CD-RW) into the drive, label up.

③ Press the eject button to close the drive.

4 Windows XP asks if you want to open a writable CD folder using Windows Explorer. Click **OK**.

5 On the Other Places section of the task pane, click **My Documents**.

6 Open the folder containing the photos. In this example, double-click **My Pictures**.

See next page

Backing Up Your Work
Use recordable CD (CD-R) media to make a permanent copy of your work. You can add more files to CD-R media, but you can't delete any. Use rewritable CD (CD-RW) media for work in progress (such as photos you plan to edit).

Sharing Your CDs
If you want to share your files with others, use recordable CD (CD-R) media. Some older CD-ROM drives can't read CD-RW media.

Click

Click

Click 7

Click 8

Click 9

7 Click **Copy all items to CD** in the Picture Tasks menu.

8 When the prompt appears, click **You have files waiting to be written to the CD**.

9 Click **Write these files to CD** in the CD Writing Tasks menu.

TIP

Canceling CD Writing
If you decide not to copy the files to CD, click **Delete temporary files** in the CD Writing Tasks pane.

TIP

Opening the CD for Writing
If the balloon indicating **You have files waiting to be written to the CD** does not appear, click the CD drive icon in the Taskbar or click **My Computer**, then the CD drive icon.

Click

Click

10 The CD Writing wizard uses the current date as the name of the CD unless you type another name.

11 Click **Next**.

12 A progress bar displays the writing progress.

13 When Windows indicates the writing process is complete, click **Finish** (the CD should eject from the drive).

End

Writing Time Varies
The estimated times listed by Windows are often much longer than the actual time. The actual time depends upon the speed of your system and drive, and the amount of data you copy to the CD.

Creating Another CD
If you want to make another CD with the same files, click **Yes, write these files to another CD** before clicking **Finish**.

Using Windows Explorer to Copy Pictures to Another Drive

Start

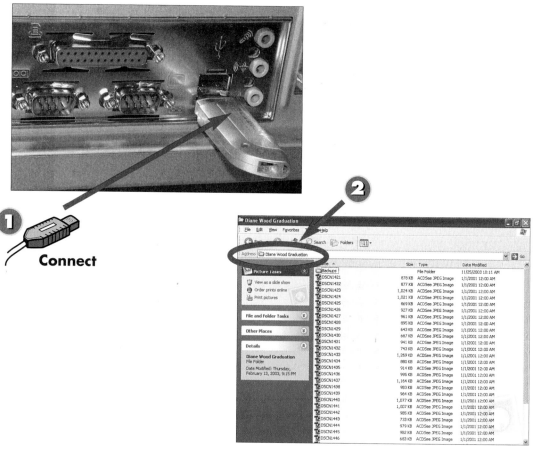

Connect

① Connect a USB keychain drive to a USB port.

② Open Windows Explorer and access the folder that contains your photos

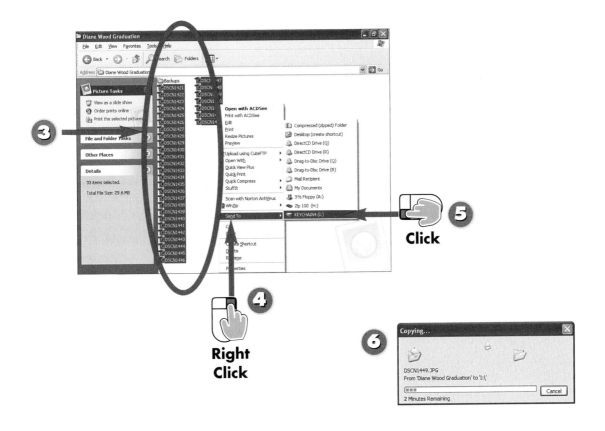

Right Click

Click

(3) Select the photos you want to transfer to the drive.

(4) Right-click the selected area and select **Send To**.

(5) Click the USB drive to copy your files. It is displayed as a removable disk.

(6) A status bar indicates the file copy progress.

End

Selecting Files

HINT

Compare the total size of the photos you want to transfer to the capacity of your removable-media drive. If you have selected too many files, press **Esc** and reselect a smaller number of files.

Moving the Drive

TIP

You can unplug a USB keychain drive and connect it to another PC to view the photos. If you use a rewritable DVD or CD, you need to eject the media and select the option to make the media usable on any computer with a compatible drive.

Using Roxio Easy CD and DVD Creator to Backup Photos

Start

1. Click **Start**, **All Programs**, **Roxio Easy CD & DVD Creator 6**, **Home** to open the Roxio Easy CD & DVD Creator 6 main interface.

2. Click the **Creator Classic** icon.

3. When the main window opens, click **Data**. Here you can look through your folders for photos.

4. Select the source folder and files you want to copy to disc.

CDs and DVDs are easy and convenient ways to store photographs. Not only are CDs durable, but their content can be viewed on almost any desktop or notebook computer; many recent computers can also use DVDs. The best way to transfer photos to your CDs or DVDs is through a process called *burning*. The process is similar for CDs and DVDs. Using the popular Roxio Creator Classic feature on Roxio Easy CD & DVD Creator 6 from Roxio, Inc., the procedure for burning a CD to store your images is explained in this task.

TIP

Getting Easy CD and DVD Creator
Basic versions of Easy CD and DVD Creator 6 are included with many rewritable CD and DVD drives. The full version is available via download from www.roxio.com or as a boxed set sold at retail.

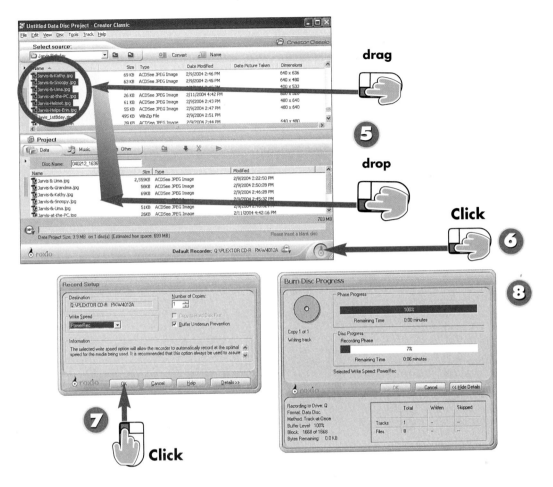

drag

drop

Click

Click

5 Drag and drop the selected files to the CD/DVD Layout pane.

6 Click the **Burn to Disc** icon.

7 Click **OK** in the Record Setup box to start the recording.

8 While your files are burning to CD or DVD, a Burn Disc Progress box displays the status of the operation.

End

Deletions

Deleting extraneous or duplicate files from the Layout pane does not delete them from your hard drive. It simply removes them from the list of files to be burned to CD or DVD.

Creating a Label

With the CD- or DVD-burning process completed, you might want to create a customized label for it. To start the process, click the **Label Creator** icon that appears when you have successfully created your CD or DVD.

Repairing Damaged Photo CDs

Start

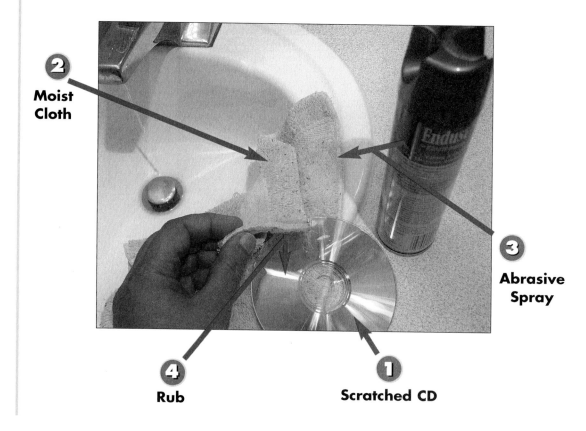

2 Moist Cloth

3 Abrasive Spray

4 Rub

1 Scratched CD

1 With your CD facing shiny (recording) side up, look for scratches.

2 Dampen a soft cloth.

3 Rub a small bit of abrasive spray on the cloth.

4 Gently rub the cloth over the scratches.

End

INTRODUCTION

Careless handling or storage can damage the recording surface of a CD. Scratches can cause the CD to load improperly and fail to display your photo files. You can sometimes repair minor damage that is causing this problem. You can use a manual procedure as shown in this task, or a commercial CD cleaning and repair product.

TIP

Finding Surface Damage
If some photo files on your CD open but others don't, note the order in which these files are listed. Data added to a CD last is at the outer edge. Data added first is to the center. Use this information to look for scratches in the affected areas.

HINT

Completing the Repair
Before reinserting your disc into your disc drive, wipe the disc with a dry section of the same cloth you used to clean it.

Renaming Photos with Windows Explorer

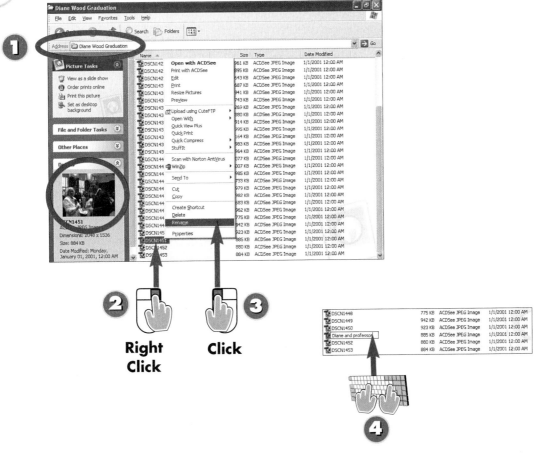

Right Click **Click**

① Open Windows Explorer and navigate to the folder containing your photos.

② Right-click a file. A preview box displays its contents in Windows XP or Me.

③ Click **Rename**.

④ Type the new filename.

End

INTRODUCTION
Digital cameras create digital photo files with alphanumeric names which don't identify the contents of the photos. To make your photos easier to locate and use, you should rename photo files with descriptive names. This task shows you how to rename files using the Windows Explorer.

HINT
Organizing Related Photos
To make it easier to rename your files, create a folder for each group of files and place related files in the same folder. For example, put wedding photos in a folder called Wedding, and graduation photos in a folder called Graduation.

TIP
Group File Renaming
You can rename a group of files with Windows Explorer in Windows XP only. Highlight the files, right-click the files, and select **Rename**. Enter the filename to use for the group, and the files are renamed with the name you entered and sequential numbers.

Renaming Photos with A.F.5 Rename Your Files

Start

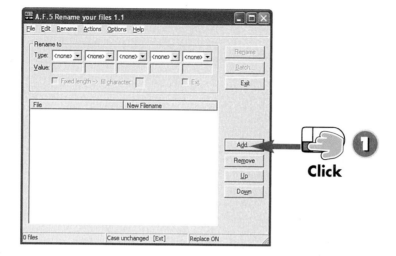

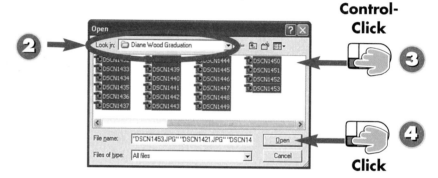

1 With A.F.5 Rename Your Files open, click **Add**.

2 Navigate to the folder containing your photos.

3 Hold down the **Ctrl** key and click the files you want to rename.

4 Click **Open**.

TIP

Selecting All Files
To highlight all the files, click the first file, hold down either **Shift** key, and press the **End** key.

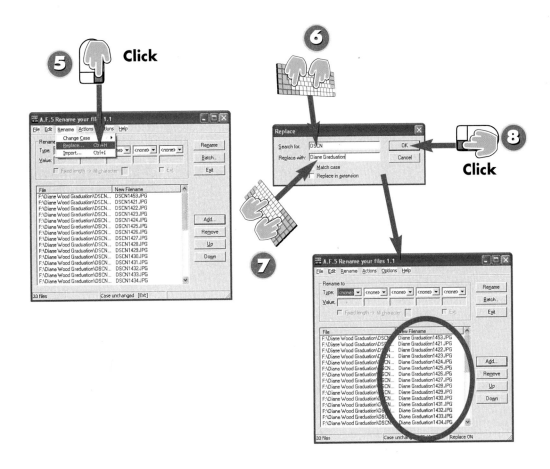

5 Click **Rename**, **Replace** in the top-level menu.

6 Type the filename characters you want to change in the **Search for** field.

7 Enter the descriptive filename you want to use in the **Replace with** field.

8 Click **OK** to rename the files.

End

Searching for Your Files
Usually, digital cameras name files with four common characters at the start of the filename, followed by a unique four-digit number. Enter the common characters in the filename in the **Search for** field.

Creating Folders for Your Photos

Start

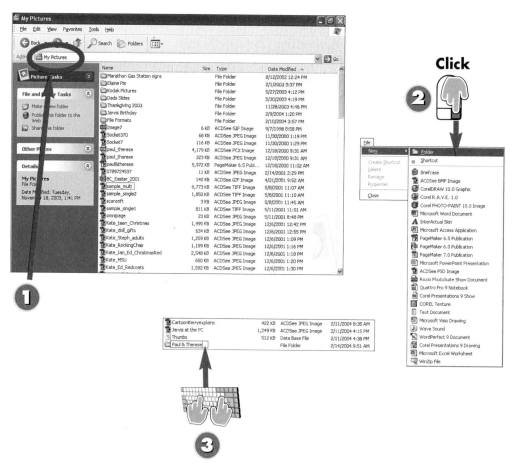

Click

1 Navigate to the folder containing your digital photos.

2 Click **File**, **New**, **Folder**.

3 Type the name desired for the new folder.

If all of your digital photos are stored in a single folder such as My Pictures, it can be difficult to locate the photos you took of a particular event. Fortunately, it's easy to make a new folder and move the pictures you want to place in that folder with Windows Explorer.

Right-Click Menu
You can also create a new folder with the right-click menu. Right-click an empty area in the right-hand window and select **New**, **Folder** from the menu. Then, type the name of the new folder (the default name is New Folder).

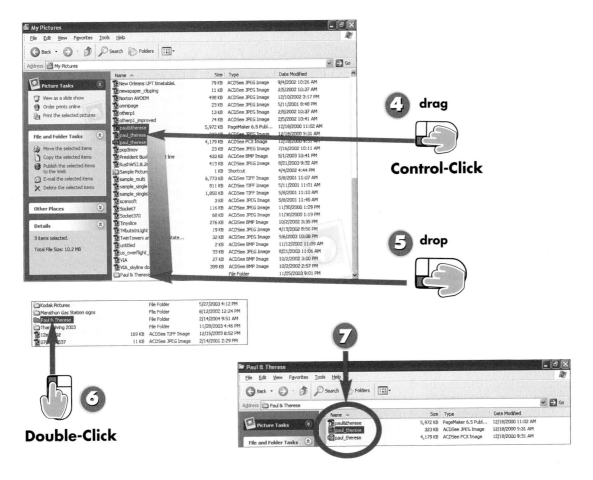

Control-Click

4 drag

5 drop

Double-Click

6

7

4 Hold down the **Ctrl** key and click the pictures you want to move to the new folder.

5 Drag the pictures to the new folder and drop them.

6 To verify the files were moved properly, double-click the new folder.

7 The photo files should now be located in the new folder.

End

Selecting a Group of Photos
To select a group of photos, hold down the **Shift** key and click on the first and last photo in the group.

Creating a Slideshow
After you move photos into a new folder, you can use Adobe Photoshop Elements to create a slideshow or photo album of the photos in the folder. See "Creating a PDF (Adobe Acrobat) Slideshow with Adobe Photoshop Elements," Part 11, and "Creating a Photo Album with Adobe Photoshop Elements," Part 11.

lighting

photo editing

Rather than having you read through a lot of text, Easy lets you learn visually. Users are introduced to topics of technology, hardware, software, and computers in a friendly, yet motivating, manner.

Easy Adobe® PhotoShop Elements

Gerald Everett Jones
ISBN: 0-7897-3112-6
$19.99 USA/$28.99 CAN

Easy Creating CDs & DVDs

Tom Bunzel
ISBN: 0-7897-2972-5
$19.99 USA/$30.99 CAN

Easy Windows® XP, Home Edition, Second Edition

Shelley O'Hara
Kate Shoup Welsh
ISBN: 0-7897-3036-7
$19.99 USA/$30.99 CAN

Easy Microsoft® Office 2003

Nancy Warner
ISBN: 0-7897-2962-8
$14.99 USA/$22.99 CAN

Special Offer!
Save 25% on *Easy Photoshop Elements*!

If you want to learn how to enhance those pictures you took with your digital camera, *Easy Photoshop Elements* is the perfect book to help make your photos all they should be! You'll find out how to remove red-eye from flash photos, fix contrast and brightness on under- or overexposed shots, and fix old or damaged family photos. And purchasers of *Easy Digital Cameras* get three chapters from *Easy Photoshop Elements* on this CD, and a special discount of 25%! To get your discount, go to www.quepublishing.com, look up *Easy Photoshop Elements*, enter discount code ESYPHOTO when prompted at checkout, and you will get a 25% discount and free shipping! Take advantage of this special offer today.
Offer expires January 15, 2005.

License Agreement